From
Quebradita
to
Duranguense

Dance in Mexican American Youth Culture

Sydney Hutchinson

The University of Arizona Press
Tucson

The University of Arizona Press
© 2007 The Arizona Board of Regents
All rights reserved

Library of Congress Cataloging-in-Publication Data

Hutchinson, Sydney, 1975–
From quebradita to duranguense : dance in Mexican
American youth culture / Sydney Hutchinson.
p. cm.
Includes bibliographical references and index.
ISBN-13: 978-0-8165-2536-2 (hardcover : alk. paper)
ISBN-10: 0-8165-2536-6 (hardcover : alk. paper)
ISBN-13: 978-0-8165-2632-1 (pbk. : alk. paper)
ISBN-10: 0-8165-2632-x (pbk. : alk. paper)
1. Mexican American dance. 2. Mexican American
youth—Southwest, New—Social life and customs. I. Title.
GV1624.7.M58H88 2007
793.3—dc22
2006028188

Publication of this book is made possible in part by the
proceeds of a permanent endowment created with the assis-
tance of a Challenge Grant from the National Endowment
for the Humanities, a federal agency.

Manufactured in the United States of America on acid-free,
archival-quality paper containing a minimum of 50% post-
consumer waste and processed chlorine free.

12 11 10 09 08 07 6 5 4 3 2 1

For my parents

Contents

Figures

Tables

Acknowledgments

I extend special thanks to all the dancers, musicians, teachers, and other friendly folk whose voices appear in these pages and who gave their time and mental energy in order to make this project possible. Many others helped me along the way with suggestions, recommendations, contacts, and advice. In Tucson, these individuals include Jan McCoy, Carlos Encinas, Maira Enríquez, Tianna Kennedy, Francisco Rentería, the Canyon del Oro High School staff, and Janet Sturman. At Indiana University, Ruth Stone and Sue Tuohy, members of my master's thesis committee, and fellow graduate students Gustavo Ponce and Lisa Akey offered guidance and support. In New York, Winnie Lee helped with editorial expertise, Rachel Lears supplied technical expertise, and Danielle Brown provided invaluable contacts in Los Angeles. While in Los Angeles, I incurred great debts to Gloria, Chris, and Sam Stone, whom I thank for their generosity; I also thank David, Sol, and Siris for going out of their way to help me understand. I am grateful to Juan Dies of Sones de México, Simplicio Román of Grupo Ansiedad, and Tom Ordover—all in Chicago. Thanks also to the New York University music faculty for giving me the chance to pursue my Ph.D. and the flexibility to allow me to pursue other projects such as this one.

Most especially, I thank my wonderful family. My parents' love, support, and academic expertise made this work not only possible, but also achievable; my sister and brother-in-law's hospitality made it much more pleasant. To them I am eternally grateful.

From Quebradita to Duranguense

ʄ

Jumping on the Banda Wagon

An Introduction to the Quebradita

The first time I heard of the dance called *quebradita* was during 1994, my junior year of college.[1] I was studying piano performance at the University of Arizona in Tucson at the time, and I recall reading about this new dance craze in the local newspaper. My two roommates attended a quebradita performance in the park, and when they came home, they couldn't stop talking about it. "It was incredible! It's *so* cool," they said. They tried to demonstrate it for me: "Their legs were whirling around behind them like this, and then the guy bends the girl over backward and it looks like he's breaking her back, and then he tosses her around like this." My roommates' performance left something to be desired, but they assured me that I would love it. We even thought of finding someone to tutor us in quebradita so we could perform it ourselves. Like so many of our excellent plans, however, nothing came of that idea.

By the summer of 1998, though, I nearly had forgotten about quebradita. I had graduated with a bachelor's of music degree a year and a half earlier and finally had decided to go back to school. To commemorate my last summer as a person with an actual job complete with unused vacation time, I decided to take myself to Puerto Vallarta, in the state of Jalisco, Mexico, to relax on the beach and work on my Spanish. The decision to travel by myself ended up being a good one because it was much easier to meet people. I became friends with a young man who worked in a shop selling Huichol art. It was a family business, and he was quite an expert on the subject. During the course of one of our afternoon talks, he invited me to a party in this

way: "Do you want to see what Mexico is *really* like?" This question sounded a little fishy to me, mainly because Mexico is such a large and diverse country. Still, I was curious to find out what *his* Mexico was really like, and I accepted his invitation.

This party turned out to be a major event in the small town of Pitillal, where my friend lived. We caught a bus from downtown Vallarta, and after twenty or thirty minutes we were deposited in the main square of the town. It was a Sunday night, and the plaza was full of vendors selling food and toys, children playing with firecrackers, and couples strolling. A surprising number of these people were actually my friend's relatives, so, after walking around a few minutes, I felt that I had been introduced to most of the town's population. We stopped to eat at a quesadilla stand, where the young woman in front of us in line looked strangely out of place in a minidress with coordinating shoes and handbag. "Fresa," my friend explained, and when he realized I was unfamiliar with the term, he elaborated: a *fresa* (literally, "strawberry") is a spoiled rich kid. We continued down a side street and encountered a mass of people milling about, most wearing jeans (in contrast to the fresas, who were not in attendance), and many in cowboy hats and boots. They all were waiting to buy tickets to the party; it seemed capacity had nearly been reached. I leaned up against a pickup truck while my friend investigated. Luckily, he found some friends with extra tickets, and once the police stationed at the entrance had patted him down and examined my handbag for weapons, we were in.

Directly in front of us was a dance floor packed with couples and flanked by speaker towers blasting out *banda*, popular music played by Mexican brass bands with more than a dozen members. *Tecnobanda*, an updated variant that replaces some brass instruments with keyboards and electric bass, could also be heard along with a few *norteña* tunes played by the accordion-driven groups typical of northern Mexico. On the opposite side was a stage, although not much was going on there because all the music was recorded. To the left of the stage was a concession stand that sold beer and only beer, as well as two sets of bathrooms. To the right a few tables and chairs were scattered, which no one was using. I was enjoying the music and wanted to dance, but my friend, embarrassed by his dancing ability (or lack thereof), declined. He did promise to dance with me once they played a *cumbia*, but his friends told me that I shouldn't hold my

breath. Instead, I quizzed him on the songs being played; he appeared to know the lyrics of every one.

Soon, a middle-aged man with a microphone appeared on stage and announced the start of the quebradita competition. My friend and his buddies, knowing of my interest in dance, pulled me up on stage to get a better look. As we stood behind the judges' table on stage right, I tried to hear what the announcer was saying but was unable to do so because a young man on our right was swearing loudly at another one on our left. As I was pressing myself into the wall to stay out of this confrontation, the aggressor turned and noticed me, whereupon, having guessed at my country of origin, he switched into English—some of the foulest English I had ever heard! This torrent of obscenities resulted in an uncontrollable fit of giggles on my part, and pretty soon all my neighbors on stage were smiling, too. Later, the man asked me if he hadn't pronounced his English correctly, and I was barely able to squeak out a "yes."

For the most part, the onlookers quieted down when the dancing began. About five couples competed. The mode of dress consisted of blue or white jeans for both sexes; long-sleeve shirts for men and T-shirts or long sleeves for women; leather belts, some with fancy tooled buckles; boots for everyone; and optional cowboy hats for the men. In fact, the performers did not dress much different from the audience. But to me, it wouldn't have mattered what they were wearing—these dancers were so amazing, they left me uncharacteristically speechless. I decided then that I had to learn more about this dance.

The most memorable elements of that night's performances were the incredible tricks. The male partner would flip the female dancer behind his back, under his legs, or into a handstand from which she would spring back up and continue dancing, not missing a beat. There were also hat tricks—in one case, an offstage observer tossed a cowboy hat to a male performer, who caught it on his foot and then proceeded to spin it around and flip it from his foot onto his head. However, one couple did none of these things. In fact, they danced around each other without ever actually touching, doing fancy foot and leg work individually. The crowd response was not as deafening for these competitors, so after they finished, the announcer reminded the audience (and judges) that there were different styles of quebradita, all equally valid, and that each should be evaluated on its own merit. Still, those two did not win. The winning couple, who took

home three thousand pesos for placing first, was no surprise to anyone because the man had won a number of the local competitions previously.

After the competition had finished, the deejays returned to playing banda music, interspersed with some cumbias and even a salsa number to which I danced. At one o'clock, the music stopped, and the dance floor cleared out. As we stood talking to various friends, deciding what to do with the rest of the night, a short man in a white shirt and hat pushed his way into our little group. My friend threw him some very dirty looks, and I asked what was the matter. He explained that the interloper was an enemy of the family, who on one occasion had stabbed one of his cousins. Although friends intervened to prevent any confrontation, that moment hinted at some of the violence I later learned was perceived as common at banda and norteña music events and did sometimes actually occur.[2]

The Best Laid Plans . . .

When I returned home to Tucson a few days later, I continued thinking about the dance. I discovered that little had been written on the quebradita, so I began talking to friends to see what I could find out. I had not yet started my graduate course work, but already it seemed to be an excellent topic for a thesis. It was also one that, recalling my roommates in 1994, I realized I could research in my hometown. An acquaintance, Theresa Scionti-Baro, had taught dance at a local middle school a few years previously, where, it turned out, a quebradita dance group had once existed, and some of her pupils had been members. She no longer had any means of contacting these students, though, and my other avenues of inquiry also came to dead ends. I also started experiencing reservations about studying a topic that was both so close and so far from home. Anthropology was originally practiced by Europeans who traveled far to live among people whose cultures were very different from their own. In recent years, however, it has become common to conduct anthropological research in one's own community. Ethnographers have now realized that no one is ever completely an "insider" or an "outsider," and all of us experience different degrees of "otherness" when conducting fieldwork. In Tucson, quebradita was performed mainly by Mexican American teenagers, and, even though I, too, had grown up in Tucson and am

bilingual, I would share neither age nor ethnicity with my interviewees. I worried about how I might be perceived "in the field."

I let the matter lie for a few months. As I began school in Indiana, studying ethnomusicology, I pondered other ways to conduct this research, as well as other possible thesis topics. Then I heard from Theresa that she had run into one of her former students, Darma Pérez (a pseudonym), with whom she had developed a particularly close relationship. She mentioned my interest to Darma, who was quite willing to help, and Theresa felt it would be good for both of us to work on this project together. It took me a few more months to work up the courage to dial Darma's phone number. I was imagining how strange it would sound that I, who didn't even know her yet, wanted to spend my summer talking to her about dancing. Not only that, but I wanted to learn to perform the quebradita, too. When I finally spoke with her, however, she was quite enthusiastic. Our conversation convinced me that this project could work and that I could feel good about it.

In May 1999, I found myself in Tucson once again. My intent was to learn about the quebradita through participant observation. I am a musician and a dancer, so my usual way of approaching a new art form is to learn to perform it myself. Darma had agreed to teach me some steps, and she thought some of her friends would also be able to contribute to this endeavor. I envisioned working closely with her, trying to learn the aesthetics of the dance while learning the steps, and at the same time finding out what about the dance was important to her. I would round out my study by speaking with other members of her dance group and observing any performances they might give. The end product would be an ethnography of that particular quebradita group.

Unfortunately, I was not able to carry out this plan. I found out that my knee required surgery as soon as possible for an old dance injury that had been improperly diagnosed. I would not be able to dance at all for several months; even walking would be difficult for some time. I also learned that Darma's dance group had broken up because of internal disagreements as well as several members' recent motherhood. Not only that, but none of the other quebradita clubs in Tucson was performing any longer. Worse, I was able to meet with Darma only a few times before she decided she needed to leave Tucson to look for work.

Still, I had grown rather attached to the dance and its music and

was not willing to give up yet. As soon as I could walk again, I began to scour the city for anyone who knew anything at all about quebradita. I went to radio stations, community centers, youth clubs, churches, nightclubs, and high schools, and I spoke with faculty in many departments at the University of Arizona. Someone at each site would tell me to talk to a particular person who worked there, who would refer me to someone else he or she thought might know the dance, who would have me call a friend of theirs, who turned out not to know much about quebradita after all. The only successes I had in my first six weeks of such work were in finding new dance clubs and in meeting Reynaldo Franco, the program director of a local Spanish-language radio station who also played guitar in a band that included quebradita in its repertoire.

With the summer drawing quickly to a close, I finally hit the jackpot and met about twenty knowledgeable people all at once. I note here how I made these contacts because such circumstances affect one's research. From Tucson High School, I met *ballet folklórico* (Mexican regional folk dance) teacher Marcela Cárdenas, who then put me in contact with two of her students, Sandra Franco and Ximena Gómez. I met another of her students, Cynthia, teaching folklórico at one of the Tucson Parks and Recreation centers, and through her I was introduced to Ernesto Martínez. The biggest surprise to me was the number of interesting and enthusiastic dancers I met at Canyon del Oro (CDO) High School. It is a mostly Anglo, middle-class suburban school, so I never thought to visit it until an alumna and childhood friend of mine, Tianna Kennedy, mentioned that her school had had a quebradita performance group that was "the best thing about the pep assemblies," later amending that opinion to "the only good thing." I paid a visit to CDO (which incidentally is also the archrival of my own alma mater Amphitheater High School), and through a helpful staff member met dancers Shannon Ortiz, Robby Espinoza, and José Hunt, as well as their mentor, Darron Butler.

I also decided to expand my search south of the border. I met Carlos Encinas of Hermosillo, Sonora, through my stepmother, Jan. He had grown up in a rural, small-town setting near Hermosillo, where he recalled dancing quebradita at parties as a teenager. He suggested I speak with his friends Pablo and Daniela Ayala because Daniela was an avid participant in various types of dance and might have some tips for me. Hermosillo is the capital city of the state of

Sonora, which borders Arizona to the south. It is often compared to Tucson, and in fact the two cities have many similarities, both environmental and cultural. I decided to make the five-hour trip to Hermosillo to meet the Ayalas and, while I was there, investigate the quebradita dance scene. (Friends in Tucson had given me the names of several clubs to try.) I took with me two friends: Emily Simon, a photographer, to document our journey; and Francisco Rentería, a musician and Hermosillo native, who could help us find our way around. While there, Francisco recalled the name of a dance professor he knew at the University of Sonora, and he introduced me to Xicoténcatl Díaz de León.

The new acquaintances I made and the new, binational circumstances of my research caused me to change my plan from doing an ethnography of one particular dance group to doing an ethnography that looked at the quebradita community as a whole, in Mexico and throughout the southwestern United States, but with a particular emphasis on Tucson groups. I found it interesting to compare not only the opinions of those on each side of the border, but also the opinions of both insiders and outsiders to the dance, which were often markedly different. The people I met in Mexico usually had negative reactions to the dance, which led me to additional questions. Why did the Mexican police officer who stopped me on my way to Hermosillo laugh when I told him I was there to study quebradita, and why did he suggest I study "something nice" like folklórico dancing instead?[3] Why did factory workers dance quebradita, but not their supervisor, who found it "tacky"? Were class issues at work here?

After rethinking my original research plans, I found I had four principal things I wanted to learn. First, I wanted to learn more about the music and the dance in general, as well as the aesthetic system that seemed to tie the two together. Second, I wanted to understand their relationships to other forms of expressive culture so that I could place them in a broader context of Mexican and Mexican American music and dance. Third, I wanted to find out where the dance had originated, how it had been spread and transformed, and how it fit into the complex contexts of Mexican and Mexican American cultures today. Finally, I wanted to understand what roles it played in these cultures and in the lives of individuals, particularly as related to issues of ethnicity and class.

Six years later, during the second phase of my fieldwork, I ex-

panded my field sites to include Los Angeles and Chicago, to which I paid brief visits in the spring of 2005. In Los Angeles, I met a group of quebradita dancers through David Padilla, to whom I had been introduced by fellow New York University graduate student Danielle Brown. In Chicago, Juan Diés—a member of Sones de México, community outreach director for the Old Town School, and a fellow Indiana University alumnus—introduced me to musician Simplicio Román. Simplicio in turn introduced me to the members of the all-female group Las Hechiceras de la Jungla; and finally, I made contact with local music fan Daniel Castro through his Web site dedicated to Chicago's *música duranguense* (music from Durango) scene. To my original list of research concerns I added questions about why Mexican regional music was becoming increasingly important among Mexican Americans, both as a category and in its specific manifestations; how and why distinctive local forms of quebradita, a mass-mediated type of popular culture, developed in different parts of the United States; and what lasting effects the quebradita might have had on individuals and on Mexican American culture as a whole at the turn of the twenty-first century.

Theoretical Foundations: Borders and Youth Cultures

This work will be of interest to dance scholars simply by virtue of its subject matter, and it is relevant to the fields of anthropology and ethnomusicology for the same reason.[4] Yet I wish to show how the study of dance can contribute to other fields of study as well. The prominent cultural theorist Néstor García Canclini writes, "Although Mexico has a potent literature, its cultural profile was not erected primarily by writers. . . . [T]he conservation and celebration of patrimony, its knowledge and use, are basically a visual operation" ([1990] 2001:168, this and all translations mine, except where indicated in works cited entries). For this reason, dance should play a central role in our analysis of Mexican culture. Dance is a type of visual art because it communicates primarily through that sense, but it is also inherently ephemeral in that it exists in time rather than on a canvas or on paper. The topic has therefore been difficult to study: we have little specific information on dances as they existed prior to the advent of film and video technology or reliable systems of movement notation, and even today many kinds of popular and traditional

dance seldom appear on film. Yet dance reaches a larger audience than many visual arts—as spectacle, as theatrical form, and as a participatory activity. It also reaches a different audience because teenagers are more likely to participate in popular dance than to visit art museums or attend the theater. Finally, dance can be more powerful than other kinds of art in that participants literally "feel" and thus internalize its messages. For these reasons, observing, participating in, and talking about dance can reveal aspects of a culture that might otherwise remain unspoken and unrecognized.

The particular dance I study here is a product of the cultural milieu of the U.S.–Mexico border and an expression of the youth who reside in this region. Border areas were once considered "peripheral" to the cultural life of a country, but today they seem of particular relevance to the social sciences (Donnan and Haller 2000). Borders may divide two political entities, but they seldom separate people and their practices. Instead, they serve as transitional zones between two countries and their respective cultures and are distinctive cultural regions in themselves. Even when cultures and worldviews may be similar on both sides, a power imbalance between the two countries generally results in differing living standards and economic opportunities and thereby creates tension. Borders, therefore, are in-between lands, ambivalent sites of instability and potential conflict, but they are also sites that offer the possibility for change, the exploration of alternative paths, and the forging of new identities. I argue that *quebradores* (quebradita dancers) took full advantage of these possibilities, creating a dance that expressed both the conflicts and the uniqueness of the Mexico–U.S. border region.

This region is, however, not confined to the Southwest United States and northern Mexico. It is a region of cultural contact that many now consider to extend far south into Mexico and northeast to Chicago and even New York. Borders, in the sense of real or imagined boundaries between groups of people with different lifeways, can now be found even in countries' interiors as a result of economic globalization and mass migration. Even cities such as Chicago can thus be viewed as containing their own borders, and duranguense musicians and dancers in that city participate in border culture just as southwestern quebradores did before them.

The Mexico–U.S. border seems in many ways to offer an ideal laboratory in which to examine questions of power, global capitalism,

inequalities, and cultural interchange. In his 1958 book *With a Pistol in His Hand*, which some consider to be the first border studies text, Américo Paredes showed that border Mexican Americans have a unique culture and history of their own that is separate from that of the Mexican "center." Artistic expressions such as *corridos* were developed through conflict with Anglos in the region, he explained. This perspective formed a powerful antidote to previous border scholarship that had focused mainly on the Spanish colonial influence in the Southwest, apparently assuming a static relationship rather than viewing border culture as an ongoing process formed by national policies and by interactions between Mexican and American peoples (e.g., Bolton 1921). Research works that came out of the 1960s Chicano movement elaborated on this viewpoint, pointing out differences between Chicano and Mexicano groups while exploring the possibilities of activist scholarship (e.g., Galarza 1970, 1971). In this work, I draw from these streams of thought by discussing the artistic/aesthetic consequences of interethnic conflict in the border area and by considering the practical lessons that border policymakers may learn from the story told here.

Discussion of borders has become increasingly popular since the early 1990s, when scholars such as Renato Rosaldo, Emily Hicks, and García Canclini argued that cultures are multiple, contradictory, and constantly changing and that border zones are therefore everywhere. This conception of culture was widely adopted because many scholars were excited by the possibilities that this blurring of boundaries offered for the explanation of postmodern culture. García Canclini, who calls the U.S.–Mexico border the "laborator[y] of postmodernity" ([1990] 2001:233), has added the notion of cultural hybridity to the discussion. In *Culturas híbridas* ([1990] 2001) and other works, he looks at the Tijuana–San Diego border in particular and at Mexico in general to examine art forms and identities that span two or more cultures and to look at how they relate to processes of reciprocal borrowing and unequal power relations. Others, however, argue against the application of generalizing theories to the concretely located border. Josiah Heyman, for example, suggests that anthropologists should be more critical of the "rhetoric of deterritorialization" because it seems to echo the capitalist rhetoric of the North American Free Trade Agreement (NAFTA), and that the influence of power must be considered in order to understand the "bitter realities of border

life" (1994:46). Pablo Vila (2000), too, reminds us that social scientists must attend to the specificities of the actual, geographical border to avoid becoming lost in theory.

Writers such as Gómez-Peña (1986) and García Canclini ([1990] 2001) have shown us that hybrid border cultures can offer possibilities for creating new ways of dealing with political and social fragmentation. Following their lead, I show in this book how quebradita dancing served this same need: it was a way in which young people dealt with cultural difference and culture clash and a way to create positive and forward-thinking expressions from border situations. Yet at the same time I try not to forget the role that the "real" border plays and the power imbalances it continues to propagate in the lives of border dwellers. The quebradita can also serve to remind us that action must be taken in order to resolve such inequities.

A number of scholars have written on musics of the broadly defined border region. Manuel Peña (1999a, 1999b) writes of how *conjunto tejano* relates to class and ethnic conflict in Texas Mexican culture, and José Limón (1994) has added dance to this same discussion. Helena Simonett (2001) uses the idea of border crossing to explain how banda's popularity has stretched across not only political borders, but also the boundaries between musical genres as more dance styles are incorporated into the repertoire. Cathy Ragland (2003a), in her study of Mexican *sonideros* (deejays), sees the border zone as expanding, now reaching even into New York, where the sonideros help to convert a sense of displacement into a collective identity that crosses national and cultural borders.

Although both Simonett and Ragland deal implicitly with the question of border youth, few authors have explicitly discussed the broader questions of border youth cultural patterns. A sizable and important body of sociological literature focuses on youth gangs in the Southwest, particularly in California, yet less sensational youth cultures, especially those of minority youth, remain understudied. (This situation may be residue left over from the origin of youth cultural studies in 1950s delinquency scholarship.) One notable exception is José Manuel Valenzuela Arce's 1988 book *¡A la brava ése!* which describes and compares youth subcultures such as punks and *cholos* in Tijuana, Ciudad Juárez, and other Mexican cities. Border studies scholars have indeed revised their notions of border cultures in general: rather than being peripheral, backwoods variations of the "cen-

ter's" mainstream culture, they are now recognized as unique regional entities in their own right. Yet the fact that border youth cultures are still unquestioned and largely uninvestigated indicates that they continue to be subject to those earlier conceptions of the border that assume they are simply reproductions of those cultures found in other parts of the country. These conceptions also contribute to the continuing invisibility of Mexican American youth cultures within the mainstream. The case of the quebradita offers a useful corrective: it questions assumptions by demonstrating the uniqueness of youth experiences on the border.

Border studies can contribute useful perspectives to the study of youth cultures in general. For example, boundary studies, a branch of the field that emerged in the 1960s with the work of Fredrik Barth (1969), focuses on social and symbolic borders rather than on national ones, particularly on the ways in which boundaries between social categories are maintained. Barth argues that ethnic groups are more a means of organization than a set of cultural attributes, and the boundaries between groups are more important than the "cultural stuff" they enclose (1969:15). Such viewpoints are particularly useful when examining peer groups that use symbols of taste to establish boundaries between themselves and others, as quebradita dancers used banda style to delineate their communities. Martin Stokes and the other contributors to his 1994 volume *Ethnicity, Identity, and Music* clearly show that music plays a central role in such situations. I argue that dance is equally important. In addition, Paredes and Ragland's assertion that the border zone has expanded beyond the confines of the Southwest United States with the movement of people of Mexican origin into other parts of the country can be verified by looking at youth cultures in these other parts. The Chicago community I look at in chapter 6 serves as one example: the experiences of teenagers in that city are quite different from those of Mexican Americans in the Southwest, yet youth cultures and their dances have developed along similar lines in both areas. Finally, the notion of hybridity in the Canclinian sense—as a strategy for dealing with startling juxtapositions of different cultures, classes, and worldviews—can help us to understand how youth deal with the conflicts in their own life situations. At the same time, we must be careful to view "hybrid" cultural expressions such as the quebradita and tecnobanda not as mere adaptive reactions, but as arts shaped by individuals who selectively combine and create.

In spite of the usefulness of border perspectives, the study of youth cultures has been the task mainly of researchers in cultural studies rather than of researchers in border studies. The works by Dick Hebdige (1979) and the other members of the University of Birmingham's Centre for Contemporary Cultural Studies (cccs), who suggest that subcultures are created in response to inequalities in a society's class structure, have been most influential. The connections between quebradita dancing, on the one hand, and class and ethnic conflict, on the other, that I explore in this book show that in many cases subcultural activity is still closely related to socioeconomic matters such as class relations. However, class discourse is likely to be masked at the present time, translated instead into seemingly innocuous discussion about differences in "lifestyle," "morals," or even urban geography (which usually features clearly demarcated boundaries based on differing socioeconomic levels). Julie Bettie (2003) shows how this type of camouflage is the case for Anglo and Mexican American high school students in California: they make class invisible by displacing discussion of it onto categories such as race and gender or into talk about "family values" and living situations. Yet class consciousness is still present among students as a "sense of place" (Bettie 2003:200) that conditions their social groupings and relationships, and class struggle manifests itself through conflict over expression of identities. I argue that conflict over the quebradita, as expressed in the discourse surrounding the dance, is an instance of just such a masked struggle.

Unlike the cccs school of youth cultural theory, however, I have chosen to rely more on data collected through fieldwork and interviews than on personal knowledge or "big theory"; also unlike those earlier works, I include both men and women among my interviewees, and I favor some changes in terminology. Whereas the cultural studies group preferred the term *subculture*, others feel this term is belittling, placing the cultural expressions of such groups always in a subordinate position. For this reason, I generally use the term *community* rather than *subculture* when referring to the teenagers who participated in quebradita dance clubs and competitions. This term has the further advantage of recalling Benedict Anderson's (1991) "imagined communities"; although in its original formulation this concept referred to the birth of nations and nationalism, it is useful here because it reminds us of how quebradita dancing connected teenagers in widely dispersed locations through participation in an

imaginative activity. As Dorothy Noyes has pointed out, *community* also emphasizes networking, interaction, and the "collective construction of tradition" (1995:468)—all important parts of quebradita dancing. Communities and individuals' identification with such groups is effected through performance via repetition, formalization, and consensus. Consensus, in its etymological sense of "feeling together" (see Noyes 1995:467–68), is achieved by participation in group events such as the social dances and competitions I describe in chapters 3 and 5. I also chose the term *community* in order to reclaim it from conservative commentators who use it as a code word for the largely white upper and middle classes (as in "juvenile delinquents are destroying our community").

The socioeconomic situation in which the quebradita arose bears many similarities to the one that gave rise to the various British youth subcultures described by the cccs group in *Resistance Through Rituals* (Hall and Jefferson 1976). The disintegration of both neighborhood and family has become a familiar lament in newspapers and magazines. The gap between rich and poor in the United States has never been larger—it is in fact the largest among any of the industrialized countries (Smeeding, Rainwater, and Burtless 2000)—and opportunities for upward mobility are becoming increasingly inaccessible for the working class owing to such factors as changes in education policy and low-wage service workers' inability to unionize. The unhappy fact that race or ethnicity is still often a factor in the lack of possibility for class mobility in the United States has been made clear time and again (see Brown et al. 2003 for a noteworthy example). Finally, class as a structural concept has disappeared almost entirely from everyday North American political discourse, making it next to impossible for members of the lower and working classes to unite in order to effect change.[5]

How are teenagers to respond to the situation in which they find themselves, as a group with no political voice or representation? How can they react to the anti-immigrant, often racist, political environment? In the Southwest of the 1990s, they responded through dance. They created a new artistic expression that allowed them to show pride in their ethnic identities; they organized groups that enabled the pursuit of positive leisure-time activities and networking with youth in other areas; and they forced the country to notice them by using their power as consumers. To nearly everyone's surprise, this power turned

out to be so great that it made a Latino radio station number one in Los Angeles for the first time in that city's history (see chapter 2).

The work of Hall and colleagues predicted such a response: when class restructuring occurs, as it has with the disappearance of organized labor and the rise of the low-wage service sector, a new subculture will arise as an attempt to resolve class conflict symbolically. They wrote, "[S]ub-cultures are shown to address a common class problematic, yet attempt to resolve by means of an 'imaginary relation'— i.e., ideologically—the 'real relations' they cannot otherwise transcend" (Clarke et al. 1976:33). Quebradita, in its overt celebration of a class-based aesthetic, does all that and more. Border youth must deal not only with U.S. class conflict, but also with the collision of poverty with plenty and the culture clashes that are an inherent feature of the border environment. In this work, I show not only how quebradita negotiated class conflicts within the Mexican American community and the larger U.S. society, but also how it represented and symbolically resolved interethnic tensions by aesthetic means. Following Hall and Jefferson, I explore the quebradita community's relationships to both parent and dominant cultures, and, following Hebdige, I dissect the various components of quebradita performance practice in order to uncover the hidden meanings expressed there. Yet I diverge from these scholars and from others who have written specifically on banda music in my emphasis on dance and in my focus on the ways in which local varieties of popular culture are produced. My combination of perspectives from ethnomusicology, dance ethnology, border studies, sociology, and cultural studies should help to shed new light on these topics.

A Note on Terminology

The growing number of ethnic labels used in the United States has produced much confusion among both academics and laypersons. The population that is the subject of this work has been called by a number of terms, among them *Mexicano, Chicano, Mexican American, Hispanic,* and *Latino,* but in my understanding and usage each has a slightly different meaning. *Mexicano* in the U.S. context refers primarily to Mexican immigrants, naturalized citizens, and temporary residents. Both *Chicano* and *Mexican American* refer to U.S.– born persons of Mexican descent. The primary difference between

these two terms is a political one: Chicano movement activists felt that the term *Mexican American* implied assimilation and a second-class citizenship, so they chose the new label *Chicano*, formerly a derogatory term for lower-class Mexicans, as an assertion of ethnic pride and cultural nationalism. Today, the two terms are often used interchangeably, though *Chicano* still retains a political overtone. *Hispanic* is the term most often used to refer to all three previous groups in Arizona; however, many dislike the word because it refers only to Spanish heritage, ignoring indigenous peoples and other ethnicities that contribute to the genetic and cultural makeup of Mexicans. Meanwhile, the term *Latino* is used to refer to people whose heritage derives from any Latin American nation, though the term seems to be somewhat more common on the East Coast than in the West.

In this book, I use the labels preferred by my interviewees whenever reporting their words and opinions. Likewise, when discussing art forms and styles about which other researchers have already written, I use their terminology (e.g., Tomás Ybarra-Frausto's use of the term *Chicano* in reference to the *rasquache* aesthetic, which I discuss later). Elsewhere I most often use the term *Mexican American* when referring to persons of Mexican descent in the United States. Although I recognize that this label can be problematic, I wish to avoid the favoring of one ethnicity over another that is inherent in the term *Hispanic* (or the corresponding Spanish term *hispano*); I also wish to avoid the political connotations of *Chicano* because many of my interviewees did not have highly politicized identities and did not themselves use the term. Marcos Sánchez-Tranquilino has explained that he uses the term *Mexican American* to refer to those who are "in the process of *becoming* politically aware" but have not yet reached the level of awareness implied by the term *Chicano;* to him, it is "a political identity that is *prior* to that of 'Chicano' " (1995:56–57, emphasis in original). For many of the dancers with whom I spoke, quebradita was a step in the process of becoming politically aware and was thus part of what Sánchez-Tranquilino would consider a pre-Chicano identity. The term *Mexican American* here refers to both Mexicanos and Chicanos in the United States unless otherwise specified.[6] In this way, the term aids in distinguishing between north-of-the-border and south-of-the-border cultural practices.

Procedures and Methods

During my initial stage of research in 1999, my primary method was the ethnographic interview. I interviewed the musicians and dancers I met in a variety of settings, including restaurants, hotels, parks, and their homes or offices. Although they knew that the general topic of the interview would be the quebradita, I preferred to leave our conversations as open-ended as possible, letting them speak of anything that came to mind. However, some preferred that I ask more directed questions. I tape-recorded most of the interviews. If I did not, it was owing to the interviewee's expressed preference or to technical difficulties. Unless otherwise indicated, the portions of interviews presented as quotes in this text have been transcribed directly from my tapes. I have used ellipses to indicate where I have left out portions of the interview I am quoting, because of either unintelligibility or irrelevance to the topic at hand. Full capitalization indicates emphasis the speaker placed on certain words. Words in square brackets are those I have added to increase coherence or to explain the interviewees' comments. All translations are mine.

I also carried out participant-observation activities in Tucson nightclubs as well as in Hermosillo during a brief visit. This aspect of my research was more limited than I would have liked, both because of my physical condition at the time and because of the waning popularity of competitive quebradita dance. Nevertheless, I was able to dance and to observe other dancers at banda, norteña, and *grupera* music events in central and south Tucson, Hermosillo, and Indiana. Finally, I also conducted what library research was possible on the subject. Articles on the topic of quebradita were few and were limited mainly to journalistic accounts from southwestern newspapers. The only scholarly effort at that time was Helena Simonett's 1996 article entitled "Waving Hats and Stomping Boots," which was a primarily theoretical and non-fieldwork-based work. However, after I had finished an earlier draft of my manuscript, Simonett released a book entitled *Banda: Mexican Musical Life across Borders* (2001). Although this book is an excellent resource for information on banda music in Mexico and Los Angeles, it does not expand significantly on the information presented on quebradita in her earlier article except in the addition of some quotes from California dancers and a brief analysis of gender relations.

During the second stage of my research, in 2005, I traveled briefly to Los Angeles and Chicago in order to compare the local dance communities in those cities with the community in Tucson. In Los Angeles, I was able to interview a number of people who had been involved with quebradita dancing during its early days in different parts of that city, from South Central to the San Fernando Valley. In Chicago, I observed dance events featuring the newly created dance *pasito duranguense*, and I discussed this new style with local dancers and musicians. Longer-term research in these field sites would of course have been preferable, but even in the short time available to me I began to see how each "scene" both connected to and diverged from the others, creating local variants of popular music and dance (future studies would help to flesh out these concepts further). To complement my field studies, I also looked closely at mass-mediated products created for young people interested in the new trends, from fan magazines and Web sites to CDs and DVDs. This part of my research was much easier than it had been in 1999 owing to the growth of the Internet, now much more widely used both in Mexico and among Mexican Americans, as well as to the growth experienced by Latino media in the intervening years. Many fans of música duranguense use the Internet to participate in on-line forums pertaining to their favorite groups, so I was able to eavesdrop on and participate in their discussions. In addition, nearly all the popular music groups now have their own Web sites, making it much easier to obtain products and information related to this regional style.

Research Questions Addressed in This Work

In studying any form of expressive culture, a researcher can address an infinite number of questions, and those that are ultimately chosen often result from the circumstances affecting the particular researcher and his or her project. This has certainly been the case for me, as new questions arose organically from the experiences I had in the field and in interview sessions. From the beginning, I had been interested in the relationship between music, dance, and identity. This issue has been central in many other works exploring the more traditional arts of Mexican Americans, and I therefore wondered how a modern, urban cultural expression such as quebradita might be used to establish or construct identities in terms of ethnicity, group membership, or individuals' self-perception.

In chapters 3, 4, and 5, I use quebradita dancers' own words to address such questions; their views are complemented by those of some non-dancers who have explicitly contradictory opinions on the subject.

After my trip to Hermosillo, Mexico, a second issue began to take a central role in my thoughts on banda music and quebradita dancing: their relationship to class. I questioned why many people I met had such a low opinion of this music and dance, and why, in many cases, quebradita gained greater acceptance among Anglos than among the older generations of the Mexican American middle class. I found that Manuel Peña's (1985) analysis of Texas Mexican conjunto helped to illuminate the subject when I applied some of his concepts to my own research material and to the lyrics of banda songs. This topic is discussed in chapter 2 as I explore banda's history and current state.

Another issue I saw as increasingly important the further along I got into my research was that of the concept of *lo ranchero*, an aesthetic system that references cowboys and ranch life. Banda and quebradita fit within this larger system, which also includes norteña ("northern," or border region) music and even mariachi. Again, this concept is a central one in Peña's writings (1999a, 1999b), and it is also mentioned in Simonett's (1996, 2001) works. It was striking to me that rural imagery was used as a trope in banda and quebradita, a primarily urban music and dance complex. In chapter 3, I examine this issue as I discuss in more detail the music, dance steps, and clothing associated with quebradita, as well as the dance event itself.

In chapter 4, I examine how quebradita communities were constructed in Los Angeles. Connections between dance clubs and gangs were proposed in numerous newspaper articles. Accustomed to media exaggerations of minority youth involvement in gangs, I was initially skeptical about such claims, yet I found that quebradita clubs in that city did share some features (and, in some cases, members) with local gangs. In this chapter, I discuss how and why such parallels existed, while demonstrating the political importance of the dance in that place and time.

In chapter 5, I focus on the shape the quebradita community took in Tucson, comparing and contrasting it with the community in California and placing it within the historic and contemporary social context of southern Arizona. Statements by specific individuals illustrate how each of the larger issues this book explores is played out in

real life and how each is subject to significant variation. I explore the Tucson dancers' relationship to the quebradita community at large, a binational and transcontinental community whose members share common interests and motivations even though they may not know each other or even speak the same language. I also return to what were naturally my first questions about quebradita: What is it, and where and when did it begin? Most available literature asserts a Mexican origin for the dance; it seems to be the kind of knowledge that is "taken for granted." But should it be so? In interviews, I heard dates of origin from the early 1980s to the mid-1990s. Also, and perhaps more perplexingly, I heard places of origin that ranged from Jalisco all the way up to California. As I continued my research, I noticed that the answers I received fell into a pattern, with the northern origin being most often asserted by those from Mexico and the southern one being offered only by those in the United States. I discuss this dichotomy of opinion further in chapter 5.

In chapter 6, I offer a follow-up to my discussion of the quebradita and banda music in chapter 2, moving away from those particular forms in order to compare them to another contemporary Mexican American cultural phenomenon. In 2003, years after I had completed my original research project, a new musical style and dance arose among Mexican immigrants from Durango, Michoacán, and neighboring states who were now living in Chicago. I learned about this new trend after its arrival in New York in 2004 through a tip from fellow ethnomusicologist Cathy Ragland and later from my coparticipants in the dance classes offered by the New York–based ballet folklórico group Calpulli Mexican Dance Company. The music, called música duranguense, was similar to tecnobanda in that it combined regional Mexican musical styles with an updated, synth-driven ensemble, and Chicago-area dancers quickly came up with a way to accompany its catchy rhythms by combining merengue with banda dances such as the quebradita in order to form the pasito duranguense. Thus, in this chapter I explore how the pasito both connects with and diverges from the story told about the quebradita in the preceding chapters and discuss how the popularity of these styles and others has resulted in the recent creation of the marketing category "Mexican regional."

Finally, in chapter 7 I place both the quebradita and the pasito within a historical continuum of border youth cultures, evaluating

their impact while also suggesting where we might go from here. I discuss how rock music groups, "urban regional" artists (another new marketing category), and even salsa dancers have drawn from quebradita and banda. I also suggest that the quebradita and duranguense phenomena can offer important lessons to policymakers, teachers, and community activists as well as scholars.

The Beginning

This work is in essence a case study related to a particular time and particular places, which shows how youth reacted creatively to a time of political and economic stress, and how individuals worked together to create regional variations on transnational popular culture. My goal is to shed some light on the complex relationships between dance, popular culture, and youth identities, as well as on how economics and politics can influence the formation of each. Because of the complexity of these issues, however, this work can only be a starting point, so I look forward to seeing other researchers continue where I have left off. At the very least, I hope to increase my readers' understanding of and appreciation for both quebradita dance and contemporary regional Mexican music, while showing how participation and education in arts of all kinds can and do make a difference in young people's lives. I also hope to demonstrate the importance of dance, a topic too often left out of the discussion, to cultural analysis of all types because I believe dance can add much to debates in border studies, sociology, anthropology, and ethnomusicology. Finally, I hope this work will serve as a starting point for expanding the dialogue on contemporary North American politics, culture, and class structure by including those who are least often given an opportunity to speak.

2

Music and Meaning on the Border

The quebradita is most often associated with tecnobanda music because the best-known quebradita songs were recorded by such groups. Originally a regional style, banda music and the quebradita fed each other's popularity, and during the mid-1990s tecnobanda topped the charts all over Mexico and the southwestern United States (see Haro and Loza 1994). Some observers have even claimed that "this is the first instance in which a Mexican popular music has been revived and commercialized in the United States" (Welsh 1994). Although Ragland (2004) more correctly gives this distinction to norteña music, the social and economic impact of the "banda boom" was more dramatic than the comparatively slower growth of norteña since the 1960s and therefore attracted more attention. In the 1990s, the quebradita dance, banda music, a particular clothing style, and certain types of dance events came to form an integrated complex, defining a youth culture that could be found throughout the region and, in some cases, even beyond.

In this chapter, I move through different levels of analysis to uncover the meanings of tecnobanda music and its sudden popularity. After a general description of instrumentation and repertoire, I give an overview of the histories of the three types of music (*banda sinaloense*, norteña, and cumbia) combined in tecnobanda and then move on to discuss the style's current transnational situation. Next I examine the lyrics of tecnobanda songs, and then I finally arrive at the core of the music, the sound itself, in which auditory symbols combine to produce meaning in listeners and dancers' minds and bodies. I argue that the music's meaning is conditioned by its position in Mexico's socioeconomic class structure, a structure that is closely inter-

twined with questions of ethnicity and race, as it is elsewhere. Yet tecnobanda songs are able to create new meanings by referencing traditional music and culture, placing this mass-mediated pop music within a continuum of tradition even while creating a very modern combination of banda, norteño, and tropical styles.

The tecnobanda style is a modern interpretation of Mexico's centuries-old regional banda traditions combined with influences from *música norteña* and *música tropical* (the latter a catch-all term for a variety of Caribbean-derived rhythms). Brass bands are found throughout Mexico and take many forms. Military, municipal, and popular bandas have long histories,[7] and unique regional styles have developed in many states. However, a particularly strong style developed in the state of Sinaloa, where the music has long played a role in the state's class politics. Because Simonett (2001) has already documented the history and development of banda sinaloense, I only briefly summarize this information here before moving on to discuss how tecnobanda draws on other popular styles.

Northwestern states such as Sinaloa were quite isolated from mainstream Mexican life until well into the nineteenth century, geographically cut off from central Mexico by the Sierra Madre Occidental mountain range (Simonett 2001:99). This fact has much to do with the development of the region's unique style of music. Simonett tells us that musical life during the early 1800s consisted of amateur players of harp, guitar, or *jarana* (a small guitarlike instrument of Spanish origin); visiting *zarzuela* or musical theater groups; and performances by informal military bands (101). Inhabitants of Mazatlán were also exposed to foreign bands during the brief North American occupation of 1847 and later the Franco-Austrian occupation of 1864–66 (106).

According to folklorist Rubén Campos, the Mexican brass band was born at the same time as the nation itself (1928:197–205). After the Austrians were expelled and independence was regained in 1867, several types of bands were created. First were the official military bands. Modeled after the French army bands and Emperor Maximillian's Imperial Guard, these bands were composed of highly trained musicians who played adaptations of European orchestral and Mexican salon music. Some became quite famous and toured the United States. Campos states that they soon replaced civil bands everywhere except in small towns, but the best civil bands remaining were to be found in the central and western states. Second, state-supported mu-

nicipal bands also were founded after the French intervention, and the most famous were the bands of Guadalajara and Guanajuato (Campos 1928:200). These city musicians kept to a European performing style and played mostly works "of Italian music, or music from other countries done in Italian style" (199). However, Campos lamented that "today," at the time of his writing, "they adapt everything for modern bands, with more or less success" (204). He seemed to be referring in particular to the bands' playing of popular music because he expressed horror at the fact that these "degenerate" urban bands even played foxtrots. To him, dance music was not commensurate in quality with the bands' military and salon repertoires, which were mostly European in derivation.

Last, but most important in Campos's opinion, rural popular bandas began to appear. These groups' music was known as *música de viento* (wind music), a generic term still used today. Campos considered the rural musicians' greatest asset to be their facility with improvisation. He wrote, "[T]he curious thing is that their musical ear and their rhythmic instinct, their imagination for improvising variations on a theme, are intuitive and always in good taste" (1928:198). These rural musicians performed before circuses or bullfights and were used to announce community celebrations.

Campos found bandas to be an important Mexican tradition, and he held such groups in high esteem, in particular those of rural areas; he also felt that the best civil bandas were the ones in central and western Mexico, the same region in which the modern tecnobanda was born. To him, bandas were an emblem not only of musical excellence, but of democratic sentiment, explaining, "[T]he banda was and continues to be a popular institution par excellence, born of the people and for the people" (1928:200). He furthermore called the banda "la alegría sonora de nuestro pueblo" (the sonorous happiness of our people) (197). Not everyone shared his opinion, however. He recounted an anecdote in which he was traveling through the town of Chapala with the poet Luis G. Urbina in 1907. Campos asked the poet whether he liked the music they heard there and received the answer: "string music from a half-block away, and 'wind' music from a half-league" (197). A class-based division between these types of music apparently already existed at that point, with banda music occupying the lower rung.

In Sinaloa, the importance of Mazatlán as a Pacific port city grew during the late nineteenth century, allowing a greater variety of musi-

cal genres to be heard in the state. At the same time, the separation between the classes and their musical preferences grew through the early twentieth century. The lower classes still had access to public performances by military and civil bandas (Simonett 2001:107–8). However, dance music was also a part of daily life, and waltzes and *jarabes* could be heard at the fandangos or lower-class dances (later known as *mareaches*, or mariachis) that were the cause of much upper-class scorn at the time (Simonett 2001:110–11). By the turn of the century, the Sinaloan brass band, known as a *tambora* after its central instrument the bass drum, was well established as the entertainment of choice for Sinaloan villagers, although the upper classes persisted in viewing this type of band as merely "a shabby imitation of their sophisticated military bands" (Simonett 2001:125). Although the instrumentation of regional groups was highly variable, the Sinaloan banda generally consisted of wind and brass instruments such as clarinet, cornet, trumpet, saxophone, saxhorn, and valve trombone, together with the obligatory tuba, snare drum, and bass drum or tambora (Simonett 2001:139–40). It continues today to be the "primary folk/traditional ensemble" of the state (Pearlman 1988:51).

Steven Pearlman contends that such bandas are an example of the merging of European instruments with indigenous musical performance preferences because pre-Hispanic musical ensembles also consisted of idiophones, membranophones, and aerophones (1988:52). Mariachi is another music often considered symbolic of *mestizaje* (cultural and ethnic mixing, particularly between Spanish and indigenous Americans), and after the Mexican Revolution mariachi, not banda, was chosen as a symbol of national identity. Both traditions were originally stigmatized as rural, lower-class genres, but mariachi came from the state of Jalisco, which is closer to Mexico City and had long been a source of both politicians and national symbols (see Jáuregui 1990). Simonett (2001) surmises that banda may not have been selected as the national music simply because of its location in the country's periphery. Whatever the case, it remained on the periphery of Mexican musical life up until the 1990s.

Music in the Border Area

It is difficult to talk of modern banda music without reference to other popular Mexican regional styles, in particular norteña. Although banda did not originate in the borderlands, it now has close ties with

that area because it reached its greatest popularity in the border region and was commercialized there; in addition, the state of Sinaloa is also considered to fall within the broader region of northern Mexico, causing a correspondence in many fans' minds. Because these two genres now share a listening audience, there is much crossover and stylistic similarity. Today, music marketers lump the two together under the umbrella label "regional Mexican" (also a Grammy Awards grouping), a development that likely dates to the major record labels' entrance into the Tejano market in the early 1990s (see Burr 1999:31–33). Others classify banda and norteña under the term *grupera*. One Mexican journalist explains, "Grupera is a type of soft ballad, sometimes rhythmic. Within this genre we can include the famous quebraditas, and Tex-Mex, which is nothing more than the fusion of Texan and Mexican music" (Del Moral 1997). Although the term once referred only to those groups that play pop ballads *(baladas)*, it may be applied by extension to any keyboard-driven ensemble whose instrumentation resembles that of North American rock groups, and today the three genres—banda, norteña, and grupera—are often combined. Generic labels such as *grupera* and *regional Mexican* are useful when looking at broadly defined taste cultures, but they also obscure the distinct histories of unique regional and local styles. It is thus useful to pair our brief look at banda history with an equally succinct examination of some of the dominant musical trends of the border states.

While the large bandas were developing to the south, another type of music and dance was taking shape in the northern borderlands. This music was played by a much smaller ensemble and is known variously by the names *música norteña* (northern music), *música tejana* (Texan music, if from that state), or *conjunto* ("combo," or small ensemble). The origins of this genre are unclear because, as with many popular musics (including banda), it has not been well documented. Manuel Peña (1985) describes it as the principal musical expression of working-class Texas Mexicans and asserts that it evolved through a cultural exchange between Texas and northern Mexico, in particular the city of Monterrey, Nuevo León. This city was the cultural and economic capital of the northern region during the nineteenth century and could afford to maintain high-quality orchestras and military bands. Such large ensembles played all the current musical forms, including *pasodobles*, marches, polkas, schottisches, fantasias, overtures, quadrilles, contradances, mazurkas, and *redowas*

(Vizcaya Canales 1971:47). Much traveling and trade took place between Monterrey and Texas, and interchange between musicians of both areas continued until well into the twentieth century (Peña 1985:28).

Monterrey also received a large number of German immigrants during the 1860s (Peña 1985:35). This fact is important for the development of conjunto: Germans brought their own musical instruments and styles with them, so the accordion came to be adopted by Mexican musicians. Continuing contact with Germans may be partly responsible not only for the accordion's popularity but also for the polka's dominance. In the twentieth century, such contact occurred mainly in south Texas, which also received a large share of German immigrants (along with other central European groups such as Czechs). Although relations were not always entirely friendly between the two groups, some older tejano musicians such as Santiago Jiménez Sr. do recall being influenced by German musicians they heard during their childhood (see Marre and Charlton 1985:110).

By the 1920s in Texas, the accordion had been paired with the *bajo sexto*, a twelve-string guitarlike instrument played with a pick. Contrabass or *tololoche* was added to this basic ensemble in the 1940s, later to be replaced by electric bass, and a drum set was introduced to the group in the 1950s (Peña 1985:60). Since then, the instrumentation has remained fairly stable, although electronic keyboards and saxophone also are often part of present-day groups. For much of the twentieth century, the conjunto norteño has been the main cultural expression of the Mexican American working class on the border (Peña 1985).

The labels *tejano* and *norteña* are often used interchangeably, but there are differences between the Texan style and that of other border states. Tejano or conjunto, played by U.S.–born Texas Mexicans, is a genre dominated by love songs and cumbias. Norteña, or música norteña, is played both by Mexican nationals and Mexicanos in the United States. It is characterized by a focus on corridos, traditional narrative ballads used to recount heroic tales or newsworthy events, and older rhythms such as *polca* and *vals* (Ragland 2003b, 2004). Burr notes that tejana music suffered in the mid- to late 1990s as a result of the increasing popularity of fresh-sounding Mexican norteño groups such as Los Tigres del Norte and Los Tucanes de Tijuana (1999:38). In addition, norteño groups are supported by a transnational recording industry, allowing them to tour cities and towns throughout the

United States and Mexico, whereas tejano groups are more of a local-ized phenomenon (Ragland 2003b, 2004).

Today, música norteña is very strongly associated with dancing, but some scholars believe dancing was not always an important part of border culture. Limón notes that the earliest Texas settlers "frowned on excessive music and dancing" until the polka arrived (1983:232). This dance made its first appearance in Mexico in the 1840s and 1850s, reaching the border area somewhat later (via Monterrey, if Peña is correct). Although other early types of dance music such as the redowa and schottische are now seldom played, the duple-meter polka con-tinues to be one of the most common and popular rhythms in the norteño repertoire to this day. Today, however, polkas with sung lyrics are now generally preferred to the previously dominant instrumental ones, and they are often referred to as *canciones rancheras* or *canciones corridas* (Peña 1985:97). In Sonora, *corriditas*, a local way of dancing to polkas, are particularly popular. Corridos have long been popular in the borderlands (see Paredes 1958), and they can be sung in either duple or triple meters. Other danceable genres commonly played include the *vals ranchera* (waltz) in triple meter and the more recently introduced cumbia.

The cumbia played a significant role in the development of que-bradita music and dance because the songs used for dancing quebra-dita are in fact very, very fast cumbias. This type of music emerged from the Caribbean coastal region of Colombia, but it was brought to Mexico City, where other types of Caribbean music were already familiar through films and records, in the 1950s. However, the city's then regent, Ernesto Uruchurtu, placed so many restrictions on musi-cal production that many local groups broke up and moved to the northern cities (Olvera 2000). The new musical style accordingly trav-eled with them. Northern *sonidos* or sonideros (party deejays) quickly picked up on it and popularized the Colombian cumbia in that region (Olvera 2000). These sonideros also had their origin in the poor neighborhoods of 1950s Mexico City, where residents who could not afford a band would hire them to play recorded music for dances, baptisms, birthdays, and weddings. They became so popular that by the end of the 1980s more than six hundred of them were registered in Mexico City (Carrizoso 1997:100). Cumbias were always the deejays' mainstay, so much so that in 1978 the Peerless label officially recog-nized sonideros as being "the greatest promoters of música tropical" (Carrizoso 1997:103).

Before long, border-area musical groups adopted the style, too, and they even began to give it a new, unique sound. The first groups to play cumbia in the border area were Conjunto Bernal and Valerio Longoria on the Texas side and Beto Villa on the Mexican side, though numerous others quickly followed suit, altering style to conform to northern rhythm and instrumentation (Olvera 2000). Although at first Tejanos (Mexicans and Mexican Americans living in Texas) resisted the new style, preferring their own home-grown conjunto sound, the boom in Mexican immigration to the state contributed to a gradual rise in the cumbia's popularity (Peña 1999b:187). In the late 1970s and early 1980s, groups that focused on pan-Latino genres such as cumbia and balada began to appear in Texas, including Mazz and La Mafia. They combined cumbia with other popular music styles such as reggae and funk. Although Peña finds these mixes superficial, postmodern pastiches rather than true bimusical, bicultural expressions (1999b:187), by the 1990s the cumbia was an integral part of Texas Mexican music. Some artists, such as Selena, even made that genre their focus.

Olvera suggests that cumbia became popular in the border region because musical experimentation is common and natural there as a result of two factors: first, border groups have less to lose than established urban groups by virtue of living on the periphery, and, second, there has always been great diversity in the types of music commonly heard in the area (2000). As I see it, the association of cumbia with working-class audiences wherever it has traveled is another reason why norteño and tejano groups adopted the style with such ease. Although Peña believes Tejano musicians' shift of focus from polka to cumbia was a "decentering" one that detracted from local culture, because the cumbia was not a part of that culture but rather a commodified international musical form (1999b:198), it held at least the potential for working-class unity across national boundaries.

Norteño and tropical groups have created a unique, "Mexicanized" type of cumbia rather than simply imitating the Colombian style as many groups in both Monterrey and Mexico City did.[8] The Colombian music underwent several transformations in the process, sometimes with the intention of appealing to Mexican tastes and other times for purposes of "modernization" (Olvera 2000). A detailed comparison of the two is not within the scope of this study, but because little information on Mexican cumbia style is available elsewhere, I here describe a few basic characteristics. The instrumenta-

tion of both styles is quite similar. The bass line is more or less the same, and the accordion may be used in both Colombian and norteño styles, although brass and reed instruments are more common in the former. The larger Colombian rhythm section that might consist of such instruments as *bombo*, *guache*, *güiro*, congas, and other types of drums is generally reduced to the drum set and cowbell in Mexican cumbia, resulting in a lower rhythmic density. Mexican cumbias are often sung by two voices in thirds, as is typical of ranchero style, unlike their Colombian counterparts. The call-and-response feature common in many Colombian cumbias is usually absent in Mexico, where the songs more often take a strophic or verse-and-refrain form. The most notable feature of Mexican cumbia, and one most often cited by cumbia aficionados as the distinguishing feature, is a basic rhythm that has a much heavier feel. In effect, the Mexican cumbia norteña takes the genre's most recognizable characteristic and exaggerates it, boiling the cumbia down to its essence. This effect is also found in quebradita and duranguense dancing, a topic explored further in chapters 3 and 6.

In conclusion, banda and norteña music are quite different in their early histories and can easily be told apart by their instrumentation. However, both listeners and music marketers often group them together, a fact that is illustrative of the blurring of boundaries between musical genres now occurring in Mexican music as elsewhere. The creation of the category "regional Mexican" forces us to consider the two as a pair, which can be a useful exercise when searching for patterns in the production of Mexican popular music today. Both norteña and banda share a function: they are dance music. They have an overlapping repertoire that includes baladas, valses, polcas, rancheras, corridos, cumbias, and, most recently, quebraditas. They have parallel histories; both began as rural, regional styles but were later popularized all over the United States and Mexico. Finally, although both types of music were once consumed only by local audiences, today they tend to share an audience that is composed mainly of the transnational working class. (In chapter 6, I add two more regional styles to this discussion.)

Banda Today

Today, rural, traditional bandas can still be found in many parts of Mexico. A folklorist friend showed me a film he shot of old men

performing traditional corridos during a festival in the small town of Mezcala, Jalisco; they were nearly drowned out by a banda playing popular tunes in the distance. Jesús Arevalo, leader of a banda in Houston, said of his tiny hometown of Santo Tomás, Guanajuato, "Everyone in my town played in a banda; you had no choice. It was part of the local tradition" (quoted in Ragland 1996). And the small-town banda Brigido Santamaría de Tlayacapan, founded 128 years ago in the state of Morelos, recently won a national prize for outstanding work in the area of popular art and traditions (Aranda 1998).

Of course, urban bandas are more visible and influential than the local groups. These ensembles have become popular even in areas where banda music has not traditionally been heard. Reynaldo Franco, a grupera musician and program director for a Mexican radio station in Tucson, noted that years ago Arizonans did not care to hear bandas because they vastly preferred norteño groups, yet now bandas can sell out the large arena at the Tucson Convention Center. He traced the change in attitude to the touring efforts of one of the oldest and most popular of the traditional Sinaloan bandas: "Banda el Recodo . . . used to come often to California, but it's a curious thing that they came only to California, much more than to any other state. California was known as a state with a lot of Mexicans, you see. But in Texas, they never, ever played there because the style didn't really take off. However, now they tour all over the United States and have had tremendous success" (interview, 1999). In Franco's opinion, Banda el Recodo almost single-handedly popularized banda throughout the Southwest, with the exception of Texas. This group is still popular today, having won three Grammies, made 180 recordings, and sold more than twenty million copies by 2002 (Fonovisa 2004). However, it was the tecnobanda, the more controversial, electronic variant of the Sinaloan banda, that truly gained mass appeal and raised interest in banda among Mexican American youth.

The most obvious feature of the tecnobanda sound is its instrumentation, which combines traditional banda elements of snare drum, bass drum, and a pair of either trumpets or saxophones or sometimes trombones with the nontraditional electric guitar, bass guitar (or, less often, tuba), and a keyboard imitating brass-band sounds. Traditional bandas have long played a diverse repertoire to satisfy the cosmopolitan audiences of port cities such as Mazatlán; the tecnobanda repertoire is equally diverse, sharing musical forms with many other regional Mexican styles. Besides quebraditas, such groups

also play corridos (narrative ballads), rancheras (lyrical, usually sad songs in two-four or three-four time), waltzes, polkas, cumbias, and *zapateados* (a ranchero style derived from the Mexican *son* with fast rhythms changing from three-four to six-eight time; intended for dancing with improvised and often impressive foot-stomping steps). Romantic boleros are sometimes added to the mix, and merengues and *charangas* have also been imported from the Caribbean; all form part of the genre known as música tropical in Mexico. Rock and blues are occasionally borrowed from North American music. Quebraditas seem to be the most recent addition to the repertoire, and because they evolved from Colombian cumbias, they, too, are generally placed within the genre of música tropical.

Corridos and rancheras may treat serious subjects, but quebraditas are for dancing and enjoying oneself, so their lyrics are simpler and more light-hearted. Many lyrics simply discuss the dance itself. Others are humorous and make use of sexual double entendres. Some are romantic songs, either about the beauty or the difficulty of love. A few do make some kind of social commentary, though usually in an entertaining way. "Presumidas, S.A." by Banda Zeta is one such song, whose lyrics discuss tension between different peer groupings. Others, such as "Vamos a Las Vegas" by Los Tigres del Norte or "El Bilingüe" by Banda Machos, comment on the culture of Mexicans in the United States by using "Espanglish."

As pop songs, quebraditas tend to utilize the uncomplicated harmonic structures that have earned them the disdain of some Mexican critics (e.g., Fonseca 1998). However, they can often be quite cleverly constructed with overlapping phrases, uneven phrase lengths, and a creative reuse of melodic material in the brass sections (as in "Como la luna" recorded by Banda Maguey). Structurally, quebraditas are usually strophic songs, with the verses separated by instrumental sections often involving a restatement of the vocal melody by the brass instruments (see chapter 6 for further discussion of song structure). During vocal sections, either sung as a solo or a duet, with a second voice *(segunda ranchera)* singing a third above the principal melody, the brass sections respond to vocal phrases with fills, in essence playing the role of the accordion in norteña music. Accompaniment patterns are fairly standard, and I have transcribed two of these patterns in figure 2.1, along with the rhythms played by Los Huracanes del Norte in "El Ranchero Chido," a song several musicians told me was the "first quebradita."

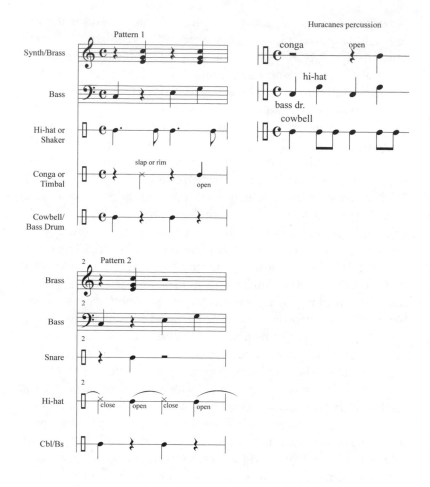

Figure 2.1 Quebradita accompaniment patterns.

Simonett traces the development of tecnobandas to Guadalajara during the mid-1980s, when Fonorama studios manager Manuel Contreras began experimenting with hybrids he created out of existing regional music ensembles. Deciding that he liked "the grupo version of a Sinaloan banda best," he recorded a mix of cumbia and norteña music with electric bass, keyboards, a vocalist, and some brass instruments (2001:29). Although the new style was at first slow to take off, it

began to gain wide appeal in Guadalajara in the late 1980s through radio airplay, following some popular recordings by Banda Vaquero's Musical (Simonett 2001:30–31). The years 1991 and 1992 saw the release of albums by all the groups who would become leaders on the quebradita scene, including Banda Machos and Banda Maguey of Jalisco, and Banda Arkángel R-15 and Banda Vallarta Show of Nayarit (Burr 1999: 59–62). By the summer of 1993, the quebradita craze was in full swing in Southern California, a fact attested to by the numerous newspaper articles on the subject that appeared during that year as well as by the upsurge in popularity of banda-oriented radio station KLAX-FM or "La X." The new style quickly caught on throughout the Southwest and in some East Coast Mexican communities as well, though Los Angeles remained the epicenter of tecnobanda's production and consumption, causing several Mexican groups to relocate to that city.[9] The catchy tecnobanda hits led to a search for the music's roots and a resurgence of interest in the "original" sinaloense sound on the part of both fans and musicians working in the United States. Simonett reports several bandas playing Sinaloan music in Los Angeles during the 1990s (2001: 3), and live banda performances still occur weekly in Southern California clubs such as Lido's (see chapter 4).

The surge in banda music's popularity during the early 1990s was owing to several musical and social factors. I have already described the first important musical change, its conversion into "tecnobanda" via the introduction of the synthesizer, which reduces costs by replacing several brass instruments, and the replacement of the traditional tuba with electric bass or synthesizer. A second change was that vocalists were added to the once exclusively instrumental genre. Carlos Haro and Steven Loza suggest that this change was initiated by Antonio Aguilar, a Mexican film star who recorded an album with banda sinaloense accompaniment in the 1980s, even though a similar sound had been achieved by Luis Pérez Meña in the 1950s (1994:61). The popularity of such recordings led many bandas sinaloenses to incorporate singers into their ensembles in the 1990s. In a third and, I would argue, most important change, bandas began to diversify further their already varied repertoire and to focus more on dance music. Bandas now play a variety of song genres, including rancheras, corridos, cumbias, and even blues. Many of their songs are in polka rhythm, so they can be danced to just like their norteño antecedents. Yet no genre contributed more directly to the skyrocketing popularity of banda music than did the quebradita.

¿De Dónde Es la Quebradita?

Quebradita songs, as noted previously, are actually very fast cumbias, making it difficult to draw the line between where cumbia stops and quebradita begins. Songs labeled as quebraditas began appearing in 1991 and 1992, though other tunes in the same rhythm were just as often labeled cumbias or even charangas. Opinions differ on when this musical style really originated. Tony Rodríguez, a Southern California dancer originally from Durango, traced the craze to the aforementioned 1988 Antonio Aguilar recording (Easley 1993). Journalist Antonio "Toño" Carrizoso agrees that Aguilar's recording of "Triste recuerdo" was a major factor leading to banda's popularization because it became a hit in California and throughout Latin America (1997:271–72). Banda el Mexicano of Mazatlán also claimed they created the new sound in 1988, although they termed it not quebradita but *caballito* (Flores Vega 1997; Simonett 2001:31). Yet I spoke with several touring banda musicians from Jalisco and a radio deejay at a concert in Indianapolis who all agreed and answered without hesitation that the first quebradita song was "El ranchero chido," composed by Jaime García and Carlos Villagómez, recorded in 1978 by the norteño group Los Huracanes del Norte (Jaime García, personal communication, 2002), and rerecorded as a quebradita by Vaquero's Musical in the early 1990s (Simonett 2001:31). The fact that my interlocutors estimated the song's birth date in the early 1980s leads me to believe it was the earlier norteño recording they had in mind, not the later tecnobanda version; one of the dancers I interviewed in Tucson also believed the quebradita to have originated with norteño groups. Los Huracanes themselves describe "El ranchero chido" as "la de brinquito" (the one with the little skip) (Inclán 2004), and *brinquito* was itself another early term for the quebradita dance. These facts suggest the quebradita's origins are tied to developments in norteña music such as its growing popularity among Mexicanos in the United States. In fact, Cathy Ragland suggests that "norteño music was the first truly transnational popular music genre to emerge in the Mexican diaspora in the late 1960s, and [it] serves as a blueprint to the development and popularity of newer, regionally-based genres like banda" (2004). In other words, emergent regional Mexican genres must take into account and musically acknowledge norteño styles in order to achieve success among diasporic Mexicans.

Other sources connect norteña and quebradita not through their

music, but through their dance styles. I explore this topic more fully in chapter 5, but it is worth pointing out here that several *sonorenses* (people from Sonora) remarked to me on the quebradita's similarities with corriditas and other Sonoran dances. Toño Carrizoso adds further complications to the debate over the quebradita, which to him sounds like "polka chunchaquera con tintes de pop y son" (cumbia-style polka with hints of pop and son) (1997:284). He cites singer Lupe "La Yaqui" Mejía as stating that the quebradita in fact originated in Hermosillo, Sonora, in the 1940s as a local interpretation of country music that had come down from Arizona through Nogales and Agua Prieta. The new dance called "corridito" was faster and more rhythmic than the polka and included knee bends called *quiebres* (breaks). From there, the dance passed to the other Pacific states, including California, Nayarit, Sinaloa, and Jalisco, where it stayed for so long "that there are people who think that it was there that they invented the rhythm" (Carrizoso 1997:284).

Tecnobandas themselves were aware of the debates surrounding their music, as a song by the group Banda Arkángel R-15 makes clear. The title of this 1993 quebradita asks, "¿De dónde es la quebradita?" (Where is the quebradita from?), and answers the question with a list of states that includes Durango, Guanajuato, Zacatecas, Jalisco, Colima, Michoacán, Sonora, Sinaloa, Chihuahua, Guerrero, California, Nuevo León, and Nayarit. In this way, the group resolves the debate through inclusion, managing to name almost all the northern and western states—the traditional regions of ranchero culture—as sources for the quebradita. Of course, they end the list with their own state of origin, thereby claiming authenticity for themselves as quebradita musicians. To Simonett, the true meaning of this song is that "the quebradita comes alive where it is being danced" (2001:55). It also shows the importance of regional origin to quebradita dancers and listeners; yet no eastern or southern states are mentioned, so only some origins are worthy of being claimed (this situation is discussed further in chapters 4 and 6).

From these debates, we can see that the only thing clear about the quebradita's origins is that they are not clear. Boundaries are blurred as banda—a music whose production is split between Jalisco, Sinaloa, and California—bleeds into norteña (itself produced in locations as disparate as Texas, California, and Nuevo León), meshing the two into a single phenomenon with transnational popularity, drawing from

diverse regional traditions. Regardless of origins, few dispute the claim that the banda craze—the recent surge in the popularity of this updated traditional music—began in the United States, spreading from there back toward the country in which it was born (e.g., see Carrizoso 1997:271–72).

Quebradita's uncertain origins, combined with its widely dispersed sites of production and consumption, clearly mark it as a transnational dance. The concept of transnationalism arose out of migration studies and originally referred to immigrant communities who retained economic, cultural, social, and even political ties with their homelands, thus seeming to reside neither "here" nor "there." Many Mexican and Mexican American communities fit this description. For example, some researchers found that in western Mexico 40 percent of all household heads had traveled north of the border, and 73 percent of them had social ties to someone living in the United States (Phillips and Massey as cited in Levitt 2001:17). For this reason, anthropologist Richard Rouse (1991) sees contemporary Mexican migrants as inhabiting an extended border zone rather than belonging to one or two distinct communities.

Transnational practices and mobility affect expressive culture in a variety of ways. Patterns of production, marketing, and consumption change as they are split between two or more nations. Today both banda and norteña exist in such a form (see Simonett 2001 and Ragland 2004). In addition, transnational musics make the contradictions inherent in contemporary life obvious. The tecnobanda craze, for instance, "was nourished by a profound sense of uprootedness or unrootedness caused by globalizing and transnational processes" (Simonett 2001:276). Local Mexican culture was decontextualized in its transfer to Los Angeles, where it helped migrants and disenfranchised minorities make sense of their lives in that "global city." Yet even as Los Angeles nightclubs became the new capitals of tecnobanda, in Sinaloa the music continued to be "deeply rooted in local culture," fulfilling its traditional roles at Carnival, in cantinas, and at village celebrations (Simonett 2001:279). On the opposite coast, sonideros, the party deejays known for their huge sound systems, take a somewhat different approach to filling the same needs. They create a transnational space for Mexican migrants in New York by creatively combining Colombian cumbia music, "space" sounds, and voiceovers. Constantly shifting between Mexican and North American frames of

reference, sonidero dances dramatize migration routes through sound and effectively bring the border to the East Coast (Ragland 2003a).

Veit Erlmann suggests that transnational "world" musics are unified by a shared aesthetic based on pastiche and nostalgia. The global and the local are pitted against one another and often translated into the conceptual pair "modernity" versus "tradition," where the latter is romanticized and mythologized. In this way, "locality itself becomes a fetish which disguises the globally dispersed forces of production" (1993:9). Although tecnobanda is not a "world music" of the type Erlmann describes—those popular Third World styles marketed to First World consumers—it is subject to many of the same dynamics. For example, according to Erlmann, in "world music" the local becomes uprooted: geographic names seem to lose their direct ties with places, becoming only evocative markers of a music's past. For Ernesto Martínez, a quebradita dancer from Tucson, this is exactly the case. To him, the term *sinaloense* does not show any particular tie to that state: "Sinaloenses . . . that doesn't mean they're from Sinaloa. A *banda sinaloense* means there's a lot of them [musicians], I mean a *lot*, probably twenty of them, and with different instruments playing a different rhythm" (interview, 1999). Yet the concept of "sinaloense" continues to be meaningful simply because it continues to serve as a marker of tradition—a talisman of the local that can serve to ward off the disorienting effects of the global. For many quebradita dancers, their understanding of the dance is in fact shaped by an insistence on its ties to distant local and regional Mexican cultures, as I discuss further in chapter 5.

Tecnobanda's Social Relevance

Un indio quiere llorar	(An Indian wants to cry
pero sea cuanta las ganas	So very badly.
se enamoró en la ciudad	He fell in love in the city
se enamoró de una dama	he fell in love with a lady
de esas de la sociedad	one of those society types
que tienen hielo en el alma.	who have ice in their soul.
Un indio ronda por allí	An Indian goes around to her place
por la mansión de esa ingrata	to the mansion of that ingrate

queriéndole platicar	wanting to speak to her
la pena que a él le mata.	of the pain that is killing him.
Cuando la llega a encontrar	When he finds her
Ella lo insulta y rechaza.	she insults and rebuffs him.
Un indio quiere llorar	An Indian wants to cry
sus lágrimas casi brotan	his tears almost gushing,
herido de corazón.	wounded from the heart.
Él no la puede olvidar	He can't forget her,
Y su tristeza me mata	and his pain is killing me
porque ese indio yo soy.	because I am that Indian.)

—Banda Machos (1992)[10]

As it grew in popularity, tecnobanda had not only musical and stylistic appeal, but social relevance as well. Its relevance derived partly from the transnational manner of its production and its combination of diverse musical styles, which reflected changes in the global economy and the new ways of living that resulted. It acquired additional social meanings through its rise from a much-scorned lower-class genre to one with international popularity and acceptance. Socioeconomic class is and has always been a key issue in the production and use of both norteña and banda music. Class relations are a determining factor in the histories and present situations of both conjunto and banda musicians, and they can be tied to many other general characteristics of banda's listening audience. Peña writes of the ways in which the divide between middle-class assimilationist Tejanos and working-class Mexicanized Tejanos contributed to the development of two opposing styles of music: *orquesta* by the former group and conjunto by the latter. Orquesta developed in the late 1940s as "the emerging Chicano middle class . . . began to aspire for new cultural symbols to express its newfound identity" (Peña 1985:291). Meanwhile, that same middle class both frowned upon those who played conjunto and prevented their access to resources. Conjunto helped the working class to disseminate its own oppositional ideology, to promote class solidarity, and to develop its own aesthetic: "to legitimize its culture while at the same time preserving some semblance of integrity in the midst of often harsh and uncompromising conditions" (Peña 1985:170).

One of José Limón's informants expressed a common attitude toward conjunto music: "Es música baja . . . de los ranchos . . . para

borrachos" (It's low-class music . . . from the ranches . . . for drunk-
ards) (quoted in Limón 1983:233). Banda fulfills many of the same
functions as conjunto music, and my own observations suggest that
the two types of music have similar class associations. Banda, too, is
generally looked down upon by members of the Mexican middle class
(as well as by some members of the working class). Reactions to banda
and quebradita like those I describe in chapter 1 make it clear that the
middle and upper classes see a clear distinction between, on the one
hand, "nice" music and dance such as mariachi or ballet folklórico,
worthy of scholarly attention and national pride, and, on the other,
those genres that are not nice, such as banda and the quebradita.
When I asked one dancer, Darma Pérez, what her parents thought of
the music she danced to, she replied that her mother described it as
"music for *borrachos*" (drunks) (interview, 1999). Mrs. Pérez's opin-
ion is a common stereotype, but it is also based on fact because
Sinaloan men often hire bandas to follow them through the street
while they get drunk, a tradition dating to the late nineteenth century
(Simonett 2001:126–28). Daniela Ayala, a factory supervisor in Her-
mosillo and aficionada of folklórico dance, stated that the quebradita
was danced by workers at her factory, but that she, an avid participant
in corriditas and ballet folklórico, would never dance it herself (inter-
view, 1999). The reticence that José Hunt, a middle-class teenager
originally from Hermosillo, displayed about being identified with
quebradita dancers may also have stemmed from its low associations
(see chapter 5). The *Los Angeles Times*, too, made such connections. In
an item describing the dance's arrival in Mexico City from the border
states, reporter Juanita Darling wrote: "Like the tango, *la quebradita*
springs from humble origins: It first appeared here [in Mexico City]
in bars such as El Pacífico, where soldiers and minor drug dealers
from northeastern Mexico mix with wide-eyed urban secretaries, and
a Saturday night is hardly complete without a stabbing or at least a
brandished pistol." And although she declared it the "dance to know"
in 1994, she acknowledged that not all *chilangos* (inhabitants of Mex-
ico City) were wild about dancing quebradita. At a dinner dance,
"many carefully coifed clerks and office managers, who had gracefully
segued from mambo to cumbia throughout the evening, watched the
prancing movements with puzzlement" (1994).

 Although banda is not part of a clear oppositional pair like con-
junto/orquesta, it can for purposes of comparison be pitted against

other contemporary musical forms, such as *rock en español*, that are more popular among the middle class. According to *Arizona Republic* journalist Randy Cordova (1998), rock en español has been gaining popularity in the United States and has found a loyal audience among Mexican American college students. During the 1980s and 1990s, it was similar in sound to English-language alternative rock and was also an "underground format" like that music during the 1980s. It seems to be particularly popular among Mexican Americans of the second, third, or even more distant generations who may not speak much Spanish.[11] Its listeners note that they previously associated Spanish-language music with their parents' generation: "It was in the background . . . it was for them," said Durango, a member of Phoenix-based rock group Casa de Locos. "Vicente Fernández, Juan Gabriel . . . [their music] doesn't speak to our generation," added Arizona State University graduate student Rafael Reyes (quoted in Cordova 1998).

Ranchera music like that of Vicente Fernández also carries an association with recent immigrants to the United States. Armando Zamora, a Phoenix-based concert promoter, blames the lack of local radio support for rock en español on the fact that "[w]e have a lot of people from Sinaloa and Chihuahua. We have more border people here. They don't really like that type of music. It's a Mexico City kind of thing" (quoted in Cordova 1998). The tastes of recently arrived Mexicans from border areas, who usually occupy the lowest rungs on the socioeconomic ladder in the United States, are clearly contrasted with those of the cosmopolitan denizens of Mexico's capital. In 1999, Valeria Gardea Nacoch, a teenager from "el D.F." (the Distrito Federal, or Mexico City), further explained the regional difference in musical tastes:

> In Mexico City, there are people who dance quebradita, but it isn't a very popular dance. . . . They listen more to American music. More music from the United States than from Mexico . . . because right now, everything is developing, evolving, so the people's tastes are changing too. And right now, for example—I don't know if you know what Hellenism is. It's like a country adopts the culture of other countries, and that's what is happening with most countries. Like all the other countries, we are hellenizing with the United States. You know, the music from the U.S. is what the whole world listens to. English is everyone's language. Clinton

is like the president of the whole world. It's a bit bothersome, but invariably that is what's happening. So, obviously, in Mexico we have our own things, and I really love Mexican culture. But . . . the clothes, the fashions come from the U.S. The music is from the U.S., the science, everything is U.S. So a lot is lost—the quebradita, things like that. [Perhaps quebradita was more popular in the North because] it was the culture from a long time ago. It isn't something that seems like it's up to the minute. It comes from before, from the ancestors, from how the culture was. It's different. . . . It's more conservative. (Interview, 1999)

According to her description, northern Mexican/border culture is more conservative, whereas that of Mexico City is quickly changing. Therefore, in Mexico City there is a greater concern with keeping up to date in musical fashions, especially those that emanate from the United States. My own experiences matched some of her observations. While in Mexico City in 1995, I stayed with a middle-class family whose musical tastes included rock, salsa, and mariachi (on special occasions), but no norteña or banda, and I socialized with musicians from the state of Sonora who had moved there to "make it" on the hard rock scene. The banda craze, then in full swing in the U.S. Southwest, had not registered on their radar, although the Macarena and heavy metal had. As Mexico City–based author Francisco Hinojosa explains, "the real problem [in Mexico] is that, with hopes that one day we'll be confused with a First World country, imports matter a lot to us—especially those that come by way of the northern customs office" (1995:71).

Chilangos, therefore, often express pride in those things considered to be uniquely Mexican, such as mariachi music, Diego Rivera's murals, or Aztec temples, but in their daily lives they are more likely to consume imported cultural forms. For example, Los Angeles dancer Sol Porras noted that whereas her mother's family from Nayarit dance to banda and norteña, her father's family from the D.F. dance only cumbia, salsa, and merengue because banda "is really viewed critically by chilangos." Urbanites from other large cities often follow suit, she further explained; she was surprised to learn that a cousin from Ensenada danced only cumbia and had never attended or even heard of jaripeos (rodeo competitions where banda and norteña are often played) (interview, 2005). Valeria equates the adoption of foreign

expressive culture such as rock and salsa with developments in science and technology: both are indicative of the cosmopolitanism the urban middle and upper classes wish to project. It is noteworthy that the lower classes in Mexico City exhibit a similar transnational orientation, although by different means: by dancing to Colombian-style *cumbias sonideras*.

A viewpoint more extreme than Valeria's was voiced in the Mexico City newspaper *El Nacional* in 1998. Musician/academic José Jesús Fonseca quoted his friend Guillermo Cohen Degovia, a "famous Panamanian psychologist, musicologist, and admirer of Mexican folklore," who described the norteña music played by a cassette vendor near a Mexico City metro station as a "rotten, stunning stench." Fonseca went on to call cumbias and quebraditas "basura musical" (musical trash), and norteña songs "excretions of [the musicians'] deformed spirit." He suggested that the government should regulate Mexico's sonic environment because "orchestras sound like the worst of their musicians, and societies conduct themselves as do the worst of their uncultured masses" (1998).

The dichotomy of opinion on this music between chilangos and norteños or Mexicans of other regions is analogous to the opposition between orquesta and conjunto music described by Peña. Members of the middle class, such as Valeria, are more likely to listen to rock or salsa or even classical, like Fonseca, than to banda or grupera.[12] They seem to support closer ties with other nations and especially with the English-speaking culture of the United States, even if they disagree with many U.S. policies. And they can be compared to the Tejano middle class described by Peña, which is in favor of greater assimilation into mainstream American culture. Alan Riding describes the North American character of Mexico City's middle-class suburbs in the 1980s, which adopted the practice of situating homes around private golf courses, where "even the concentration of bilingual schools—teaching as much English as Spanish—emphasizes the mood of a rising middle class bent on self-improvement" (1985:268).

Working-class Mexicans, in particular those living outside of the capital, seem to prefer grupera, banda, or norteña/conjunto. They hope to project an image of Mexicanness, as did quebradita dancers in the United States. For example, Eric Ramírez, president of a Los Angeles–area quebradita club, was quoted in the *Los Angeles Times* as saying, "I'm proud now to show the world I'm Mexican" (Easley

1993). As journalist Rubén Martínez describes the situation, "The Anglos say that immigrants should assimilate; Latinos retaliate with *quebradita*" (1994). Martínez's statement, in particular, suggests that quebradita is in some cases seen as promoting a counterideology. That is, it promotes a manner of thinking or a value system that contrasts with that of the dominant group, much as low riding has sometimes served as a "conscious rebellion against middle class ideology" (Plascencia 1983, 141). In the United States, the dance may be used to undermine anti-immigration rhetoric. In Mexico, it may be used to counter middle-class aesthetics and values.

The power of music to promote ideologies has not gone unnoticed by Mexican politicians. For the most part, attention has been focused on "autochthonous and regional music," in particular the complex of traditions generally and collectively known as folklórico dance (Riding 1985:303). However, newspaper reports show that in recent years Mexican political parties have attempted to utilize popular music, including tecnobanda, for their own purposes: "The PAN [Partido de Acción Nacional] allowed the ubiquitous hit 'No rompas más' by Caballo Dorado to be made into their catchy electoral jingle; if that isn't enough, Mi Super Banda el Mexicano . . . are charged with giving a grupero accent to the afternoon's political festivities . . . the least inhibited PAN candidates will even try to dance quebradita" (Flores Vega 1997). As PAN is the more conservative of Mexico's principal political parties, its members and candidates might have thought it necessary to show solidarity with the working class through musical means.

In discussing low-rider aesthetics, Brenda Jo Bright writes, "[C]lass and social hierarchies are replicated in the axiological nature of 'taste' distinctions" (1995a:6). Tecnobanda musicians and listeners are very aware of such hierarchies of taste, and some quebradita songs discuss differences between the musical preferences of members of different social classes. In "Presumidas, S.A." (Stuck-ups, Inc.) by Banda Zeta, for example, the singer tells of some "presumidas" who find the atmosphere at a banda club to be "lame." Although the singer and his friends urge the "refined" girls to stay and enjoy themselves, the girls prefer heavy metal to banda and do not fit in with the singer and his friends; he describes them as *popis*, a slang term for a wealthy snob. The voice of the "presumida" has a stereotypical Mexico City accent, which is used to humorous effect. The perception of chilangos

as arrogant is a common one, and such resentment is not without foundation because the government continues to pour resources into the capital, where "politics, business, and culture are concentrated" (Riding 1985:274). Northerners "despise the political and bureaucratic ways of the *chilangos*," and southerners "regard *chilangos* as interfering foreigners" (Riding 1985:283, 290).

Race and ethnicity form additional dimensions in the problem of music and class in Mexico. Economic classes in Mexico, as in many other countries, often have strong racial connotations. Indigenous people are often discriminated against and even exploited, and they do not have the same access to economic resources that their light-skinned compatriots do. This discrimination extends even to dark-skinned mestizos, or persons of mixed heritage. It is a paradox that, as Riding puts it, "[p]roud of its Indian past, Mexico seems ashamed of its Indian present" (1985:199). Indian cultures, however, have been seen since revolutionary times as "an ethnocentric aberration within the new concept of national unity" (Riding 1985:201) because of their conservative views, their attachment to traditional religion and clothing, and their resistance to assimilation. Although elected officials often pay lip service to improving the plight of the *indígenas*, few changes have been made either in individual attitudes or in official policy. Carmen Borja, an indigenous woman, remarked, "The eyes of the *mestizos* and of the ordinary people of the city are filled with contempt or curiosity or pity when they see us" (quoted in Riding 1985:208).

This painful situation has been discussed in banda music. I opened this section with the lyrics to the ranchera hit "Un indio quiere llorar," popularized by Banda Machos. In this song, the singer is a self-described Indian who moves to a city and falls in love. We can assume that he is from a rural area and of a lower socioeconomic class because he contrasts himself with the "society people" who have "ice in their souls." He is treated poorly by the object of his affection, who lives in a mansion. The "strong public response to the lyrics of this song" (Haro and Loza 1994:68) indicates that many listeners identified with the racial and social conflict they depict. Another popular banda song, "Sangre de indio" (Indian blood), offers a more positive take on the issue of ethnicity. The lyrics to this early hit by Banda Machos appear in Simonett (2001:49–50) and therefore need not be reprinted here. What is important is that the singer expresses pride in his Indian

heritage and rural origins while delivering his message that ethnicity need not be an impediment to achieving a good life through hard work. The enormous U.S. sales of the album *Con sangre de Indio* (1992) suggest that its hopeful message resonated with many immigrant listeners.

In the United States, these ties between race and class do not remain static. They may change for several reasons. First, non-Latino North Americans tend to lump all immigrants together by country without regard for categories of race and status that might have been in place in the country of origin. This overgeneralization can in some cases encourage immigrant groups to band together, lessening racial stigma within the group (although the opposite can also occur). In addition, racial stigma has been mitigated in some circles by the positive value the Chicano movement placed on Indian heritage, a value also adopted by the cholo community (Vigil 1988:110–11). Such factors helped quebradita to cross class lines in the United States. Two of the young dancers I interviewed in Tucson were light-skinned and middle class, yet they had fewer reservations about joining a quebradita group or listening to banda than did those dancers born in Mexico who had similar characteristics. In writing about banda's impact in the United States, Haro and Loza state, "It cuts across different generations and age groups, different economic status groups, and individuals with different life experiences" (1994:60). Peña also acknowledges that banda attracted some middle-class listeners, although it was especially popular among the working class (1999b: 309). And Simonett, too, notes that banda's lower-class connotations were less important in the United States than in Mexico, allowing the music to attract an audience that "transcend[ed] class boundaries" (2001:90). As I have shown elsewhere for *merengue típico* music of the Dominican Republic (Hutchinson 2006), when musics with strong class associations in their country of origin are placed into transnational situations, such associations may be weakened. In such cases, as a result of the host country's real or perceived hostility toward immigrants, the immigrants' need to express pride in national and regional origins becomes stronger than the need to maintain class stratification. This was the case with banda music in the United States: although parents at times resisted their children's incursions into banda music, its teenage listeners came from all levels of society.

Sound and Symbol

Lyrics can provide important clues to music's meanings, but they do not tell the whole story. The song lyrics I have examined here provide insight into how tecnobanda and the quebradita relate to issues of race or ethnicity, class position, and peer social groups. The sounds themselves add another dimension, demonstrating how banda and tecnobanda are able to evoke strong emotions in listeners, which are then released through *gritos* or shouts and through dance.

Music is generally understood to be a form of nonverbal communication, but the ways in which it communicates are complex, and thus its messages can be difficult to decode. Thomas Turino (1999) has shown how semiotics, the study of signs, can be applied to music to serve this end. Following Peirce, he outlines two main ways in which signs can be related to their objects. Icons are those signs that resemble what they are meant to represent, whereas the relation of an index to its object is learned through experience. An index is laden with emotion and therefore has a high degree of personal investment; thus, indexes can often be used to construct social identities.

Both icons and indexes can be found in tecnobanda music. The Banda Maguey trumpeter's imitation of a horse whinnying in the beginning of their song "El Alacrán" (itself originally a Cuban carnival song with the sugarcane harvest as its theme) is an icon used to connect their music more directly with ranch life. The gritos heard in many recordings are a second example because such vocalizations are believed to have originated as cattle calls and are heard in conjunction with all types of ranchera music. Many more icons are visible in musicians' and dancers' Western-inspired clothing and movements (discussed in chapter 3). Indexes are more indirect signs, which here are used to create links between pop music and historically legitimated expressions of tradition. For example, the use of zapateado rhythms recalls the Jaliscan son to those who are familiar with that tradition and therefore serves as an index of historic rural culture. Banda and tecnobanda recordings of ranchera songs, with their highly recognizable vocal qualities, including gritos and cry breaks, serve the same purpose and provide another tie to norteña culture.

Turino further explains that signs can be interpreted in at least two different ways, each having a different effect. If they are judged as

a possibility rather than as a true or false proposition, they are called *rhemes*. Or they may be seen as being directly related to their object, as a weathervane is judged as a true indication of wind direction, and these more convincing signs are known as *dicents*. The combination of old and new in tecnobanda music may be considered a rheme because it offers a vision of a possible present or future in which modernity and tradition coexist without conflict. However, tecno-banda's use of traditional musical forms is often judged as a real relationship with traditional culture, serving as a dicent that gives tecnobanda roots and legitimacy among some listeners. (Dancers' comments on quebradita origins, in chapter 4, make this connection particularly clear.) In sum, through its combination of literal and nonliteral signs, tecnobanda music communicates a vision of a culture in which Mexicans and Mexican Americans are able to participate together in modern, technological, transnational society without losing their unique identity, their history, or their ties to place.

Conclusions

There is a long tradition in Mexico of mestizo musics occupying low-status positions, but some of them have risen in standing. Mariachi once held such a position and now not only is accepted by most Mexicans of all social classes, but also is revered as a national symbol and an "art" music. Conjunto's position seems to be improving too, perhaps owing to the prestigious awards that norteño and tejano musicians have received in recent years, such as U.S. National Heritage Awards and Grammy Awards. Banda music has not yet advanced in social standing to such a degree. At the same time, its acceptance among youth in the United States has crossed class lines, and its commercial potential has not gone unnoticed by record companies.

As might be expected, the dramatic rise in the popularity of banda music during the 1990s went hand in hand with a commercialization and commodification that many observers have criticized. California radio announcer Jaime López, for example, feels that the whole quebradita movement was based principally on an "exaggerated consumerism" (interview, 2005). Many of the criticisms one hears of recent banda music were leveled at norteña in the past. For example, José Limón wrote of norteña that "[w]hatever gains the [working] class made in 'style,' it was *paying* for it through the capital-

ist commodification of its music and paying at increasingly higher ticket and record prices. . . . [I]t also bought a wholly depoliticized lyrical content" (1983:240). Banda music has likewise gone through a dramatic increase in price. I attended a concert in Indianapolis in 1999 that charged forty-five dollars per person, a price the largely working-class clientele would pay simply because of the lack of competition and scarcity of Mexican cultural events in the area. Manuel Peña has also expressed concern over the effects of commodification. Like myself, he notes banda music's powerful ties to ethnic pride in the United States and alludes to its relationship with class: it has "struck a deep, responsive chord, especially among working-class Mexican immigrants." However, he also believes that "the [political] potential locked up in *banda* remains unrealized" because of its commodification (1999a:309).

It is true that commercialization has had its effects, such as the somewhat uniform sound of the more popular groups, the replacement of instrumentalists with synthesizers, high ticket prices, and the uninspired nature of many lyrics. And, in some ways, tecnobanda and the quebradita are perfect examples of how transnational rural styles begin to adapt to their new locations in capitalist societies (see chapter 6). Yet such adaptations are necessary in the competition for audiences who have a multiplicity of other options. Without the large audience such changes have gained, banda would not have had the opportunity to have much impact at all. I would argue that banda is making a difference: social statements may be made in many different ways, and these musicians and dancers are making quite strong statements through their use and support of an aesthetic system that subverts middle-class culture and insists on strong ties to roots. Sol Porras told me, "[Q]uebradita music has really made an impact on the Chicano generation, or kids of immigrants primarily. New immigrants now are more into that [banda music] than the immigrants of before, who were into grupera." The switch from pop ballads to quebradita got "more Chicanos involved with their cultural side." Furthermore, although the music did not include any lyrics at all in earlier times, banda musicians now have the opportunity to discuss their social situations in songs such as those quoted here.

Finally, I would like to note that music does not always need to be explicitly political to be significant. At its inception, banda music was associated with good times (recall Campos's "alegría sonora"), and

the association continues: "when we play, people get happy. Life in this country is different; everyone is in a rush, people don't have time to relax. But when they hear our music, they remember what it's like to have a good time" reported Jesús Arévalo, member of Texas-based Super Banda Revelación (quoted in Ragland 1996). Everyone needs a way to escape the harsh reality of everyday life at times, and many banda listeners have particularly difficult issues to deal with from day to day. Escape is one of the functions this music fulfills, but this purpose does not necessarily make the music trivial. In fact, escape itself can be political; as Anthony Macías suggests for the "hep cats" and "zoot suiters" of the 1940s, many banda listeners "rejected the values of the work world for those of the dance hall," thereby reclaiming public spaces and intervening into the "leisure lifestyle of their 'social betters'" (2001:68).

Although banda has historically been a marginalized music and continues to be treated as such in many sectors, during the 1990s it managed to break free and become extremely and unexpectedly popular on both sides of the border. In doing so, it became part of a larger trend in the Americas, a trend in which many formerly rural, lower-class musics have achieved previously unimagined success. This has been true of conjunto and norteña music, as well as of U.S. country music, which Professor Xicoténcatl Díaz de León calls "quebradita's counterpart" (interview, 1999). Another example is Dominican *bachata* music. Deborah Pacini Hernández (1995) has shown how this guitar-based rural ballad tradition was actively avoided and repressed by middle-class Dominicans owing to its musical style, which they viewed as an unskilled imitation of Cuban boleros, and its sensual lyrics, which they considered crude. However, once internationally acclaimed singer-songwriter Juan Luis Guerra paid homage to the style on a 1995 album, other Dominican musicians soon followed suit, and bachata now not only is accepted by Dominicans of all classes, but is a major musical export for the country, second only to merengue. Pacini Hernández mentions several other musical traditions that have followed a similar trajectory. For example, Brazilian *brega*, the modernized traditional music of poor, rural people (and a synonym for a low-class aesthetic), became chic when adopted by a rock singer; and reggae, which originated in Kingston's shantytowns, became internationally popular after being transported to London by Jamaican immigrants (1995:234–36).

Why have all these musics received so much attention recently, becoming such unexpected hits? Is it simply a search for novelty? Novelty may be one cause, but it is more likely that these styles are serving a deeper need. Bright suggests that in the visual arts, "dissatisfaction with modernity" is a key factor in the nostalgia and accelerating search for "primitive" cultures and the acquisition or appropriation of their art by artists and museums (1995a:11, after Andreas Huyssen). These processes have parallels in the field of music, where consumers seek to acquire rural cultures once considered "backward." Scholars such as Veit Erlmann and Reebee Garofalo have effectively analyzed transnational musics, many of which are updated traditional styles with rural roots, and can help us to understand the larger processes at work. Erlmann's (1993) work suggests that transnational musics are a means of dealing with the changes wrought by globalization: in their attempt to re-create local linkages where such links may no longer exist, they help to reestablish a sense of place. Similarly, Garofalo (1993) proposes that technology leads to the decentralization of musical production and consumption, a process that yields two results. One is *transculturation*, a term he borrows from Cuban scholar Fernando Ortiz for the process in which international styles are incorporated into local ones and vice versa to create transnational musics (such as tecnobanda); another is a growing insistence on the "preservation" of "traditional" musics (such as banda sinaloense). To Garofalo, these results demonstrate that technological developments resulting in globalized musical production have outpaced our ideas about musical authenticity, which many listeners still understand as being tied to specific places.

I would add that urbanization must also play a role because it is yet another process that serves to destabilize our sense of place. In this time and this part of the world, most people either already live in big cities or are having to move to the cities to find work. These cities, no matter what country they are in, are often overcrowded, polluted, ugly, and alienating. They make some residents yearn for a past—or a rural present—which, though never experienced firsthand, is perceived as healthier, closer to nature, warmer, simpler, even perhaps more "authentic." When people cannot have this experience in their daily lives, some instead try to import it or purchase it, living vicariously through their musical choices. In chapter 3, I examine the role this theme plays in the quebradita.

3

Quebradita Dancing

Exploring Mexican American History, Identity, and Aesthetics Through Movement

According to Iveris Luz Martínez, dance is "a way of perpetuating a visual/sensorial historical memory" (2002:271). It is also a way of creating that historical memory by making physical connections between past and present. The dances of popular culture perhaps play the most important role in this endeavor because, as George Lipsitz reminds us, "commercialized leisure is history—a repository of collective memory that places immediate experience in the context of change over time" (1990:5). I argue that quebradita drew on Mexican American collective memory in the form of visual and kinetic icons and indexes in order to create a sense of historical continuity, to elaborate a new sense of cultural identity, and to begin the work of politicizing the young people who participated in it.

In chapter 2, I discussed the relationship between banda music, economic class, and ethnicity, and noted the ways in which such issues are discussed in banda songs and symbolized in banda sounds. In this chapter, I look at how these issues are explored stylistically—through movement, attire, and the performance of quebradita dance. These three aspects of the dance are unified by a common aesthetic system that ties the quebradita to other Mexican American cultural expressions from ranchera music to the visual arts. Through these visual codes and through memory, the dance taps into history, creating cultural meaning and feeling. I also explore the relevance of the concept of mestizaje in the analysis of the quebradita and other modern cultural expressions.

Quebradita Performance and the Ranchero Aesthetic

My analysis of banda/quebradita style is based primarily on a concept about which ethnomusicologist Manuel Peña was the first to write. In his works on Texas Mexican music, he describes in detail the aesthetic/ideological system called *lo ranchero*, or ranch style, and its association with conjunto music. The concept applies equally well to banda and the quebradita. Peña describes it as being associated, for Mexican Americans, with "the rugged but pristine, unspoiled and virtuous life that *el rancho* promotes," as well as with "our ancestors" (1999a:123–25). It is found musically, he says, in songs of slower tempos[13] and is indexed by romantic lyrics (usually of a sad sort), a "crying" vocal quality, and the use of gritos, the stylized shouts some researchers believe originated as cattle calls. It visually makes use of a host of symbols that evoke ranch life for the listener and viewer, in particular vaquero (cowboy) style clothing. Lo ranchero is pitted against a competing, middle-class aesthetic system colloquially known in Texas as *jaitón* (high toned). The latter also may be described as *lo moderno*, modern style: "a code phrase for the assimilation of middle-class elements" (Peña 1999a:125). Together, the pair may be seen as illuminating and representing other polarities such as "[c]ountry-city, rustic-cosmopolitan, Mexican American, working-middle class, cultural resistance-assimilation" (Peña 1999a:123). In other words, lo ranchero ties together and expresses all the issues I have so far discussed. When one examines banda music together with its associated dance, clothing, and social events, one can see that here, as in música tejana, lo ranchero is the central aesthetic principle that unifies the whole complex and gives it such symbolic power.

One may well wonder why this concept has become so important in Mexican American culture. I have already noted that rural musical styles are reemerging around the world as a response to urbanization and globalization, and have suggested that this response was one of the sparks that ignited the tecnobanda/quebradita craze. Taking a historical view of this particular case, Peña adds that lo ranchero was and is a response to class struggle, shifts in social structure, and processes of production following the outcome of the Mexican-American War and the continuing Anglo-Mexican conflicts in the Southwest (1999b:15–19, 51). For example, members of the Chicano movement chose música ranchera as a symbol both to celebrate their own heri-

tage and to counteract the homogenizing effect of Anglo culture. Similarly, one reason banda may have risen to such heights in California in the early 1990s is the legislation being passed at the time, such as the English-only laws and those laws that sought to deny immigrants basic rights, including education. One contemporary reporter asked, "Is it mere coincidence that the *quebradita* craze was born roughly at the same time that politicians began staking out positions against the presence of immigrants—especially the illegal immigrants—in our midst?" (Martínez 1994).

Among all the options available, banda—a rustic, ranchero-style music—was chosen as the most potent symbol in that time and place for several reasons. First, música ranchera (mainly in the form of conjunto/norteña, with the exception of Californians' customary mariachi preference) has long held sway over the border area, in part because of its ability to induce nostalgic and patriotic emotions in those far from home. It represents "a form of ethnic resistance, and the continuity of norteño culture on this side of the border" (Peña 1999a:122); it also evokes strong feelings among listeners—feelings that can be used to strengthen that community. Second, it is strongly attached to working-class aesthetic sensibilities and values, such as "glorification of *machismo;* a certain cynicism toward wealth and power; a romantic attachment to *lo mexicano* . . . and in the absence of an effective political voice, [a] recourse to the *gritos por abajo* [shouts from below]" (Peña 1999a:3). As such, banda often clashes with North American middle-class aesthetics and beliefs and is therefore a much more effective weapon against them. Listening to banda shows that one has not swallowed North American pop culture whole and that one still retains ties to Mexican culture and the Spanish language.

On a more individual level, youths turned to banda and the quebradita as a means of exploring and negotiating their own identities on both sides of the "hyphen." Clifford Geertz writes, "Quartets, still lifes, and cockfights are not merely reflections of a pre-existing sensibility analogically represented; they are positive agents in the creation and maintenance of such a sensibility" (1973:451). Likewise, for these teenagers, banda not only represented the values of their forefathers, but also helped them to discover what they themselves most valued and to create their own means of expression. Decades earlier, members of the "Chicano generation" (a group that includes the parents of some quebradita dancers) used folklórico music and

dance in a similar fashion. For them, it "evoked a highly stylized and romantic vision of Mexican folk aesthetics, in this way symbolically contesting the hegemony of Anglo culture which reconnected with their imagined (and sometimes remote) cultural roots" (Peña 1999a: 217). Many members of other minority and immigrant communities in the United States have similarly been contesting so-called mainstream North American culture through exploration of their own artistic traditions. In this way, they attempt to bridge the gaps between the culture of their ancestors, to which (as Peña notes) they may be only distantly connected, the difficulties they face at present in their daily lives, and their future here in this country. Angela Keil and Charles Keil explain that "migrants often resist the oppressiveness of rapid urbanization under conditions of extreme poverty by creating new musical styles that link their rural past with an urban present" (1987:75–76). Such conditions were probably an important factor in the creation of ranchero-style music a century ago and very likely continue to be so for recent Mexican immigrants. But it can be especially difficult to make sense of these competing value systems—rural and urban, Mexican and American—for those who are part of the middle class in the United States or who aspire to be so.

Peña describes how upwardly mobile Texas Mexicans "[vacillate] between acculturation and resistance: between a Mexican and an American identity," thereby creating bicultural, bimusical expressions (1999b:120, 21). It seems to me that for many of the young people I interviewed, their experimentation with quebradita was part of just such an internal struggle. Griselda Mariscal, a young Chicana in Los Angeles, described her changing sense of identity in a *Los Angeles Times* article. When she began attending college, she "hated the gringos," but a trip to Mexico taught her that she didn't quite belong there either and "had something in common with the gringo" after all. After becoming involved with the quebradita, she "doesn't see herself as a pure Mexicana. But she still doesn't see herself completely as an American, either" (Martínez 1994). The quebradita is one symbolic means of combining those two identities into a new one.

Quebradita Moves

Darron Butler, mentor and manager of the CDO High School Quebradita Club in Tucson, described quebradita as "kind of a modern,

Latin version of break dancing" (interview, 1999), which is about as good a description as any. One teenage reporter elaborated, "It was formed from the traditional dance of cumbia and it mixes some types of break dancing and B-bop [sic] moves from the fifties and adds very quick and dangerous movements including flipping the female partner around" (D. Rodríguez [1998]). Marcela Cárdenas of the Tucson High School folklórico dance program described quebradita as both sensual and *alegre* (happy)—an important aspect of this art form that connects both with Rubén Campos's early portrayal of banda music as alegría sonora, happiness in sound, and the name of Tucson's first quebradita club, Ritmo Alegre. (According to Ramiro Burr, Tejano music in its early years was often simply called *música alegre* [1999: 24].) Marcela believes the characteristics that make up the quebradita style are the flips performed by the female partner, the jumping or hopping motion, and the steps in which the lower part of the leg is used to describe a circular motion behind the body (interview, 1999a).

When I asked dancers how they would describe the dance, they were usually at a loss for words and were not sure how to classify it. Upon first viewing the quebradita, many observers remark on superficial similarities with swing, country-western, even hip-hop or break dancing, but such comparisons cannot really do it justice. It is something that must be seen because it is truly impressive when done well. It is highly athletic, requiring great strength, flexibility, and agility. It is also very individualistic; dancers must be creative enough to be able to develop their own steps and trademark style. In this, it differs from the more conservative norteño dancing styles. Los Angeles dancer Sol Porras explained, "I think [in] norteña, you're very limited [in] the way you're supposed to dance. Banda, you can jump around here and there, even if you're dancing by yourself." Norteña cumbias, at least in California, are danced mostly in place, whereas banda cumbias cover much more space. Porras attributes these differences in part to the fact that norteña lyrics are more political, serious, and "rugged," whereas banda is oriented to love songs; in addition, banda has more variation in rhythm and tempo as well as influences from rock and roll (interview, 2005).

Because of the exciting rhythms and the emphasis on creativity, there are many ways to dance quebradita. In a step called *la campana* (the bell), the dancing couple keep their upper bodies mostly still as their legs, wide apart, move in an arc from one side to the other like

the clapper of a bell. They seem barely to touch the ground as they spring from one foot to the other; as one toe touches the ground, the other leg may accent the step by executing a small kick in the air. In el caballito (the little horse), each partner's right leg is sandwiched between the other's two. As the man either rocks back and forth or travels forward, lifting his right knee up every time he rocks back onto his left foot, the woman hops from one foot to the other over his knee, kicking her booted feet up behind her with each step. Or she may grip his right leg between her thighs, allowing him to bend her backward or move her from side to side. In between, dancers may throw in hip-hop moves, country line dancing, a few steps taken with a merengue-like hip motion, or anything else that may come to mind. Partners may also separate to execute individual moves, particularly during songs suitable for zapateado, footwork that emphasizes the sound of the boot against the floor. There are a few "trademark" moves, such as a windmilling motion done with the lower leg held behind the body, its toe tapping the floor on each revolution. And, of course, there's the "quebradita" itself, where the male partner quickly "breaks" the female's back by lifting and twisting her to one side while bringing her arm down and slightly pushing her upper body, bending her backward over his arm or knee and then bringing her upright, all within a second or two.

Arm movements also played an important role. Dancer Lucina Rodríguez remembered that usually the man's left arm and the woman's right arm are stretched out nearly straight, but then "sometimes [my partner] would just grab my hand and put it right behind his back and just *quebrarme* [break me] like that" (interview, 2005). The arm position thus signaled the woman for an upcoming break, a turn, or another dramatic movement. Although there are few constants between all the styles, nearly all of them emphasize verticality and buoyancy through hopping and jumping, and all favor big movements over small, helping the dancers take possession of the space around them and ensuring that they will be noticed. Just as Mexican cumbia music emphasizes its basic rhythm so as to produce an essentialized and immediatcly recognizable style, so quebradita exaggerates basic movement units in order to produce a larger-than-life dance that cannot help but attract attention wherever it is performed.

All the Tucson dancers with whom I spoke became involved in dancing the quebradita after seeing and being inspired by an impres-

sive performance by other dancers, usually at their own school. CDO dancer Robby Espinoza described his first impressions:

> They were doing like a *carne asada* [barbecue], they were doing fund-raising and stuff like that, and they were dancing trying to bring money in, you know, to help raise for uniforms. They already had a club . . . the CDO Quebradita Club. I saw them performing it—the same guy I saw performing there is now my best friend. They were doing all these cool flips and everything. I was like, "I want to do it! It kind of looks like swing." So my friends are like, "Come check out the club, we're trying to recruit more people into it. . . . " So I went one day and I totally loved it. And that's how it all started. (Interview, 1999)

Like many others, José Hunt, also of CDO, was most impressed by the dangerous flips: "The first time I saw it I thought it was a lot of fun because they would do all these tricks. They would just dance very well, pick the girl up, and it was fun just to watch. Even though sometimes the girls would hurt themselves" (interview, 1999). Shannon Ortiz began by joining the CDO Hispanic Culture Club, and when one day she saw other members practicing quebradita steps, she asked them to teach her. At Tucson High, Sandra Franco and Ximena Gómez were first exposed to the quebradita when members of their folklórico group began practicing it after class. Ernesto Martínez, a student at Tucson's Sunnyside High School, had a somewhat different exposure to quebradita because he first saw it in Guadalajara, Mexico, in the early 1990s. He and some family members went to hear a live band, and they began to show him the steps at that time.

More immigrants were represented among the dancers I interviewed in California, so their experiences were closer to Ernesto's than to the others'. Sol Porras, for example, started dancing quebradita when she traveled to her mother's hometown of Sayula, Nayarit, in 1992; she helped to form a quebradita club at her school in California the following year. David Padilla, too, first learned caballito while at a friend's high school graduation party in Nayarit. An avid dancer of the competitive solo form called *cachongo* in Nayarit, he naturally moved on to quebradita when he arrived in California, mixing in some of his cachongo moves for good measure. Lucina Rodríguez, in contrast, had grown up dancing to *tamborazo* in Guadalajara and saw quebradita only after moving to California's Bay Area. She was taught the dance by friends who had traveled to Los Angeles.

The young dancers' abilities were remarkable even to professionals such as Marcela Cárdenas. She remembered being impressed by the complexity and difficulty both of the steps and of the choreography. "It wasn't just one, two, three, turn, one, two three, turn, repeated ten times," she noted. It was one difficult step after another. The sensuality of the movements was also somewhat shocking at first because her own daughter was performing it, and Shannon's parents had the same reaction: "When I said I'd joined a dance group, they were thinking folklórico, something formal. . . . Quebradita, the first performance that they saw . . . was provocative, the guys and the girls dancing really close, doing those moves, and it really threw them off! But after a while, they were proud that I was doing performances" (interview, 1999). The one thing Marcela most remembered about the first performance she saw, aside from her shock, was the pride in the dancers' eyes: this was something they had worked hard for and achieved. The quebradita was really theirs.

All the dancers learned primarily through informal, face-to-face instruction. Friends, relatives, or fellow club members would demonstrate steps; the new initiate would attempt to copy them; and sometimes a critique would follow. Shannon described some corrections she was given: "I had a lot of problems with my upper part of my body because I wouldn't move as much, I wouldn't be as loose. And you know they're not doing it to be mean, it's just constructive criticism, so we never took it the wrong way. 'You've got to move your shoulders'; just 'do this,' 'do that.' And if one person couldn't teach you, someone else would try."

Ernesto often scolded his group for trying to dance to the song's words rather than to the rhythm: "No, it's the rhythm! Listen to the rhythm!" interview, 1999). Members of semiprofessional groups sometimes were invited to teach steps to one of the student clubs, as Marcela remembered it happening at Tucson High. But the dancers usually learned many steps simply by observing more experienced dancers. Ernesto stressed the importance of the visual in his learning experience, which was often mediated through television:

How did I learn? Just by watching. Just by watching and doing what people were doing. TV, I'd watch it on TV, and got onto a stage and did whatever I can. . . . I had to learn. And I had an idol, his name was Pato, and he was one of the old ones that danced quebradita, [from] Guadalajara. El Pollo. They came from Gua-

dalajara here, so it was Pollo, Pato, El Diablo; and I liked how Pato danced. I used to go with him, go dance, and I guess I probably learned a lot from him, just from watching his moves.

He also described his choreographic process as occurring visually: "I just saw it in my mind just by looking at them [the dancers]." For José, learning was a matter of trial and error, with the help of his fellow club members' suggestions. "[You learned] by going and trying . . . just practice. And they would tell you, 'Well, if you move this way, and try to do it, it would be easier for you,' or stuff like that. Or, 'if you pick the girl [up] and try to do this other thing, it would look pretty much the same.'"

Ximena recalled a somewhat systematic approach, where other dancers began by helping her to perfect the jumping motion, then went on to teach basic steps, saving more complicated moves, such as flips, for last (interview, 1999). Similarly, Robby described how his group did not have him dance with a partner until he had mastered the basics:

> They just basically taught me the steps by myself, not with a partner. Kind of how to go like that, you know, jerk—basic steps. So I caught on really quick and they're like, "OK, let me see you try to dance with me." . . . I wasn't good when I first started. I wasn't catching on really quick. I would kick up my legs, and you're not supposed to kick up your legs; you're supposed to kind of lift them rather than kick them up. They would teach me little things, like, "don't kick up, lift them up"; "put your legs closer to mine."

Shannon told me about the progression of steps she took in learning the dance: "It wasn't anything formal. I just said, 'Well, teach me how to do that, I want to learn how to do that,' and they'd start with the simple moves like jumping and rhythm with the shoulders, and then it gradually got into performances."

Sandra Franco remembered that at first one girl was in charge at Tucson High practices, but later everyone would butt in with comments. They would watch each other out of the corners of their eyes, and if someone was not synchronized, they'd say, "You're not with us," or "you're not on the same beat." Other common corrections were that someone wasn't jumping enough; that a girl was twisting when

going across the guy's back instead of holding herself straight; that a guy was throwing his partner too hard, or that the girl was landing wrong (interview, 1999). Darma Pérez noted that she began exercising more when she joined her school's dance group because of the high level of endurance the very aerobic quebradita requires (interview, 1999).

Just as there was an accepted system for teaching quebradita in Tucson, a core set of steps would also be taught, although this body of material was in no way fixed and was always being augmented. Simonett calls the most basic step the vaquero ("cowboy"), probably known by every quebradita dancer throughout the Southwest. However, only one of the dancers I interviewed reported a name for this step. Robby knew it as the *viejito*, or little old man. The rest were only aware of names for the fancier steps, almost all of which were given descriptive titles. Most dancers were uncertain as to the origin of these names, but some reported that the naming was done by members of their own group. In Tucson, one popular step was called *el yo-yo*. In this move, the male lifts his partner horizontally and lets her roll down his arms to his feet in a way that imitates a toy yo-yo. They hoped she wouldn't hit her head in the process, though sometimes injuries did happen. José knew a step called the *blind* because it was reminiscent of a window shade being rolled up and down. According to his description, this step may be the same as the yo-yo, just called a different name by different groups. Another named step, described by Sandra, was known as *la media luna* (half moon). In this step, the man swings his partner halfway across his back and then brings her down on her feet, so that the path she takes is a crescent or half moon in shape (see fig. 3.1). In *el toro* (the bull), a step I heard mentioned several times, the male partner is on the ground with the woman standing above him, and she waves a handkerchief as if she were riding a bull. Ernesto was able to recall a large number of named steps, including *la llanta* (the tire), *la rueda* (the wheel), *sesenta y nueve* (the number 69), *la luna* (the moon), media luna, *piolita* (little rope), *la "V"* (the letter V), *el uno* (number one), and *la patadita* (the little kick). Robby remembered a step involving a lot of hip movement called *la culebra* (snake), and Professor Díaz de León stated that this particular step came from Cuba (interview, 1999). In fact, the step received its name from a song that was originally made famous decades ago by Cuban singer Beny Moré and that was re-recorded as a

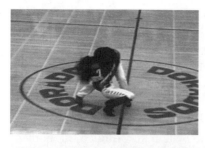
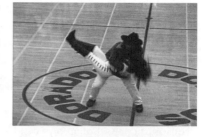
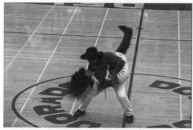
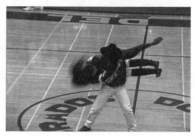
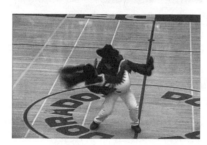

Figure 3.1 Members of the CDO Quebradita Club perform the step called *media luna* during halftime at a basketball game. (Filmed by Darron Butler; used with permission)

quebradita in the 1990s. In Los Angeles, dancers recalled fewer named steps, though Siris Barrios reported *el borracho* (the drunk) and *el burro* (the donkey) (interview, 2005).

Dancers transmitted these steps mainly from person to person, but they also learned other steps by watching popular bands and mass-media products. All of the Tucson dancers and many Los Angeles dancers I interviewed mentioned using steps they had seen on television. Although Sandra learned mainly from her sister, the sister would use her as a partner to try out the new steps she had seen on TV. Most, however, asserted that their principle source of quebradita steps was their own imaginations. Darma said, "You know how the rhythm of the music is like—Oh!—and you come up with a step." Robby, stressing the visual over the auditory, invented steps in the following way: "I

would go home and stand in front of the mirror—believe it or not, I have a mirror on my closet—and my cousin would come over, and we'd dance, or [my partner] would come over and we'd make up steps, try to be original."

In the interviews, my consultants revealed a surprising variety of sources of and inspirations for the dance steps they used. Ximena and Sandra noted that their group incorporated many steps they had learned as folklórico performers into the quebradita by simply changing the tempo or hopping more. In fact, Ximena saw their prior experience in folklórico as being the group's principal strength because it gave them useful knowledge about choreography and performance in general. Sandra also stated that some quebradita steps came directly from North American country line dancing. Ernesto agreed: "We even had the Electric Slide in there! In the quebradita, we had it in there. Yeah, [it was something we added ourselves], but it looked good." In Los Angeles, too, country-western dancing was an influence. One quebradita line dance was even given a name: El Borracho de El Paso (the Drunk from El Paso) (Quintanilla 1993). And Siris surmises that the quebradita's exaggerative qualities are a result of the influence of hip-hop, which was extremely popular in Los Angeles at the time as well and also prefers large movements over small ones.

Many of the dancers I interviewed also found close ties between quebradita and swing dance. Ximena described some of the flips as being almost identical. Ernesto felt that one possible influence on the dance was "like the fifties, the twist, how you pick up the girl and stuff like that. I look at it, and it's the same thing as in quebradita. It's the same thing. Swing, like that. Under the legs and all that, the same thing, but different songs." An article in *Smithsonian* magazine noted, "Like most American fads, the swing-dance revival started in California" (Stewart 1999:74). The quebradita, too, either originated in California or was popularized there, so it is likely that some crosspollination between the two dances did occur.

Although the invention of steps could be done individually or in groups among quebradita dancers, choreography was, by most accounts, a collective effort, everybody having equal right to contribute steps and ideas. Only Ernesto choreographed routines entirely on his own and then taught them. He first had to choose a song, though. "The best songs are the fast songs, oh—they'll get you into it! Those are the ones I would pick . . . the ones that have a good rhythm, that

make me get into it, dancing." Once that was done, "Well, first I would do it by myself, make dances by myself, and after that . . . they were in couples, and I'd put the music, and I'd show them step by step. 'This is the first step to this rhythm, and keep on doing that.' After every rhythm I would do different steps, and I'd teach them step by step. But it was quick . . . they had it, they liked it, they wanted to do it, so they helped me a lot. I had trophies and all that, but I gave it to them. I thought they earned it."

Ernesto later stated that the main criterion he used to judge which moves he would use in a particular dance was how well they fit the rhythm. José agreed: "They [the dancers] would just try to make sure that [the step] went with the same rhythm [as the song they were using]. And it depends: if the music changes, they would kind of change. And they would go and rewind and rewind, so it would go the same. They would go with the song." Shannon described some other choreographic considerations:

If we did a performance to a song—I don't know too much Spanish, but I would try to translate it. If I didn't know, I'd go ask my parents. I wanted to learn. The moves just had to fit the rhythm. We had one song that would start off slow, so if it's slow you want to be more with your partner, and you want to be closer to your partner. If it's fast, you want to be individual—fast beats and neat moves. Then when it would hit the height of the music, that's when we would do our flips. We'd usually end it [with] one move that we would synchronize—all with our hands out, or something like that.

In this CDO group, the routines took shape spontaneously and were composed by consensus. Robby described their creative process:

We would all say, "OK, go home, make up a routine, come back, and we'll see whose ideas are better." . . . We'd come back to practice, and we'd be like, "Hey, check this out, we did this." And everybody'd be like, "Oh, that's pretty cool. You know, I like that. OK, you guys can do that." We would even make up solo things. It's hard. It's really time-consuming for everybody to catch on, and the way we liked to perfect things was very—it took time, a lot of time. None of us had jobs, so we had all the time on our hands after school. It's hard work but if you enjoy it—there's nothing that can buy that, you know?

The routines would sometimes change in response to the quality of the performance. José recalled:

> They would make up the dances—they would be dancing and they were like, "Oh, why don't we include this, or why don't we do this here," and then we all, they would be making it up in their minds, and they would be like, "Oh, and then we're all in a line, and then you come and do this and this." I mean, that's how they got formed. At the end there was this whole routine that we had to do. And it was never finished. It was never, ever, because even at the last minute, they were like, "Oh, we should do this." In some of the dances I remember that if somebody messed up, the very good ones would at the end do something that they weren't told. They would do harder things just to make the thing look better.

As outside observers, both Marcela and Darron commented on how difficult it could be to make artistic decisions in a communal fashion. Marcela observed that some students were natural leaders, but some were shy. Disagreements would arise, but they could usually be resolved if a dancer could show why his or her particular step was better. Arguments would occasionally go too far, and dancers would leave the group, but they usually came back just because they loved the dance. Darron remembered, "They had so many creative ideas, all of them, that consequently, sometimes, they'd butt heads a little bit because they thought, 'We should do it this way, we should do this move in this way,' . . . when all ideas were actually pretty good." Darma, too, remembered group members even getting into fights over dance steps when one felt another was not performing a move correctly. It could be frustrating to work with people who were at all different skill levels and learned at different speeds. Still, problems generally were resolved sooner or later, and the dancers I interviewed felt that it was overall a positive experience to work together as a team.

A number of factors contributed to variation in quebradita steps and style, including region, gender, and total number of performers, although opinions differ on these issues. In California, some dancers gave different names to the different varieties of the dance: quebradita is the style that involved more acrobatics, whereas caballito or brinquito is the less athletic, trotting step (Simonett 2001:68). Lucina feels that in California quebradita became more of a partner dance than a

solo *zapateo*, which was more popular in Mexico; basic steps in both countries were the same, but U.S. dancers incorporated a greater variety of styles. For David Padilla of Los Angeles and Nayarit, caballito and brinquito were simply styles that were more popular in Mexico than in the United States. He recalled, "In Guadalajara, caballito was extremely popular. . . . My friend was from Guadalajara, and he said, 'I can move the girl in three steps to the other side of the room.'" The object of this style of caballito was to cover a lot of space and "make the girl and yourself fly" (interview, 2005). Lucina, too, danced this style in Guadalajara, using "long steps, a lot of space, a lot of jumping," and she agreed that there it was called either "caballito" or simply "banda," but never "quebradita." Sol Porras also remembered seeing a dance called "caballito" in Nayarit before seeing "quebradita" in Los Angeles, and caballito did not involve the flips and tricks for which quebradita was famous. She also noticed differences between banda dance styles in different Mexican states. In Nayarit, cumbia has a greater influence, so the dance movement there is "jumpier" and more eclectic, even including hip-hop-style "freaking." In Sinaloa, traditional corrido styles predominate.

In Tucson, distinctions were not usually made between caballito and quebradita, although different regional styles were recognized. In Robby's opinion, the dancers he had seen in Mexico tended to rely more on preexisting steps, whereas dancers in California were more competitive and more likely to use original moves. Ernesto also noticed differences between dancers in Jalisco, California, and Tucson:

> [In Guadalajara] it was a different style . . . different moves and stuff. I mean not to picking up the girls and stuff, but by themselves, you know, their own thing, their own rhythm. 'Cause one night, I went to visit my family . . . and they took me to this club called the Chero, and I went out there, danced the cumbia, and, you know, everybody was dancing like the same, you know, in the cumbia, and everyone was looking at me cause I was dancing different! I was like, 'Oh my God! What am I doing!' It would just be different styles, a different move, how they would move would be different. If you were to see a person from California dance next to a Tucson person danc[ing], you would notice that. They would do a different move, dance a different style. Probably—[in] Guadalajara, it's probably more wild there.

Professor Díaz de León also commented on the unique nature of Arizona-Sonoran dancing, stating that the partners' positioning is different, with the man's leg between the woman's, helping to push her along. This can be contrasted with the postures Lucina remembered from Jalisco, where the partners' temples would be pressed together, or they would hold each other with one arm only, letting the other hang and moving that shoulder up and down in a new style introduced in Guadalajara in the early 1990s.

Gender may be another variable that contributes to differences in steps and style. Only men usually perform hat tricks, for example. However, perceptions of gender roles in the dance vary. In Marcela's opinion, steps for the two sexes do differ because men take the active, leading role—they are the ones who flip the women. This move is occasionally performed the other way around, but that is the exception and not the rule. Also, although both sexes may perform the same steps, each executes them in a different way. Marcela found it difficult to describe these differences; the girls simply have a more "feminine" style, whereas the guys are more "macho." For example, women might use swaying hip motions, whereas men might focus more on showing off their fancy footwork or hat tricks. Furthermore, although women may sometimes perform moves with a masculine appearance, Marcela had never seen a man dancing a "feminine" step. Shannon felt the differences between gender roles were of little importance. The only time she found moves for men and women to differ was during the flips because her group never had a woman lift a man. In her opinion, the equality of their roles was essential: "Even though we had separate moves, we never put emphasis that the guys are better than the girls, or the girls better. . . . In dancing, we were equally good, we each had something to offer to the dance. And that's important, that we made everyone feel that they were equal."

Ximena, too, noticed that men were typically the ones to do the lifting, although she recalled one unusual step invented by her group in which the reverse occurred. Ernesto, however, described the steps as being completely the same for both men and women. In fact, in the videos I saw of his group's performances, I noticed that women took a more active role than they did in some of the other groups I observed, flipping the men as well as being flipped themselves. His group occasionally performed dances they created for only men or only women, but "it was the same steps—we could have done the girls' dance, and

they could have done our dance. It was the same thing. The only difference with the couple was that we'd pick them up and throw them around and spin them around." Reporters, too, commented on the fact that in quebradita, unlike in most partner dances, "even the women get to lead" (Apodaca 1993).

Ernesto was the only dancer I spoke with who danced frequently to live music. He found that this experience was quite different from using recorded songs and affected their performance: "With the recorded music we would know what steps to do already. Like, to the music. How to start and how to end it. And with the bands, we would just do our own thing. . . . We'd talk to each other while we're dancing, Let's do this, let's do that. . . . We would name them—let's do this one; let's do 'media luna,' 'la V'—one, two, three, and we would do it. That was the only difference. With recorded music we would know what to do at the beginning and what to do at the end."

A fourth and final factor that affects the steps one chooses to perform is whether the dance is to be done as individuals or in couples. José felt that dancing with a partner was more difficult because "with a partner, the guy is supposed to lead. So if you mess up, it's the guy's fault." Furthermore, he found that the style of the steps were different because "when you're by yourself, you don't jump as much. When you're with a partner, you kind of jump more, [to] bring your partner up." Ximena, however, felt that the woman's steps are the most difficult in partner dancing because she has to be able to trust her partner completely while performing steps that put her at great personal risk. Darma preferred dancing without a partner because of the greater variety of steps available to her: "By yourself you can do different steps. You move your hands more, and your head, and you move your legs, you do different things with your legs." Ernesto seemed to agree that dancing on one's own offers more freedom, whereas with a partner, communication is key: "By myself, I know that I have nothing [I need] to worry about, so I would check everywhere I would want, and just be into my own mood. With a partner, I try to just be in front of her, and I'll be dancing my own moves, but try to tell her to do the same moves as me. . . . But I wouldn't just do it, you know, I have to tell her."

Marcela remarked on how these considerations affected the Tucson High group's choreography. When dancing as individuals, the group strove for a unified look, so that everyone would turn the same

way at the same time. When they danced in couples, their steps were more complicated, so it was too difficult to try to keep everyone facing the same direction. Sandra commented on the relationship between this issue and group choreography. Personally, she felt that the use of partner dancing or individual dancing should depend on the music's tempo; it is more appropriate to dance separately in the slower songs.

I asked all interviewees what qualities make one a good quebradita dancer. I received a variety of answers, but the concepts of creativity, originality, and enthusiasm were repeated in many responses. Marcela answered in a general way, enumerating characteristics valuable for performers of any style. She divided the important qualities into two groups: "Physical qualities: for technique, energy in the execution of the steps, dexterity of movement, grade of difficulty of the steps. Innate qualities: passion for dance, projection when dancing, union of rhythm and feeling when performing the dance. The conjunction of these two areas makes what we call a good dancer" (e-mail communication, 1999b, translation mine).

Others relied on traits specific to the quebradita in their judgment. Ernesto, to illustrate the features he found key, described how his favorite dancer, El Pato, moved: "Every step, every move he'd make, it would go with the song, and it would catch my attention. It was also different from everybody else, it was a different style that I didn't know and I liked it a lot. He had fun out there. Every time he would go up to dance, they'd make a circle around him, and he was the center of attention. He'd do his thing and I loved it. He would dance with a partner but sometimes the crowd would go so wild that he'd just be dancing alone, making his own thing."

El Pato had both originality and a commanding performance style, but Darma remembered how another dancer known as El Diablo was admired for his agility: "Everybody knew him, and all the girls tried to dance with him. He used to be so good. He wasn't in the group, he used to go up there and dance with them, but they let him because he was really fast." Ximena judged quebradita groups on the quality of their moves. A dancer may be considered good if he or she has the ability to perform difficult moves, she noted, and has a good feel for the music. Sandra focused on personal qualities because she believes that good quebradita dancers must be very patient and creative. They should be good listeners and have a good ear so that they are able to keep up with the rhythm. They should also be visually

oriented so that they can learn from watching people dance at clubs. However, they should not just do the same steps they see others perform, but should be able to improvise and come up with their own. José's response also focused more on attitude than on technique: "I guess you have to like it and really enjoy it, and be happy with it." Although one criterion Shannon used to judge dancers was the quality of their moves and flips, she felt that an even more important criterion was "your passion, when you *get into* it, you know; not just doing the moves, but really *doing it.*" She also commented, "Lots of practice, that's all it takes. Dedication. It's like anything else—if you want it, you gotta work hard for it."

Robby's answer was the most comprehensive, taking into account technique, dedication, attitude, and originality: "You have to be very energetic, for one. 'Cause all it is, is a bunch of jumping. You have to have a lot of energy. And—[long pause] practice. When I started, I didn't know anything, but I really wanted to learn really bad, so I caught on. It just depends if you want it. If you enjoy doing it, you'll learn, regardless. And, be coordinated, I guess! I don't know. Energetic. . . I think if you like it, you'll learn." He went on to describe the importance of developing one's own style:

> Everybody dances different. Nobody dances the same. I've never danced with one girl I could say dances just like another one. Everybody's different. Everybody has their own style. I have my own style, and then there's some people that have other styles. . . . I would always try, our club would always try to be original in everything that we did. When we would perform, we'd see other people start doing these steps, [and] we're like, "Man! They copied us! We did that first!" So I think originality is a big, important thing. You have to be original.

As an example of a good performance, he described a particular moment that stood out in his mind:

> I remember one time I went to a *quinceañera* [a coming-out party for fifteen-year-old girls], and it turned into a competition. My friend Juan and his girlfriend, Lisette, were competing with these others, it turned into a competition. They were both dancing on the floor, and it was another couple from Phoenix we had never seen. And they were just awesome. Their flips were perfect, he

would hold her up in the air and she'd fall perfect, flipped around, and they'd [continue to] dance. It was beautiful. They had practiced a lot. Practice makes perfect! I was just like, "Gosh! They're good!"

Coordination, energy, and creativity were thus key, but the most important thing was simply to give it a try, as Robby told me: "There's no certain way to dance. Everybody dances different, just with the beat, we would just go; people would . . . do whatever just came from our heart. Just do it. Just dance."

Dancing lo Ranchero

Quebradita's linkage to lo ranchero through dance steps is achieved in several ways. Helena Simonett writes that "the concept of lo ranchero" is "embodied" in the quebradita dance. She notes that steps such as "the horse tail, the rope, and the basic vaquero (cowboy) step . . . symbolically represent the ranch life" (1996:46). Aside from the rope (la piolita), I did not encounter these particular steps in Tucson, but I did find others cast in a similar mold that created the same symbolic linkages. Many dancers I spoke with described el toro, a step representing a rodeo event. Hat tricks are also an important—and very difficult—part of the dance. Hats may be spun, thrown, flipped around, and caught on feet, hands, or head (fig. 3.2). These tricks draw attention to the cowboy- or tejano-style hat worn by the performers. As mentioned previously, usually only men perform these feats, although Ximena recalled one female member of her group who was quite good with a hat. The hat tricks were by her description some of the most difficult steps, and they did not always work out as planned because it was quite difficult to keep the hat spinning. José agreed with her assessment: "I was very bad at that. When I would throw it [the hat], I would throw it a very little bit so it wouldn't fall." A less typical addition to the dance, and one I never saw in person, is a lasso: in one quebradita movie, a man performs figures with his rope while dancing with his partner (New Form 1993). Furthermore, as I have noted, the dance as a whole, or a version of it, is sometimes known by the alternative term el caballito, or little horse, because the female partner often is in a position where she is "riding" her partner's leg like a horse.[14] Some have even suggested that the name "que-

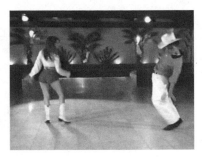

Figure 3.2 Quebradita hat tricks as demonstrated in
the dance instruction film *Pasos de la quebradita II*.
(© 1993 JC Films; used with permission)

bradita" refers not to "breaking" the female partner in back-bending
feats, as is usually supposed, but to the "breaking" of a wild horse.

The symbolic representation of the good old life in Mexico is
achieved not only by including steps that evoke ranch life explicitly,
but also by drawing from other Mexican dances familiar to many
observers. These traditional steps serve as indexes, showing those who
are "in the know" that the quebradita is a continuation of those older
traditions. Steven Loza describes the quebradita dance style as "a
hybrid of cumbia, norteño/Tex-Mex, and zapateado" (1994:55–56). It
is true that when danced with a partner in its simplest form (no flips),
the quebradita does resemble an up-tempo norteño-style polka, espe-
cially in its positioning of the two partners. In both dances, the part-
ner hold is like a modified ballroom embrace, though much closer
than that used in European-style dances. Some differences are that the
female's left arm wraps around her partner's shoulders so that her
hand rests near his neck rather than on his right shoulder,[15] and his
right hand is usually lower on her back. (This hold was in one case
reported as the main feature that differentiates quebradita from other
Latino dances [Apodaca 1993].) The held hands are not kept at a fixed
height, but are moved around improvisationally, sometimes accent-
ing the rhythms and sometimes dropping entirely. Finally, the wom-
an's right leg is sandwiched between the man's two legs.

Professor Díaz de León commented on the importance of this
latter position: "The dances of Chihuahua and Monterrey don't have
the same movements as in the state of Sonora; they don't dance in the

way they dance here." The embrace just described is one feature that distinguishes the Sonoran style from other regional styles: the woman dances much closer to the man and with her leg between his. For this reason, Professor Díaz de León felt that the quebradita had to have ties to the Arizona-Sonoran region. He described the principal characteristics of the dances of this area:

> The movement is that the man puts his leg between the woman's legs and pushes her, but pushes her along with the rhythm. It's a very fundamental Sonoran characteristic because it doesn't exist anywhere else. It only exists here. For example, in Baja California Norte, they want to hold her, but they shake her a lot. And it's a natural thing. The woman is held at the waist, then the leg is placed in between, the right or the left, and she is pushed along . . . that's where the quebradita movement comes from, but it isn't the quebradita. It's a natural movement of the dance from here in Sonora.

Marcela, too, noted a commonality between quebradita and older border dances, though she did not tie it to one specific state. Other dances from the border states of Sonora, Nuevo León, and Chihuahua are also characterized by jumping, and she has even seen the "wind-milling" motion of the legs in other dances of this region. Díaz de León emphasized that the quebradita was a combination of *lo mexicano* and *lo chicano* (Mexican and Mexican American) that grew from corriditas, a type of norteño dance popular in Sonora. The only difference is that "uno quiebre más . . . se dobla más, entonces eso es lo que sucede, por eso le llaman la quebradita" (one breaks more, bends more, so that's what happened; that's why they call it the quebradita). CDO's José Hunt also noted that quebradita dancers "took a lot from" corriditas, but that quebradita received a new name because "they do a lot of other things, and they actually 'break' the girl." And I have already related reporter Carrizoso's hypothesis that the quebradita originated in Sonora (chapter 2). Some corriditas aficionados, however, might not see the similarities. Daniela Ayala is an avid and able corridita dancer, but she finds quebradita style strange—too fast, too jumpy (interview, 1999).[16] Dancers in Ventura County, California, told a *Los Angeles Times* reporter that the quebradita was "a recycled version of an old dance step once popular among farm workers in Mexico" (Davis 1993). The article did not elaborate, and it is not clear what

dance is meant; however, the statement indicates that there is at least a perceived connection between the quebradita and older dances.

By using steps suggestive of more "traditional" dances and by focusing attention on the cowboy hats and boot-clad feet, quebradita symbolizes ranchero values and the ranchero lifestyle for its observers and practitioners. It does not fit neatly and exactly into the ranchero mold, however, because the quebradita embodies much more than lo ranchero. It embodies all of the available and sometimes contradictory influences the dancers encounter daily in the southwestern United States: Anglo American and African American as well as Mexican American, traditional as well as modern. It synthesizes aspects of each culture into a unified whole and at the same time symbolizes the highly diverse yet often disconnected world most North Americans— and in particular bicultural Americans—inhabit. *World Music: The Rough Guide* describes the dance as "a gymnastic combination of lambada, polka, rock 'n' roll, rap and cumbia" (Farquharson 1994: 546). In his guide to tejano and other Mexican music, Ramiro Burr adds country-western and flamenco to the mix (1999:58). Other probable influences include popular hip-hop and swing steps. All of these connections point to quebradita's inclusive nature, where Mexican and North American steps are interwoven, just as are the Spanish and English languages in everyday speech.

Many of the dancers I interviewed were familiar with dances from the folklórico repertoire because, for many of them, participation in quebradita clubs and in their school's folklórico dance troupes went hand in hand. They admitted that ballet folklórico had influenced and contributed to their quebradita dancing, but they also mentioned listening to and dancing many other styles: cumbia, merengue, salsa, rock (José); merengue, salsa, cumbia, norteña (Darma); jazz and modern dance (Sandra); top-forty dance music, mariachi, hip-hop, and salsa (Robby). Most of them expressed interest in doing any kind of dance at all and noted that they would listen to almost any kind of music. As Robby put it, "there's not much type of music I don't like. I think you can be creative with any kind of music." As noted earlier, the sources for their dance steps were just as varied as their musical preferences. With such eclectic tastes among quebradita dancers, and given the importance they conferred to creativity, it is no surprise that the dance combined so many different influences.

As stated in *The Rough Guide*, one might expect cumbia, the

originally Colombian music that is now an important part of the norteño repertoire, to have played an important role in the creation of the quebradita because the two styles of music are closely related (see chapter 2). Cumbia influences may be observed particularly in solo dancing. In fact, some quebradita groups, such as Tucson High's El Movilito, performed slower-tempo cumbias as well as quebradita. In the border area, the cumbia is danced in a special way, different from the way it is danced in Mexican states farther to the south. In Arizona, for example, when a cumbia is played at a dance event, couples split apart and make their separate ways counterclockwise around the floor (see Sturman 1997). Cumbia movements tend to be more subdued and sinuous than those seen in, for example, polkas. In this sense, the style is quite different from the fast, jumping movements most often associated with quebradita. However, José Hunt noted that even in quebradita different steps are used when dancing separately from one's partner: "Quebradita dancing is a lot of jumping. But when you're by yourself, you don't jump as much. When you're with a partner, you kind of jump more, to bring your partner up." He went on to describe some of the differences between cumbia and quebradita dancing: "Cumbia is more for you to dance and feel good; the rhythm of the music . . . you do it slower; you can do it fast, but it's not as fast as quebradita. Quebradita, you have to be very fast. Cumbia is just slower, and I think you enjoy more the music." Shannon thought it was easier for her to learn quebradita because she had so often danced cumbias at family affairs such as weddings, but she noted some differences between the two: "The cumbias and quebraditas are all bouncy, a lot of jumping, you know, so that's where I pretty much learned it from. [But] I think that cumbias are more . . . restrictive, not too much jumping [like in] quebradita, and . . . I don't think in cumbias there's flips." Sandra felt that quebradita and border-style cumbia must be related because she noticed that in cumbia in Tucson and Sonora everyone moves in a circle together, whereas in Mexico City cumbia is more of a partner dance, with the male partners turning the female.

Zapateado is another important part of the quebradita. It is the fast, stomping footwork associated with the sones of rural Mexico, particularly in the western states, and it both resembles and is distantly related to Spanish flamenco dance. Some researchers define the Mexican son specifically by its relation to this dance style (Sheehy

1979:18). The steps vary region to region, as does the son's music, and they are used in traditional social dances (Pearlman 1988:237). Lucina, who today teaches traditional *son abajeño* (lowland son) dancing in the Bay Area, notes that zapateados are always danced at weddings in Jalisco, and "guys . . . all of a sudden feel macho" when they dance sones, sometimes miming that they are holding a gun. This fact, combined with the son's association with western states such as Jalisco, where the tecnobanda sound was born, made the zapateado a natural fit for the quebradita.

Very good quebradita dancers sometimes perform solos, during which this kind of fancy footwork takes over, although the zapateo is a bit different than that of folkloric dances. In one of the many films that banked on the quebradita's popularity, *De la quebradita una probadita*, a character explained, "Es que la quebradita se baila con el zapateo fuerte, pero sin golpear. Es como si estuvieras acariciando el piso" (The quebradita is danced with a strong zapateo, but without striking [the floor]. It's as if you were caressing the floor) (New Form 1993; see chapter 4 for more on this film). Lucina claimed that in banda style the feet slide more and make a continuous, unaccented rhythmic pattern, unlike the more precise rhythms of the traditional abajeño style. Also, the zapateo does not incorporate hip-hop or any other foreign influences, as the quebradita often does; one California dancer remarked that the zapateo could not be changed because "it's the imitation of the way animals dance" (quoted in Simonett 2001: 290). Though this explanation is unusual, it illustrates some dancers' views on the zapateo and its use as a symbol of unchanging "tradition." Kicking, windmilling of the legs (a movement called *helicóptero* in Los Angeles), and percussive use of the requisite cowboy boots are all important features of a solo performance, and the faster the better. Ernesto remembered a particular dancer from a Nogales group who had impressed him, and he later showed me a video of this man's solo performance, which exemplified the qualities of an accomplished quebrador: "They were three couples and a short, fat guy. But he was pretty quick, I liked how he danced. He didn't have a partner, just by himself the whole time. The crowd would go, 'Wow!' when he would start dancing. They would cheer for him a lot."

If the cumbia is for "dancing and feeling good," few would disagree that the quebradita's primary purpose, or one of them, is competition. In this respect, Marcela Cárdenas offered another possible

source for the quebradita. In the *mezquitón* dance of Nuevo León, two dancers challenge each other to do ever more complicated moves, much as in a quebradita event. In addition, performances of the mezquitón by folklórico groups generally exhibit higher kicks and more jumping motion than do Jaliscan zapateado styles—traits that, it has been noted, also characterize the quebradita. Los Angeles–area dancer David Padilla also recalled performing a competitive dance called "cachongo" in his home state of Nayarit. So this feature, too, may tie the quebradita to more deeply rooted regional traditions; at least, dancers' use of such steps indicates a desire to create such a link.

Quebradita Dress: Costuming lo Ranchero

Clothing is the most obvious and most powerful single symbol in quebradita. Popular music theorist Simon Frith writes, "Pop offers identities less through shared experience than through shared symbols, a common sense of style" (1988:475). The statement certainly is true of 1990s quebradita club culture, in which clothing style was a defining characteristic. As one reporter noted, "banda has become a way of life with a fashion and an attitude all its own," and "banda style is a big part of life" for quebradita club members (Johnson 1994). Again, the clothing associated with the dance is a visible connection to the ranchero aesthetic, making the quebradita dancer analogous to a Stetson-clad norteño musician and to a mariachi in a *charro* suit. Clothing iconography is more literal than the symbolism of the music or the dance steps and therefore is more easily understood and more accessible to diverse audiences. The costumes worn by quebradita performers were influential in terms of increasing the dance's popularity, improving the quality of performance, and contributing to artistic expression.

Quebradita club members in Tucson usually had matching costumes, which they bought or made themselves specifically for performance purposes. They purchased most items inexpensively at the swap meet, which was also a performance venue. According to Sandra, many groups held fund-raisers to help with such purchases. Tucson High's El Movilito held a car wash, and the CDO group organized carne asada meals, although the latter group, Shannon told me, used "pretty much just things out of our closet that we could all relate to" in order to avoid devoting too much time to fund-raisers. Bright colors

and lots of denim were the norm across the board, and everything was Western style. Because Ernesto had danced at a professional level, he owned several different costumes, each made for specific performances. His used even flashier fabrics such as silk, lamé, and other metallics. None of the dancers I spoke with dressed in Western clothes in their everyday lives, so the costumes helped to mark the dance as something out of the ordinary. In contrast, Simonett notes that many dancers in Guadalajara wear their "cowboy gear" during the week (2001:64).

Most teams decided on their uniforms by consensus, much as they decided on music and steps to use. José described the male members of the CDO group as wearing "normal things" such as black jeans and cowboy hats, but the female members bought special matching boots. Darma remembered that she and the other female Diablitos wore denim skirts with shorts attached inside, thigh-high white boots, a Levi's vest, and a fringed white shirt; the men wore denim shirts, boots, hats, and jeans they prepared themselves, with fringe and their nicknames along the side of the pants or on the back of the shirt. Sandra described her group as having pants in colors to match the Mexican flag; short-sleeved, fringed blouses with the group's name on the back in the same colors; a similarly personalized fringed handkerchief; boots; and hats for the men. Ximena added that the dancers' nicknames were embroidered on one leg, and she described the fringe as being typical for quebradita groups because it moves with the dancer and therefore looks good in performances, further emphasizing the movements. Boots, Shannon told me, were used "to express more of the leg movement." The bandanas Sandra mentioned were decorated with the Mexican flag and tucked into a pocket. They had a piece of leather along one side that was embroidered either with the buyer's name or with the name of the Mexican state from which his or her family came, and they could be purchased in most stores or at the swap meet. Leather straps engraved with the names of Mexican states were known as *correas* (Quintanilla 1993); newspapers also reported the addition of *cuartas*, small horsewhips hanging from a belt or a pocket. These latter accoutrements are visible in films about quebradita, but they appear to have been more popular in California than in Tucson. One other optional item was a *cinto piteado*, a leather belt woven with natural fibers (Martínez 1994). Marcela, an advisor to Sandra and Ximena's dance group, added that

sometimes the girl students would take steps to make their costumes more revealing, such as tying their shirts up. Los Traviesos are the exception to the rule of consensus in deciding on costumes in that Ernesto alone designed all his group's outfits on paper, always using fringe on both shirts and pants.

Quebradita wear in Los Angeles was very similar, although special performance costumes seem to have been less common there. Instead, dancers overwhelmingly mentioned boots as the most important part of the banda look and lifestyle. About growing up in Watts, Siris Barrios recalled, "Back then, if you wore boots, you *wore your boots.* No matter what you were wearing. I wore boots to school with my dresses!" Huaraches (typical Mexican woven leather sandals), she added, became popular at the same time. David Padilla also remembered seeing cintos piteados, tejanas (cowboy hats), and suits worn regularly on the streets: "it was very much a statement." Wearing the banda style also was important for the selection of dance partners: if one hoped to attract the opposite sex, the appropriate clothing was essential. Banda fan Oriel Siu explained, "As a woman, it turns me off if they're not well dressed. . . . I will not dance with anyone who is not fully [attired in banda style]. If they're wearing sneakers at a banda club, no. It just says to me that they're not taking it seriously" (interview, 2005). Siris added that many feel that those who don't wear the hat and boots "are not respecting the music; they're not honoring that space." David agreed: he would always choose a dance partner dressed banda style over even a very beautiful woman who was not. A good look for a woman, in his opinion, included boots, tight jeans, a quebradita-style blouse, and perhaps a cinto piteado, with a bandana hanging from the belt or pocket. He himself wore a hat when dancing quebradita, specifically a Diez Estrellas Resistol hat (a weather-resistant Texas brand), and even though Western wear was not typically used in daily life, he, too, wore boots to school.

Another especially unique style of quebradita wear was also found in Los Angeles in the mid-1990s. In South Central in particular, gang culture and cholo style influenced the type of clothing worn by members of dance clubs in the area (I explore this topic more fully in chapter 4). Club members would wear airbrushed T-shirts they had custom made at the swap meet to include the club's name, their own name, and club logo, which might include a Mexican eagle or flag colors (Jesús Molina, interview, 2005). Former cholos also kept their

baggy pants, but added boots for dancing quebradita. Women, too, combined cholo style with quebradita wear: "They would wear the tight blouses, and . . . these tight pants [that] were cut really short, to make them as short as you could, and you wore your boots, and the little *chalequito*, the little vest, and their hats and . . . the little bandanas hanging with whatever state they were from," Siris explained.

Thus, the most important elements in quebradita costuming were boots and hats, allusion to Mexican origins, and jeans or full Western suits (the former more common in Tucson, the latter in California). The use of nicknames was also important for particularly active Tucson dancers, and fringe was essential for performance, as was a uniform appearance. One might wonder at the emphasis placed on uniforms in a dance that at the same time places so much stock on individual creativity. However, Marcela remarked that none of the Tucson High dancers ever really looked "the same" as the others. Although they all wore the same colors, each dancer still expressed his or her individual style through the unique way he or she wore the clothes or styled his or her hair. She saw this individuality as a distinct contrast to the aesthetic principles of classical dances, such as ballet, in which every dancer must wear his or her hair in the same way; even folklórico groups generally stress uniform hairstyles. Just as car cus-tomizers minimize their vehicles' mass-produced nature by making them into "unique objects of desire" (Bright 1995b:106), so did que-bradores create individual variations on club uniforms. These uni-forms were important for another reason as well. Darron, the mentor to the CDO group, commented, "They had to have uniforms. They had to have them match—you know, as it turned out, it was great. You know, I never really gave much credence to it, though I saw them when they, and how they performed it—they felt good about it." The purchase and use of special clothing marked the performance and the dancers themselves as different, special, and more professional, thereby helping them to dance their best.

The matching outfits worn by the members of musical groups (norteño and tropical groups as well as bandas) were likely the in-spiration for the students' costumes. In addition to marking the musi-cians by region and profession, these outfits could be status symbols too because opulence increased along with a band's level of success. A local group might choose for all members to wear black pants, boots, and hats, and purchase matching shirts. But a nationally famous

group would have custom-made matching outfits, possibly made of some glittery fabric or entirely of leather or suede with leather fringe. The group's name or logo would often be stitched or appliquéd onto a pant leg or the back of the jacket. Other status features included expensive hats or boots in colors not found in the average person's wardrobe.

Professor Díaz de León attributed the dance's success largely to the popularity of this associated clothing style, particularly because of the macho connotations of the cowboy-style clothes: "it happens that the clothing gives an ideal image of the male, the man. Very manly. 'I'm very manly, because I wear boots, because I wear jeans.'" Jaime López, a radio announcer in Oxnard, California, agreed: "We Mexicans love to be seen as *bragados* [tough guys]. There are many Mexicans who want to be seen as tall, hairy-chested, and in boots and hat. So that type of ideology [expressed in the quebradita] fit like a glove" (interview, 2005). Both Díaz de León and Marcela Cárdenas noted that this type of dress ties the quebradita to the border region, where such clothing is typical, though López added that norteña clothing has never been so "marked." Clearly, banda clothing is the most visible tie to the ranchero aesthetic, in terms of both geographic identification and machismo. It contrasts strongly with "typical" middle-class daily wear: it is flashier, it is brighter, and it loudly declares its regional origin. "They [music groups] really project the image of the old vaquero [cowboy]," a Californian radio program director noticed (Miguel Angel Arenas, quoted in Johnson 1994). Among some Mexican Americans, however, and in Mexico as well, "an *arrancherado* (usually a *campesino*, not a dashing *charro*) is someone without *roce social*—a coarse, backward country bumpkin who is out of place in the contemporary world of urbanized, culturally assimilated Mexican Americans" (Peña 1999a:124). The powerful symbolism and sometimes negative connotations of the ranchero image are exemplified by José's comment that he was reluctant to join a quebradita club because he "didn't dress like people who danced that kind of music" (a topic further explored in chapter 5). These contemporary urban youths' choice to wear Western-style clothes was consequently a potent one that could only be intended to "negate the very society which in everyday structured life these Mexican Americans endorsed" (Peña 1985:47). As noted earlier, the choice of ranchera music and folklórico dance as a symbol by members of the "Chicano generation" served a

similar purpose. Quebradita clothing therefore conveyed the message of pride in language, region, and heritage that was so important in this art form.

Rasquachismo in Motion

As we have seen, the concept of lo ranchero is an extremely useful one in understanding some aspects of many Mexican American art forms, from conjunto to mariachi. The use of ranchero symbolism in quebradita enhances the perception of continuity with earlier forms of dance and is one way in which the dance's political work is accomplished. However, quebradita is also quite clearly separate from these earlier forms, as attested to by the negative reactions it has often elicited even in aficionados of other ranchero arts. Quebradita does not fit neatly and exactly into the ranchero mold because it embodies much more than lo ranchero. It embodies all of the competing influences the dancers encounter in their daily lives. It synthesizes aspects of each culture into one unified whole and at the same time perfectly symbolizes the confusing, conflicting world we all now live in, an existence often and aptly called "fragmented." This condition is an important part of the Mexican American experience and has been utilized by many Chicano artists. As some Chicano art critics have noted, "the frames of coexistence and paradox are part of the fractured and discontinuous experience particular to a people who live in a bicultural sensibility" (Arceo-Frutos, Guzmán, and Mesa-Bains 1993:52). In a kinetic equivalent of this fragmentation, quebradita dancers in the 1990s created a pastiche of popular culture in their movements by juxtaposing folklórico steps with the Electric Slide, swing dance with hip-hop. Suzanne Seriff and José Limón explain that the use of pastiche in Mexican American visual art is "a marker of allegiance to a cultural 'homeland'" that also aids in creating an aesthetic of difference. This aesthetic is easily distinguishable from that of the dominant society and is one that "helps create and define the concept of *mexicanismo*" (1986:40). In quebradita, too, pastiche helps to produce a readily discernible aesthetic marked by visible ties to Mexican culture.

In the 1990s, quebradita movements, clothing, musical style, and performance practice were such an affront to mainstream middle-class tastes that they provoked derision in a way that other ranchero

arts did not. Quebradita dancers took traditional expressions of the ranchero theme and went a step farther: to denim clothing and tejano hats they added bright colors and sparkling fabrics; they took folklórico footwork (zapateo) and added showy flips and backbends. The use of pastiche, glitz, and a working-class sensibility showed the dance to exhibit many of the characteristics of *rasquachismo*, a term coined by Tomás Ybarra-Frausto to describe a particular aesthetic in Chicano visual arts that relies on "hydribization, juxtaposition, and integration." He writes, "Very generally, rasquachismo is an underdog perspective—a view from *los de abajo*. . . . Although Mexican vernacular traditions form its base, rasquachismo has evolved as a bicultural sensibility among Mexican Americans. On both sides of the border, it retains its underclass perspective" (1991:156).[17]

This statement recalls Peña's assertion that música ranchera is an expression of working-class values that resorts to gritos por abajo to make its practitioners' voices heard (1999a:3). So ranchero and rasquache are alike in being working-class aesthetics, but rasquache is specifically and uniquely Mexican American. In the visual arts, Ybarra-Frausto explains, "[t]o be rasquache is to be unfettered and unrestrained, to favor the elaborate over the simple, the flamboyant over the severe. Bright colors (chillantes) are preferred to somber, high intensity to low, the shimmering and the sparkling to the muted and subdued. The rasquache inclination piles pattern on pattern, filling all available space with bold display. Ornamentation and elaboration prevail, joined to a delight for texture and sensuous surface" (1991:157).

The concept can be applied equally well in this case to the performing arts because dance also communicates with its audience primarily through visual stimuli. And it is no accident that quebradita was created by teenagers who in turn created their own unique subculture. Ybarra-Frausto states that rasquachismo is often best exemplified by "the disenfranchised subgroups within the Chicano community . . . the urban youth cultures, . . . [who] all present profoundly dissident attitudes at the superficial level of style" (1991:160).

Quebradita style contrasts strongly with "typical" middle-class clothing and dance styles: being rasquache, it is flashier and brighter, and, being ranchero, it loudly declares its regional and cultural origin (see fig. 3.3). Though most Mexican American youths saw these traits in a positive light, they were still loaded symbols, as evidenced by

Figure 3.3 Dancers show off their quebradita styles in the video *Bandas a ritmo de quebraditas.* Above, the quebrador "Califas" wears a custom-made shirt, while his partner exhibits a true rasquache style combining spangled shorts and bustier with thigh-high boots and a lace scarf underneath the tejana hat. At right, a tecnobanda and a quebradita dancer are depicted on the cover of the video. (© 1993, Ritmo Films)

José's initial negative reactions to the music and its clothing style. Like the zoot suit–wearing pachucos of the 1940s, whose flamboyant clothing was disdained both by Anglos and by conservative Mexican Americans (discussed further in chapter 7), quebradita dancers found that "even disapproval and notoriety were preferable to being ignored" (Luis Valdez, quoted in Gaspar de Alba 1998:64). In Tucson, quebradores (e.g., Ernesto and Shannon) were able to overcome many adults' (Shannon's mother and Marcela) initial distaste for the dance by virtue of their impressive dancing and their commitment to long hours of practice. But in Mexico and elsewhere, middle-class and conservative observers never found the dance acceptable enough to participate in it precisely because of its aesthetic qualities. Reactions

such as laughing at the dance, calling it "tacky" or *"naco"*[18] (both code words for class-based difference), or suggesting I study something "nicer" were clear indications that class conflict lay beneath aesthetic difference.

Class, Community, and Culture

As noted earlier, the essential components of lo ranchero include reference to rural lifestyles, machismo, opposition or cynicism toward wealth and power, and nostalgia for and romanticization of Mexico, and all fit into the banda-quebradita complex. Rural imagery is brought out through the dance, music, and clothing used in quebradita events. In addition, the banda music associated with quebradita is an expression of working-class values and opposition to the powerful and comparatively wealthy middle class, as discussed in chapter 2, and macho sensibilities are sometimes expressed at dance events through drinking and violent outbreaks like those mentioned in chapter 1. As Peña (1980) has also noticed, these same dance events proclaim their ties to the working class through the choice of music, food when available (tacos), and drink (generally beer only). Similarly, quebradita dancers in Tucson organized their dance groups in opposition to other musical or stylistic interest groups associated with the middle classes, and they performed in contexts such as rodeos and swap meets that further reinforced the working-class ranchero feel.

Taken together, the parts that form the whole of a quebradita event make a powerful statement of ethnic pride that can help to increase communal feelings among participants. The repetition of symbols and of the events themselves adds to their potency. It is this quality of repetition that caused Peña to refer to Chicano social dances as "ritual behavior" (1980:49–50). As he wrote of Chicano dance events in California, "*every* symbolic effort was made to negate the very [Anglo] society which in everyday structured life these Mexican Americans endorsed" (1985:47, emphasis in original). In the case of the quebradita, the flashier the "symbolic effort" was, the better.

Rather than contributing to interethnic discord, quebradita instead served to bridge the cultural divide in much the same way it symbolically bridged generation gaps within the Mexican American community by combining the old (sones and other folklórico dances) and the new (hip-hop, swing revival). One non-Latina *Los Angeles*

Times reader wrote a letter to the editor explaining how she began listening to a banda station to help her learn Spanish, but ended up hooked on the music. She added, "I'm no sociologist, but your concept of música de bandas as a force to bridge the race gap just may hold up. Anyway, it works for me" (Palmer-Lacy 1994). The dancers I interviewed stated that their audiences' reactions were positive even— or especially—when they were ethnically mixed. Their quebradita clubs also received much school support, and the members often served as ambassadors to other schools.[19] Both the CDO and Tucson High clubs had non-Latino participants. Notably, the negative comments I heard about the quebradita came only from middle-class Mexicans and Mexican Americans.

In addition, involvement with quebradita was the beginning of an increased interest in the Spanish language and Mexican culture in general for some dancers, in particular those who had grown up away from the culture. Robby asserted: "Actually it got me more in touch with my own culture. Like, we used to perform at Kennedy Park for Cinco de Mayo. I had never really been to any of those places, to any of the fiestas, or anything like that. My Spanish improved. It was just like a big, big positive thing in my life. It got me more in touch with the culture." After becoming involved with the quebradita club, he began to buy not only banda CDs but to listen to Spanish radio stations and mariachi music as well. As noted earlier, Shannon worked harder on her Spanish in order to understand the lyrics to the songs they danced to and learned that many fellow students had not even been aware of her Mexican heritage before she joined the group. However, Latinos who did not identify with the quebradita either for aesthetic or ideological reasons had strong reactions to its popularity. In spite of the pride that the quebradita instilled in many Mexican Americans, others saw it as a step backward. In a letter to the editor, one Loyola Marymount student wrote: "[Some] minority people . . . have been made to feel inferior or ashamed because we don't relate culturally to the newly arrived or first-generation minorities. . . . I don't think that my being a Latina requires that I learn the quebradita. And I don't think that because I am fluent in Spanish I should speak English with an accent" (Canchola 1994). This statement underscores the importance of individual agency in the choice of dance style and reminds us again of how controversial such choices can be.

Although I have called the quebradita a form of ethnic resistance,

I believe it is more defensive than offensive. Instead of attacking outside influences, it incorporates them into its vocabulary, helping to maintain cultural and linguistic continuity. José Limón's comments on Texas Mexican music apply equally well to the quebradita: "It is neither pure resistance nor pure accommodation, but both in any one instance" (1983:242). Christopher Waterman writes of Nigerian *jùjù* music that it "portrays an imagined community . . . that no one individual could know through first-hand experience" (1990:221). Likewise, quebradita style portrayed an imagined community of Mexican Americans in all corners of the United States, and it created what Arjun Appadurai might call a "community of sentiment," a group of people that feels and imagines together even though separated by great geographical distances. Even though cultures and languages may clash in "real life," as do the conflicting values of working and middle classes, in the *ideal* life depicted in quebradita they all came together seamlessly.

The New Mestizaje

The term *mestizaje* refers to the mixture of native and foreign cultures, just as a mestizo in Mexico is a person with both European and indigenous Mexican ancestry (in other Latin American countries, such as Venezuela, a mestizo has mixed African and European blood). Many Mexican and Chicano writers and scholars have found strength in the concept, an affirmation of the diverse ethnicities of Mexico and an alternative to the North American black-white racial dichotomy. In the 1920s, José Vasconcelos called mestizos "the cosmic race," a race he believed superior to others. In *Borderlands / La Frontera*, Gloria Anzaldúa found a *cultura mestiza* in the "vague and undetermined" space of the borderlands of the 1980s (1987:3). The mestiza consciousness, characterized by "a tolerance for contradictions . . . [and] ambiguity," is a product of the *choque* or collision of two cultures that is continuously occurring on the border (78–80). Such a consciousness, she suggests, is an asset that will be even more necessary in a future to be dominated by cultural and racial blending: "To survive the Borderlands / You must live *sin fronteras* / Be a crossroads" (195).

Others have criticized the mestizo ideology that continues to dominate cultural discourse in much of Latin America. Anne Doremus points out that Vasconcelos's writings, along with those of con-

temporaneous Mexican scholars such as Manuel Gamio, advocated the cultural extinction of Indians through the "whitening" process of racial mixing (2001:380). Others, including Jeffrey Gould, Ronald Stutzman, and Tristan Platt, have called mestizaje a "myth" used to mask racial discrimination in Latin America (see, e.g., Appelbaum, Macpherson, and Rosemblatt 2003:9). In a related case, Robin Sheriff (2001) has demonstrated how the Brazilian claim that racial mixing has resulted in a *democracia racial*, or racial democracy, is used to hide institutional discrimination and fundamental inequalities in Brazil's class structure.

Though it is true that mestizaje can be used to camouflage the inequities present in interracial power relations, the concept has nevertheless served as a paradigm for the creation and interpretation of art in both Mexico and Mexican America. It has often been noted that in Mexican musics such as mariachi, mestizaje is manifest in the blending of indigenous and European musical aesthetics and instruments. The mestizo has also served as inspiration for modern works of art, from Anzaldúa's poetry to Amado M. Peña Jr.'s silkscreens. However, the concept of mestizaje must be expanded and updated if it is to be relevant to the quebradita and other modern Chicano artistic expressions. It now must go beyond the racial categories of the Spanish and the Indian to incorporate the huge variety of seemingly oppositional cultures that Mexican American youth utilize in creations such as the quebradita: African American and Anglo American, Chicano and Mexicano, mass-mediated popular and traditional, working class and middle class. It must also cross borders and other boundaries in such a way that diverse origins are not erased and inequities are not hidden, allowing for the questioning of categories and power structures. In this way, perhaps the concept can become a metaphor with the potential to take us beyond the limitations of the old-fashioned racialized thinking in which it originated.

The quebradita, in spite of its very modern appearance, actually forms part of a tradition of Chicano transcultural innovation throughout the twentieth century that can be explained only through an expanded conception of mestizaje. In its combination of Chicano, Anglo, and African American moves (and sometimes clothing styles), the dance follows a long-standing Los Angeles practice of cultural interchange. In the 1940s, young Mexican Americans in the area adopted the zoot suit that originated among East Coast African Ameri-

cans, and since that time Chicano musicians in East Los Angeles have been working with and exchanging musical ideas with African American musicians in styles such as jump blues, rhythm and blues, and Chicano rock (see Lipsitz 1990; Loza 1993).

Borrowings and juxtapositions in artistic expressions can sometimes be used to subvert or call into question the objects' original meanings. For example, low-rider car makers combine 1950s Chevys and Fords with a Chicano aesthetic, changing their function from speeding to cruising "low and slow," and thus they ironically subvert North American consumerism in the process. The quebradita is "iconic of the Chicano's cultural *mestizaje*," as Gaspar de Alba says of the low rider (1998:60). Also like the low rider, the quebradita's mixing of cultural artifacts with different, sometimes oppositional meanings (such as Anglo country line dancing with black hip-hop and Mexican son) can be read as ironic or conciliatory or simply straightforward— a statement about the world quebradores inhabit. Steven Loza suggests that the popular African and Anglo American musical styles that zoot suiters listened to became "symbolic vehicles of change and adaptation" for them (1993:80). In the 1990s, teenagers used the quebradita in a similar way, as a means to adapt to a changing world. If it is true that music, as Jacques Attali states, is "prophetic . . . a herald of times to come" because it "explores, much faster than material reality can, the entire range of possibilities in a given code" (1985:4, 11), then the quebradita's juxtapositions may serve as a window into our future.

Transcultural mixtures and the creative incorporation of new with old are signs of strength and confidence in any art form because they are denials of the conservatism and stagnation that can stifle creativity and turn traditions into irrelevant relics. During the 1990s, the emergence of the quebradita, an art form that effectively combines bits of many other traditions, both old and new, showed not only that Mexican American culture was very much alive and well among southwestern youths, but that these youths were active agents in reconstituting this culture and in situating it in the late twentieth century. Their efforts had counterparts across the country. In New York City during the same time period, Nuyorican (New York–born Puerto Rican) youths combined 1950s mambo dancing with Afro-Cuban movement, African American hip-hop, and Broadway theatricality to create the "On 2" or New York style of salsa/mambo (Hutchinson 2004). This inventive mixing of cultures is quickly be-

coming the norm for youth cultures throughout the United States, where young people are reinterpreting and revitalizing art forms as diverse as Punjabi *bhangra* and Puerto Rican salsa via cross-cultural borrowings and exchanges, creating new cultural identities for themselves in the process. This is the new mestizaje.

Conclusions

Quebradita dancers built on the Mexican ranchero and Chicano rasquache aesthetic systems in creating a new artistic expression that served both as a reflection of cultural mestizaje and as a means of constituting a new urban identity for Mexican American youth. Evoking collective memory through the referencing of more traditional ranchero art forms, quebradita created a perception of historical continuity that helped send a message of ethnic pride. Both the quebradores' movements and their clothing were exaggerated and flashy, which often earned the disdain of adults and peers; however, most dancers felt these drawbacks were outweighed by the feelings of empowerment and connection to their heritage they gained. For many, involvement with the quebradita was a first step on the road to increased cultural and political awareness. In the next two chapters, I examine these personal transformations in the context of the unique forms quebradita culture took in different localities.

4

Quebradita in Los Angeles

I have already stated my belief that the quebradita/banda movement
was a political response both to pressures to assimilate and to ethnic
and class conflicts. Yet because political situations and local demo-
graphics vary from place to place, distinct styles, practices, and forma-
tions of the dance appeared in different locations. In this chapter, I
explore the specificities of quebradita dance communities in Los An-
geles, California, and in chapter 5 I look at the forms quebradita
activity took in Tucson, Arizona. Through comparison, we can un-
derstand how even mass-mediated popular culture can be subject to
local variation as a result of how individuals and their communities
choose to use and develop it.

Los Angeles is home to the largest Mexican-origin population in
the United States and the second largest in the world after Mexico
City. As a proportion of the city's population, their numbers continue
to grow, and by the year 2000 Latinos were the majority population in
Los Angeles (those of Mexican origin were the largest segment in this
group). The dynamism of this city's Mexican American population is
as unrivaled as is its size; since the 1940s, its members have been major
producers of cultural trends that have affected the whole nation, from
zoot-suited pachucos to Chicano rock, from *cholismo* (Chicano gang
culture) and *placas* (graffiti tags) to Chicano movement murals. For
these reasons, following a sojourn in the city, Mexican author Fran-
cisco Hinojosa concluded, "Now I know that the old saying makes
more sense than ever: "He who doesn't know Los Angeles, doesn't
know Mexico" (1995:135). It is no surprise, therefore, that Los Angeles
was the site of origin for the banda boom and the quebradita craze.

In this chapter, I examine how the quebradita scene developed in

Los Angeles and why the forms it took there were so unique. To do this, I compare the experiences of dancers from South Central with the experiences of dancers from the San Fernando Valley in the Los Angeles metropolitan area, adding (briefly) a look at Bay Area dancers in northern California. Because quebradita club formation was conditioned by preexisting local social structures, urban and suburban experiences could differ substantially. South Central clubs were particularly unique because they took on many of the characteristics of the youth gang culture of the area. Although these groups focused on dance and did not engage in violent activities, media at the time often did not make such distinctions, feeding the public's fear of minority youth and thus giving the dance clubs a frightening image. I therefore begin my discussion of quebradita in California with a review of images of the dance that appeared on the small screen and in newspapers.

Quebradita in the Media

Video, TV, magazines, and radio played important roles in disseminating quebradita music, steps, and style in the early to mid-1990s. Televised variety shows and concerts frequently showed tecnobandas and dancing couples. Numerous didactic videos were produced, offering teens far from centers of quebradita activity the opportunity to learn the new dance moves by watching and imitating (fig. 4.1). And a number of low-budget narrative films, generally released straight to video as rentals, took quebradita as their theme. These films seem to be a subtype of the mass-produced, formulaic films that María Arbeláez (2004) terms *narcoficheras*, and the center of their production, as of the quebradita itself, was Los Angeles.

Narcoficheras emerged in the 1980s and 1990s as an update of the earlier *cabaretera* and *fichera* genres. The former came out in the 1940s and featured sordid tales set in cabarets, whose purportedly egalitarian ethos contrasted with the class stratification that Mexican government policies were then reinforcing. Their portrayal of sensuous dancing and fallen women showed the dark side of modernization and urbanization in Mexico. Later, fichera films took melodrama to a new level with their tales of dance-hall girls who earned *fichas* (tokens) for socializing with male customers. More recently, narcoficheras have combined elements of both older genres with violence, chase

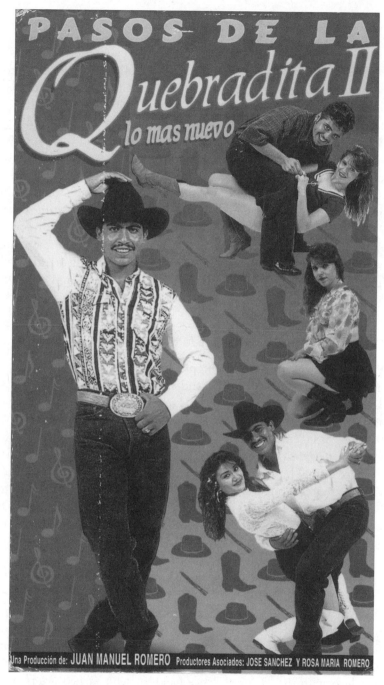

Figure 4.1 The cover of *Pasos de la quebradita II*, a quebradita
teaching video. (© 1993 JC Films; used with permission)

scenes, and border-centered stories of migration or drug trafficking. Such films are directed to an audience of Mexican migrants whom Mexican media producers believe to be predominantly working class, uneducated, and monolingual, and to have originated in rural areas or urban slums. The movies replicate the filmmakers' stereotypes through bluntly portrayed racism, sexism, and classism (Arbeláez 2004). Quebradita films of the 1990s play into some of these same prejudices, while also diverging from other narcoficheras in their focus on Los Angeles and its youth.

La última quebradita (The Last Quebradita, which appears originally to have borne the title *Quebradita* [Breakin']) (Compañía Oxxo 1997) is a perfect example of the narcofichera genre. Its somber mood is set early on. During the opening credits, the film cuts back and forth between scenes of a couple dancing a slow vals to banda music under a spotlight in a dark room and of a Los Angeles city skyline at night backed with music evocative of 1980s cop shows. Next, we see four people in a car laughing and celebrating the dance trophy they have apparently just won. Their celebration is short-lived, however, because when they pull into a parking lot, a mysterious assassin in black emerges from another vehicle and shoots all four.

Soon we discover that the murders were the work of a drug-peddling gang. This multiethnic group is led by an Italian American man who is backed by African American and Asian American cohorts. When a new quebradita competition with a ten-thousand-dollar prize is announced on the radio, the assassin calls in to tell the radio deejay she must ensure that the winner will be a certain dancer. Bonelli, the gang leader, has promised his Anglo girlfriend that she will win the contest, showing everyone that she is the best at quebradita. Yet this cannot be because, in a plot worthy of any soap opera, the deejay's best friend is an excellent quebradita dancer whose father desperately needs a ten-thousand-dollar kidney operation. This dancer's boyfriend, the brother of an honest cop, attempts to obtain the money for the operation by dealing drugs. After many violent encounters with members of the Bonelli gang, he comes to see the folly of his ways, and in the end they are able to foil Bonelli's evil plan. The heroine and hero, Rita and Victor, emerge victorious and dance their last quebradita to the music of Super Banda Nayarit in front of an enormous trophy.

This film is centered on the dangers of the city. Los Angeles is

shown to be a corrupt place, with drug dealing and violent crime on nearly every corner. The Mexican American characters try to earn a living and get ahead by hard work, but find it difficult to compete with the firepower and dirty money of the city's other denizens. These "Others" are revealed to be the source of urban strife, indicating that racial tension is a key issue for the moviemakers. Leroy, Bonelli's black right-hand man, is friendly with the quebradita dancers and dances a bit himself, but he is shown to be two-faced, not hesitating when ordered to shoot Victor. Linda, Bonelli's Anglo girlfriend, fancies herself a quebradita champ, yet not only does she not understand quebradita style (wearing short dresses and spike heels rather than denim and boots), but she is unable to win the competition on her own merits, instead relying on payoff and murder. Throughout the film, these one-dimensional racialized Others try to corrupt hard-working Mexican Americans. The Anglo, black, and Asian members of the Bonelli gang buy the nightclub's Mexican American owner drinks and offer him money in exchange for the right to deal drugs there, but he will not give in: "No thanks. Here people have good, healthy fun. And I don't drink while working." Xenophobic at its core, this film says that by moving to Los Angeles, Mexicanos who search for a better life can expect to be thwarted at every turn by Anglos, Asians, and African Americans.

La quebradita caliente (Hot Quebradita) (J. Gómez n.d.) is the lowest-budget movie of the three I examine here, if one can judge by production values. Basically an excuse to feature lengthy performances by local tecnobandas, this film keeps dialogue to a minimum. It opens with nighttime images shot out of a car driving down a wide boulevard hung with Christmas decorations. When the camera zooms into the tinsel, we are able to see an emblem in the middle bearing the initials "H. P." They stand for Huntington Park, one of the principal Mexican American neighborhoods in Los Angeles and a primary destination for new immigrants, as well as the main shooting location for the film. Next we find ourselves in a nightclub where a female singer decked out in silver bustier, sequined shorts, a red, fringed leather jacket, and black stiletto boots performs the hit "Un indio quiere llorar" to the accompaniment of a seven-piece tecno-banda. From here on out, scenes of the two main characters talking in their car, in bars, and in a "police station" (more likely a taxi dispatch office) are interspersed with ancient stock footage of ambulances and

police cars and long musical scenes shot in nightclubs. The story follows two plainclothes police officers investigating the case of a killer whose targets are young women who attend nightclubs where quebradita is danced. In the course of the action, we find out that one of the officers has been left by his wife and children, and that because they had disagreed over allowing the daughter to dance quebradita, he blames his sad situation on the dance. In fact, he thinks quebradita is "the work of the devil!" After the quebradita-dancing daughter is murdered, it is a short leap from these revelations to the discovery that the officer himself is the "quebradita killer."

The moral of the story seems to be that quebradita dancing is dangerous and wrong. All the victims are independent young women who habitually go out unaccompanied to nightclubs on weekends. The main characters in the movie are male, and there are no speaking roles for women. All women in the film appear instead as objects of desire: besides the victims with their long tresses, in their shorts and boots, we also see on stage the extravagantly dressed blonde singer in the beginning and, later in the film, two female saxophonists with the group Banda la Tribu. Therefore, the true theme may be a more specific one, one of anxiety about gender roles. This anxiety is common in many immigrant families, where it is expressed as tension between older and younger generations on the subject of acceptable female behavior. Here, it appears in the form of women who usurp male roles as musicians and who trespass into a male world—the nightclub—as dancers. The film's judgment on such women is decisive: their punishment must be death.

The comedy entitled *De la quebradita una probadita* (A Little Taste of Quebradita) (New Form 1993) uses the dance as an excuse to tell the tale of a loving family of Mexican immigrants in Los Angeles, struggling to maintain their values while adapting to life in the United States (fig. 4.2). The two younger daughters are enamored of the latest dance and music style, in which their mother is happy to note a resemblance to "tamborazo, the music of my times." The bookish older daughter, in contrast, is too straight-laced to appreciate it, preferring classical music. Or so we think. In a nonsensical and never-resolved plot twist, we see that she experiences strange headaches at night that cause her to let down her hair and sneak out of the house in denim shorts and cowboy boots, a bandana around her head. Her fiancé follows her and discovers she is leading a double life, dancing in

Figure 4.2 The cover of the quebradita-themed film *De la quebradita una probadita*. (© 1993, New Form)

quebradita clubs every night to great acclaim (though the reason for her being hailed as the "Queen of Quebradita" is not clear because she displays no moves more impressive than those of other club-goers). He tips off her family, who show up to see her performance in a quebradita competition. Contrary to expectation, it makes them proud: her headache immediately disappears, and the whole family whirls about together to a banda tune as the credits begin to roll.

This film clearly takes a lighter view of quebradita than do the other two. Although the girls' parents had earlier expressed very traditional views on child rearing and appropriate behavior for young women, in the end they seem to make an exception and accept their daughters' participation in nontraditional activities, such as nightclub dance competitions. Yet just as the family is not free from ridiculous story lines, neither are they free from conflict. At one point early in the movie, an argument erupts over the middle daughter's assertion that here in the United States young people are more independent, a statement that seems critical of her parents' strict policies that prohibit dating in favor of old-fashioned courtship. The mother exclaims, "We didn't come here to give up our culture!" and the father ominously hopes they "won't regret coming to this country," while the youngest girl expresses scorn for Latinos who don't even speak Spanish. The argument's instigator is reduced to tears and ends up agreeing that "our parents are right: look at the neighbors." One neighbor is pregnant at fifteen, one is in a gang, one lives in "shared apartments": "Is this the American way?" Even this lighthearted film expresses anxiety over generational conflict and the tension between Mexican and North American lifeways. Yet, unlike the other two films, instead of killing off those who violate traditional moral codes, this movie seeks to teach by example, offering one view of how family members can get along with one another and resolve cultural and generational differences through mutual understanding.

These three films share a vision that is critical of urban life in North America and anxious about how Mexicans can adapt to this life. In the United States, good Mexican women can turn into dance-hall girls, and hard-working Mexican men can turn to drug dealing. Both choices can have deadly consequences, and both can also be tied to the practice of quebradita dancing. The quebradita lures girls out of their homes and into nightclubs; drug dealers are attracted to the dance, and where they go, violence follows. Even when girls' reputa-

tions and lives are not threatened, participation in quebradita can produce rebellious behavior, leading to intergenerational conflicts. The films also demonstrate some telling inversions similar to those Bright (1995b) has found in low-rider mural art. For example, she describes one car mural on which a police officer gazes approvingly at a low rider, transforming the Chicano male artist into the object of envy of the mostly white Los Angeles Police Department. Police characters also play important roles in both *La quebradita caliente* and *La última quebradita*, yet they all are Mexican Americans and scrupulously honest—images that surely contrast with most Angelenos' experiences with a police force that has long been known for racial bias and brutality. The filmmakers, like the car customizer, turn Mexican Americans from the "objects of surveillance" into those who conduct that surveillance (Bright 1995b:94–96).

In the 1990s, reports in the *Los Angeles Times* and elsewhere often played into the same fears expressed in the quebradita narcoficheras, even though the latter were directed at a Spanish-speaking, largely immigrant audience and the former generally addressed U.S.–born English speakers. For instance, the on-line Christian publication *Sojourners Magazine* complained, "In Los Angeles, Christian leaders report youth active in lowrider car and bicycle clubs, *Quebradita* and rap crews, tagbanging and gangbanging—but not in church," seeming to suggest dangerous parallels between all the nonreligious activities (Carrasco 1994). In addition, a *Los Angeles Times* article reported complaints by Orange County inhabitants that banda music "is a nuisance and has brought loitering, littering and noise into their neighborhoods," then proceeded to list violent occurrences at banda nightclubs and to quote residents, who stated, "They're always fighting," and "I'm sure some of these kids carry guns and paint on walls" (Avila and Ko 1993). Another article described the death of three quebradores outside a dance they were attending, killed by Cambodian youth as part of a "5-year-old interracial gang war" (Colvin 1994). Yet another disparaged the quebradita on historical and aesthetic grounds, stating that banda will come and go, but "mariachi is forever" (Vanderknyff 1994). A fourth *Times* article was ambivalent about the trend, quoting both Los Angeles Police Department officers who talked about "fights and shootings" at quebradita parties and Orange County police who saw those same events as a powerful antidote to gang warfare (Seo 1994; see Ko and Avila 1993 and Wilgoren

1993 for echoes of the latter view). A few articles were wholly positive, however, one of them commenting "Qué cool!" when describing a quebradita dance held at Gage Middle School in South Los Angeles (Quintanilla 1993).

The *Los Angeles Times* is known for habitually portraying Chicanos "as associated with drug, gang, and criminal activity" (Bright 1995b:109). In some ways, the paper's coverage of quebradita continued these same stereotypes. At the same time, many articles seemed optimistic about dancing as a potential substitute for more violent undertakings. Some observers and commentators may have been merely hoping that youthful energies might be directed away from violence into more "harmless" pursuits or away from politics and toward activities that did not challenge the status quo. But other Angelenos, it is clear, began to see Mexican American youth as a source of hope and hipness for perhaps the first time.

Most media sources tended to portray quebradita as a source of conflict in three main areas: race, gender, and generation. Mexican immigrants feared quebradita because of its perceived threat to traditional gender roles and family relationships and because it could bring dancers into contact with people of other races and ethnicities— "Others" who themselves presented both physical and moral threats. Anglos feared quebradita because it brought together minority youth in large numbers to make claims upon city space. However, other types of media portrayed the dance in a positive light, especially after seeing the economic potential it offered. Radio and magazines played particularly important roles in dispersing and popularizing the style.

I have already noted how radio station "La X" (KLAX) became the number one station in Los Angeles thanks to the "banda boom." General Manager Alfredo Rodríguez played a central role in shaping the trend. According to journalist Claudia Puig, he decided to create a station that played regional Mexican music and was committed "to improving the image of Mexicans and instilling cultural pride" after doing his own market research in local bars and restaurants and finding that "people of Mexican descent felt there wasn't a station that catered specifically to them." Before long, La X was also sponsoring dance competitions and dance clubs in South Central and throughout the city; its management saw such clubs as agents for social change. Rodríguez explained, "We've been practically dismantling the gangs and getting kids to join social clubs—using every means possible.

Other broadcasters don't understand that. This is more than a radio station. It's a positive movement toward change." In addition, KLAX's wildly popular morning show included both humor and more serious commentary, further helping to develop the budding political consciousness of their mostly young, bilingual audience (Puig 1994).

Two print publications emerged from the craze as well. *Furia Musical*, a regional Mexican music fan magazine now in its thirteenth year and with an annual binational circulation of approximately 372,000 (according to Echo Media), owes its birth to tecnobanda. It devoted space to banda fan clubs' interests and activities (the magazine continues this practice to this day in a section titled "Furifans"), a fact that encouraged the formation of more quebradita clubs. Meanwhile, *La Quebradita*, a short-lived but widely circulated free weekly, promoted the style locally in the Southern California region by showcasing clubs and advertising events.

Radio and magazine portrayals of the quebradita thus played an important role in its promotion: dancers relied on this coverage to hear the latest bands, to find out about dance events, and to learn about new steps and styles. And although dancers' experiences with quebradita show that some of the fears portrayed in quebradita films did have a basis in reality, real life generally had little to do with the world of the movies. For many, the quebradita was as La X had hoped it would be: a path away from violence and toward greater pride in Mexican heritage. Moreover, it was far from a depoliticizing activity because it served to raise many dancers' cultural and political awareness. A closer look at the dancers' views and experiences "on the ground" will help us to understand how and why the quebradita became so important and so controversial.

About Los Angeles

As the largest urban area in the United States, Los Angeles is naturally a diverse city. However, its Anglo population has historically had great difficulty in adapting to the "Others" in their midst. Though the Spanish and Mexicans were of course the area's first non-Indian settlers, and Mexican immigration has remained heavy ever since the 1910 Mexican Revolution, tensions between the Anglo and Mexican-origin populations have always run high, and they periodically erupt into major anti-immigrant political activity. During the Depression

of the 1930s, thousands of Mexican Americans were forcibly "repatri-ated" or sent south of the border to a country many had never known. In the 1940s, war-bred tension and sensationalistic media reports led to the attacks perpetrated by U.S. military servicemen against Filipino and Mexican American youth, generally called the "Zoot Suit Riots." In 1970, Los Angeles police attacked peaceful Chicano antiwar de-monstrators in East Los Angeles, killing journalist Rubén Salazar and two others. In 1992, a majority of those arrested in the South Central rebellion that followed the Rodney King verdict were Chicano.

Today, interethnic relations remain tense for several reasons. Neighborhood segregation is one important cause of this continued antagonism. Mexican immigrants established an enclave in East Los Angeles as early as the 1920s because only there could they escape racism, establish their own media, and find ways to preserve their culture. Restrictive housing covenants ensured these patterns would continue in the next decades, and from the 1950s to the 1970s poor blacks and Mexicans became increasingly isolated on the east side and in South Central owing to poor public education and racism in jobs and housing (Laslett 1996:67). Neighborhood boundaries came to seem practically impermeable, and they remain so for many who live in these disadvantaged areas. In his book *Always Running—La vida loca*, Luis Rodríguez describes how in the 1950s Watts was kept sepa-rate from the white neighborhoods of South Gate and Lynwood by railroad tracks, and East Los Angeles was cut off from surrounding areas by the Los Angeles River. He likens the crossing of these borders to immigrants' crossing of the Río Grande/Río Bravo, so impossible did such movement seem (1993:19–20). Today, "white flight" means that even South Gate and Lynwood are now overwhelmingly Latino areas, and it has caused the inner city to be ever more segregated and separated from the so-called mainstream.

Changing demographics contributed to societal tensions as well, while also helping to set the scene for the quebradita's emergence. In the 1980s and 1990s, Mexican Americans in Los Angeles were growing in numbers and thus in economic, political, and cultural importance. A 2001 special report on census data that appeared in the *Los Angeles Times* showed a dramatically changing population (Various 2001). The white population of the city of Los Angeles had been steadily and rapidly falling over the past few decades, it revealed, dropping from 37 percent of the city population in 1990 to 30 percent in 2000. In Los

Angeles County, whites ceased to be the majority in one-third of all tracts, whereas the Latino population grew by 20.7 percent to 4.2 million (1.7 million of those in the city proper). Most especially, whites were leaving suburban areas such as the San Fernando Valley and Orange County in droves as Latinos moved in. Finally, the greatest population growth in the city and county occurred among the youth population, which grew at twice the rate of the adult population, mainly owing to immigration. In the state of California, the Latino youth population jumped by 56 percent between 1990 and 2000, and Latinos became the overall majority group in Southern California. Central American migration grew dramatically, but Mexican Americans continued to form the largest Latino group in the area.

These demographic changes unleashed new waves of xenophobia in California. During the 1990s, as we have seen, Governor Pete Wilson and conservative lawmakers enacted discriminatory legislation aimed primarily at Mexican immigrants (such as the infamous Proposition 187, which sought to deny rights to education and health care). As whites abandoned the city for an "isolated, affluent fringe," an Anaheim school board official invoked the image of Kosovo to describe diversity as "divisive and deadly," in contrast to the classic American "melting pot." A Latino activist countered those comments by explaining, "We've been ready for a long time to participate, for empowerment, in the city's political landscape" (quoted in Mohan and Willon 2001); however, it remained difficult for minorities to gain political power in the state's racially charged landscape. Since then, a few signs of hope have emerged, most notably in the election of Antonio Villaraigosa, the city's first Latino mayor since 1872, yet the situation remains largely unchanged overall.

Economic upheavals have historically provided yet another excuse for the scapegoating of immigrants. From the Depression to the post–World War II return of servicemen who claimed minorities' wartime jobs and then to the recession of the 1990s, competition for scarce resources has always fed Angelenos' fears and incited interethnic antagonism. Most important for our topic of discussion, the 1980s were a time of dramatic economic restructuring in Los Angeles that led to the loss of manufacturing jobs and the growth of exploitative service jobs (see Moore 1991; Ortiz 1996). The change in the city's economic landscape particularly affected minorities, who were still largely excluded from white-collar jobs. Unemployment and under-

employment grew, while many community programs disappeared because of a lack of funding during the Reagan years. These changes put young people in a precarious position, and minority youth in particular saw few opportunities ahead.

James Diego Vigil has described how such changes affected teenagers in the city from the 1970s to the 1990s. For example, the 1970s saw the first national shift away from an assimilation model toward ethnic pluralism. In response, barrio youth pressured one another not to assimilate, in sharp contrast to the 1960s, when Chicanos still made fun of Spanish-speaking students (1997, 24). In the 1980s, a conservative backlash against immigrants resulted in the end of many education and training programs and the beginning of "English-only" Americanization policies. At the same time, as noted earlier, the city saw a great increase in poverty because of the economic restructuring that resulted in the loss of thousands of blue-collar jobs. As a result, youth gang membership and the violence that accompanies such trends mushroomed. In the 1990s, economic difficulties continued while immigration and diversification grew along with what Vigil terms the "1.5 generation" (42)—those Mexican Americans who immigrated to the United States in early childhood. Immigrant youth, he suggests, brought new trends such as norteña and banda to the city, while new subcultures arose to accommodate those who were comfortable in neither Mexican nor Anglo society.

For all these reasons, Mexican American youth found themselves in a difficult situation in the early 1990s when the quebradita emerged. Massive immigration meant they had grown in numbers, but continued discrimination coupled with economic downturns meant that this growth was in no way paralleled by increased opportunities. On the contrary, California seemed ever more determined to deny immigrants and minorities the possibility of a better life. In such situations and particularly in depressed areas such as South Central, one might have expected to find only despair and violence. But it was in precisely this situation and place that teenagers instead found a way not only to enjoy themselves, but also to gain visibility and recover pride in their heritage.

"It Was Like a Bomb That Had Exploded"

Not long after arriving in Los Angeles in 2005, I met geography student and avid banda dancer Siris Barrios. Having grown up in Watts

and seen firsthand how the quebradita craze developed there, she felt it important that I understand the places in which the dance arose and was practiced. She took me on a driving tour of South Central Los Angeles. Beginning at the Marketplace, a large shopping center in Lynwood just across the railroad tracks from the Watts projects, we then traveled along Long Beach Boulevard through South Gate and Cudahy to Huntington Park, Siris explaining the significance of places we saw along the way.

First, she told me how the Marketplace, formerly a swap meet known as "Plaza México" but recently made over with "Spanish"-style architecture, served an important role in the 1990s: "Marketplace to me was THE center because La X [radio station KLAX] would come out all the time and have giveaways, and this was done for people who didn't have anywhere to go. You couldn't really go to the park and hang out; you really didn't have the money, [and] at the time you didn't really have any malls around. So it gave a space for young people to express themselves" (interview, 2005). The giveaways she mentioned were often held in conjunction with quebradita contests. Dancers from Watts, South Gate, Lynwood, Huntington Park, and other surrounding areas would go to the Marketplace to participate in such events. The swap meet and radio station in conjunction thus served both as the legitimizers of the new dance style and as the providers of a community service for youth who had no other city space to claim.

Long Beach Boulevard, a popular cruising strip during the early 1990s, is still lined with numerous clubs and stores catering to those with ranchero tastes, including El Paisa, a mariachi joint; Western clothing store Tres Hermanos; and quebradita-era club El Parral. Many of these sites are inscribed with history. El Taconazo, a pool hall that often features live banda music, bears the message, "Adán Sánchez te recordaremos" ("Adán Sánchez, we'll remember you," a memorial to the late Los Angeles–based corrido singer and son of *narcocorrido* legend Chalino Sánchez). Potrero Club, near the corner of Atlantic and Wilcox in Cudahy, sports a picture of a saddle outlined in lights and was important to quebradita dancers because of its no-alcohol, all-ages policy. Long Beach becomes Pacific after crossing into Huntington Park, which Siris's friend and former neighbor Jesús Molina described as "the downtown for *paisas* [short for *paisanos*, Mexicans from rural areas]" (interview, 2005) and which also was the

shooting location for *La quebradita caliente*. Here, Siris explained, dancers bought their clothes, cruised the boulevard, and attended carnivals and dance competitions for which the street would be closed off. Because Huntington Park was a predominantly Latino area, she said, it "allowed space for quebradita culture to grow."

Like the Marketplace, Huntington Park's Pacific Avenue drew in young people from surrounding parts of South Los Angeles and brought them together on common ground, enabling the interactions that produced quebradita's unique style. Yet the quebradita was in no way confined to this area. Banda nightclubs could be found in many parts of Los Angeles and its suburbs, and young people danced quebradita wherever Mexican-origin communities were located. The dance, the groups that practiced it, and the events at which it appeared took different forms in accordance with the unique localities and local cultures of which dancers were a part.

Young people today have the option of participating in multiple youth cultures and "a wide range of hybrid identities" (Austin and Willard 1998:6). Quebradores chose one such identity among the many possibilities available to them, reconfiguring Mexican American and U.S. youth culture in the process by helping to create yet another new possibility for identification. By comparing the stories of dancers from the inner city and those of dancers from outlying areas, we can begin to understand the choices young people make in the context of the places and the time in which they live. We can start to see the uniqueness of each local quebradita formation. And we can examine how, in spite of the mass media and their presumed homogenizing influence, popular dance varies from locality to locality.

Lucina Rodríguez was born in Guadalajara, Jalisco, and moved to Santa Anita in the Bay Area at age eleven. The quebradita arose soon after she came to this country, and as she recalled, "it was like a bomb that had exploded" (interview, 2005). Now a professional teacher and performer of Mexican traditional dance with Los Cenzontles Mexican Arts Center in San Pablo, she remembers seeing a variety of quebradita styles when she started dancing it at age thirteen and believes there are differences between northern and southern California styles. In her opinion, although Bay Area dancers largely copied other styles, like that of Los Angeles, they sometimes invented new moves for competition and utilized regional Mexican dances. She herself used Jaliscan style zapateado in her quebradita dancing. Lucina's father and

uncle played with bands, while she and a partner danced in many competitions at nightclubs, flea markets, schools, and even church parties. Lucina was never a member of a quebradita club, but in other ways her pattern of involvement matches those of the Tucson dancers I describe in chapter 5: she learned from friends, danced at school on occasion, and was involved with quebradita primarily as a competitor.

Both Sol Porras and David Padilla were born in the Mexican state of Nayarit and moved to Los Angeles as children, attending school in the San Fernando Valley. David acknowledged that "banda at one point in my life *was* life; it was all I wanted to hear," and it helped him make the adjustment from life in Nayarit to life in California. Still, he never belonged to any of the many dance clubs that existed at San Fernando High School: "You had to dress a certain style, and I wasn't like that" (interview, 2005). Sol, however, did belong to a club while in the eighth grade at San Fernando Junior High School. She explained, "In my school, I think it was predominantly people who had recently come from Mexico. You know, we spoke more Spanish than English. We took a lot of pride in that. And we formed our own group: it was called Orgullo Mexicano [Mexican Pride]. We would have our wannabe dance competitions during lunchtime . . . it was just a gathering of maybe twelve of us guys and girls that really liked this type of music." However, when she transferred to Patrick Henry Middle School, a place she described as "middle class," where "the Mexicans . . . were kind of whitewashed," she found that not only had other students not gotten into tecnobanda music, but few had even heard of it. Thus, it was particularly meaningful to her when a friend brought her a newspaper article that showed quebradita was then more popular than the house music many of her classmates preferred (interview, 2005). Although neither Sol nor David were involved with quebradita for long, the brief period in which they did participate had lasting effects. David explained that for him "it was about pride"; for Sol, it was the "start of cultural pride and the start of a movement."

As noted earlier, Siris Barrios grew up in Watts and started dancing quebradita in high school, around 1993. She never joined a club because of her strict parents, but she still listened to La X, wore boots to school, danced with friends, and watched competitive dancing at the Marketplace. To her, the most notable thing about the quebradita craze was the way it helped people to reclaim ethnic identities and transformed gang members into boot-wearing rancheros. Today she

is still an avid banda dancer and hopes one day to open a banda and norteño nightclub in Huntington Park.

Her friend Jesús Molina was born in Michoacán, but he, too, grew up in Watts; he danced quebradita from ninth through twelfth grades. Never involved in dance before, he initially became involved in order to meet girls. Around age sixteen, he joined a quebradita club called Si Tu Boquita Fuera after a song by Banda Arkángel R-15, with whom he attended many parties in the early 1990s. To club members, the dance was of secondary importance to the task of spreading as many flyers bearing the club's name as possible and attending as many parties as they could. They wished simply to "be known and be seen." Today Jesús dances only to corridos, but he still feels the quebradita was important because "that's when Mexican pride came out," uniting a variety of different peer groups, both Mexicano and Chicano.

From these short stories, we can see differences in how various individuals chose to involve themselves with quebradita in different parts of California. Although we are working with a small sample, we can begin to make some generalizations that also hold true for dancers in Tucson, Arizona, discussed in chapter 5. First, in the suburbs of the Bay Area and in San Fernando Valley, youth generally became involved with quebradita through school-based peer groups. Although it was easier to become involved at schools with large Mexican American populations, involvement was perhaps more significant and had a more lasting impact to those dancers who attended predominantly Anglo schools, as in Sol's case. Vigil writes that urban youth are more likely to have Mexicanized identities than suburban youth because inner-city kids have "less exposure to the Anglo mainstream," whereas outside the city the opportunities for retaining and participating in Mexican culture are limited (1997:27). Perhaps the limited options available to suburban dancers gave quebradita greater significance for them: dancers in locations such as the San Fernando Valley and San Pedro in the Bay Area were more likely to dance competitively than were dancers in the inner city.

In South Central, in contrast, quebradores became involved not at school, but through neighborhoods and friend networks (Jesús was astonished to hear that clubs in other places were school based). And although Watts was home to a greater number of quebradita clubs than the other locations I examined, the dance itself seemed less important there than did other aspects of quebradita culture, in par-

Figure 4.3 Los Angeles neighborhoods (above) and important
quebradita locations within South Central Los Angeles (right).
(© 2006, Sydney Hutchinson)

ticular clothing and other visual signs of club involvement, such as
flyers. These local variations were based partly on preexisting condi-
tions: youth in underprivileged areas such as South Central have long
relied on street socialization, whereas suburban youth are more likely
to be socialized in schools. Variations are also based on the demo-
graphics of the local area, such as whether Mexicanos or Chicanos

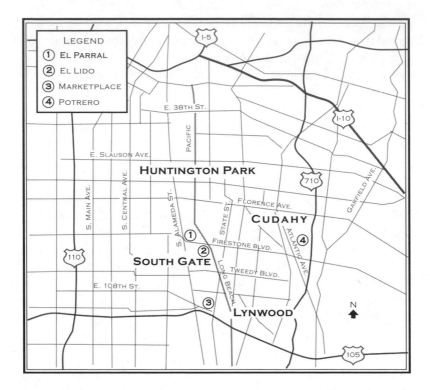

predominate, or from which part of Mexico immigrants hail (because of "immigration by network," some U.S. towns or neighborhoods exhibit concentrations of immigrants from particular Mexican localities). This is part of a phenomenon I've elsewhere described as "transnational regionalism," wherein transnational migrants retain and even strengthen their ties to regional—not national—culture in their country of origin, re-creating their home regions on a microlevel in urban U.S. neighborhoods (Hutchinson 2006). In this case, it means that immigrants from Sinaloa (to cite only one example) may choose to participate in and identify more with *regional* musics, such as banda, than with those styles considered representative of *national* culture, such as mariachi. Through these practices, they can create outposts of Sinaloa within Los Angeles, producing a transplanted geography.

Quebradita geography in Los Angeles was based not only on where dancers lived and where they were from, but also on the places to which they traveled (see fig. 4.3). Each quebradita nightclub attracted a distinct clientele with its own movement and clothing styles, and this

characteristic continues to hold true for banda clubs today. Simonett found that in the 1990s the clientele of the various clubs broke down by state, with Jaliscans at El Lido (informally known as "Lido's") and Sinaloans at El Farallón and El Parral (2001:68). According to Sol, today there is a sort of banda circuit, where the same people who attend the casino As de Oro on Saturdays also go to Arena on Sundays and Lido's on Thursdays. Most of this crowd hails from Zacatecas and Durango; many even come from the same towns. Other important sites for banda activity past and present, she told me, include the Pico Rivera Sports Arena and Rancho Farallón in El Monte, both of which hold jaripeos (rodeo competitions). Siris finds "more respect" at Rodeo, but thinks that Potreros "degrades women" through best-legs contests, and Lido's attracts an older crowd—perhaps those same dancers who attended the club during the quebradita's heyday. To her, El Farallón is among the most important of banda sites because it has been there for so long, and even Chalino Sánchez, the late king of narcocorridos, performed there: "It was a place to celebrate the music even when it wasn't popular . . . ," she told me. "People I think have that kind of sense of history."

Of all these clubs, El Lido was particularly important in quebradita times (fig. 4.4). Simonett explains that it was one of the first big clubs in Los Angeles to feature both tecnobandas and bandas sinaloenses, and the vaquero dress code was enforced because management feared gatherings of youth in baggies (2001:65, 67). New moves continue to arise there, and around 2001 Lido dancers began a step, as Sol described it, in which the man picks up the female partner and shakes her with his leg "like a broom." Attending the club in 2005, I observed this step on a night that featured performances by a mariachi, a banda sinaloense, and a norteño group. My field notes read,

> One couple stands out particularly as the gentleman in a black tejano hat and Western-style suit steers his partner quickly around the perimeter of the dance floor using a bouncy caballito motion. Every so often he stops to execute a quick *quebrada*, sometimes picking his partner completely off the floor, sweeping her legs up to his right side. It looks a bit like the quebradita step called media luna, but instead of sweeping her smoothly up and down using just one arm, he stops her in midair and supports her with both arms, shaking or bouncing her a little before setting her down. (14 March 2005)

Quebradita rhythms can still be heard in the music played there, but many couples now prefer to dance in a more duranguense style (see chapter 6). The deejay plays cumbia, merengue, and even *reggaetón* (Spanish-language dance-hall reggae) between live sets, showing how tastes have become ever more varied and international.

Also important to the Los Angeles scene, past and present, are the many transnational connections between its population and those in various Mexican states. Many of the dancers I interviewed seemed to inhabit the "transnational space" described by Rouse (1991) in that they and their families often traveled back and forth between Mexico and California, a fact that affected their dancing. Lucina learned steps from a sister who had just come from Guadalajara, as well as from friends who were from Los Angeles and Torreón, Coahuila. Sol and David danced in both Nayarit and Los Angeles, combining styles they learned in both places. These lived connections between places are perfectly illustrated by the name of a banda I saw perform at Lido's in 2005: Angeles Sinaloenses. The name might be translated as Sinaloan Angels, but it might just as easily refer to the synthesis of Sinaloa and Los Angeles in the group members' music and life experiences.

The quebradita's transnational connections spread even farther than Mexico because not all quebradores were Mexican, and neither are all banda dancers today. The dance craze also attracted people of other nationalities, allowing them to explore alternative Latino identities. It was particularly attractive to Central Americans, who were growing in numbers but still did not have a visible cultural presence in Los Angeles. Oriel Siu, for example, was born in Honduras but moved to the United States in 1999 to attend school. Because "the Mexican music influence is huge in Central America," she was already very familiar with norteña music like that of Los Tigres del Norte. She began listening to banda after befriending Mexicans in the neighborhood where she lived and discovering she enjoyed the banda-format radio stations in Los Angeles. She is now an avid banda dancer because she finds it "very romantic, very respectful" in comparison with more "sexual" styles such as the Honduran *punta* (interview, 2005). Siris Barrios, in contrast, was born in El Salvador and came to Los Angeles at an early age. Because she grew up in Watts, which was mostly African American and Mexican American, rather than in Pico Union, where Oriel and many other Central Americans lived, she had more Mexican than Salvadoran friends. To Siris, it therefore seemed natural to get involved in quebradita, even though "I didn't feel I was

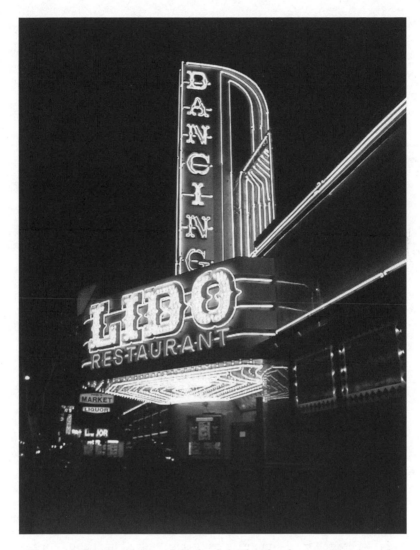

Figure 4.4 At South Gate banda club El Lido, the marquee outside recalls an Art Deco past, and the lobby features a display of boots, hats, and Western wear. (© 2005, Sydney Hutchinson)

completely a part of it because I wasn't from a [Mexican] state. I couldn't claim a state," as did the other dancers who habitually wore emblems of regional Mexican pride. She elaborated, "I think for a lot of Central Americans it was hard. It's hard being Central American already, you know, growing up during that time, maybe because a lot of Central Americans kind of deny their identity. You know, they would say they were Mexican." The quebradita was one way for Central Americans to participate in determining a new direction for U.S. Latino culture and to gain greater visibility; although the identity they adopted was not a specifically Central American one, the historic connections between Mexican and Central American music made it a viable option.

Favored quebradita steps varied from person to person, just as quebradita community formations varied from place to place. In chapter 3, I explored how such variation might be based on gender or choreographic considerations. In Southern California, it was also a function of dancers' regional origins, transnational connections, and individual preferences, so that a plethora of quebradita dancing styles

existed side by side in 1990s Los Angeles. One reason for the large degree of variation was that Mexican immigrants in Los Angeles came from so many different states, and many brought their own regional dance styles into the quebradita. For example, I earlier noted that when growing up in Nayarit, David Padilla danced cachongo, an unpartnered competitive dance that involved named steps such as el borrachito (the drunkard), helicóptero (a windmilling motion of the leg below the knee, like that seen in quebradita), and *el paso del ruso* (the Russian step, where the legs are kicked out from a squatting position). A bottle was sometimes placed between two dancers (usually two guys, though infrequently a girl might challenge a guy) who would compete to do complicated moves over and around it without knocking it over. David saw echoes of cachongo in both quebradita and the pasito duranguense, though in quebradita he also saw the influence of the Guadalajara caballito style. Sol, too, used some Nayarit flavor when dancing banda, though she saw differences between dancing there and in Los Angeles. For instance, although she saw caballito danced in Nayarit early on, she never saw there the style that arose in Los Angeles a year or so later, the type that combined swing-style lifts and tricks with caballito and other forms, which she termed *quebradita rock*. Nevertheless, bandas in Nayarit already had quite a cosmopolitan style: they played rhythms from cumbia to merengue to mambo, and dancers followed suit.

Lucina came to the Bay Area from Guadalajara and brought with her the traditional Jaliscan tamborazo style. In 1993 or 1994, her sister arrived in Santa Anita from Guadalajara and showed her a "new style" of dancing banda in which the couple were closer together, their temples nearly touching, and they moved their shoulders up and down. Shortly afterward, other friends came up from Los Angeles and Torreón and showed her their banda styles, from which they all created a hybrid. After a few more months, Lucina learned the "quebradita way" of dancing, which for her was defined by the impressive lifts. By then, she and all her friends danced "the same," even though some came from Jalisco, but others from Zacatecas, Michoacán, or Coahuila. In her opinion, people lost their regional dance styles in California as they "just [became] part of the area." After a while, only those Mexicans who came to the United States for brief visits would have noticeably different styles.

When quebradita began to go out of style, new ways of dancing

banda emerged in Los Angeles. Around 1999 or 2000, Sol observed a style out of South Gate in which the body was held very stiffly and moved "in a robotic manner," almost the opposite of the "jumping around" of quebradita; another year or two later the "broom" step emerged from the same area. According to Siris, today "the body movement is not as emphasized as it was back then . . . it's a little bit more mellow." In terms of clothing, young men now emulate either Adán Sánchez's sleek norteño look or the Chicago duranguense style that combines tropical *guayabera* shirts with Western wear. David agreed that today's dancing style is "simpler," and banda dancing as a whole is less of a "fashion statement." Los Angeles, in his opinion, has become more of a norteña town once again, resituating itself geographically and culturally.

"It Was Either That or Do Something Crazy"

Although La X, *Furia Musical*, and other media encouraged the formation of quebradita clubs, they did not determine the form of such clubs or the activities they undertook. Instead, these elements were shaped largely by the preexisting social environments in which they arose. We have seen that Huntington Park was a principal social center for quebradita dancers in Los Angeles, but many of the dancers actually lived in nearby Watts. Both places were considered part of South Central, an area in which blacks and Latinos are more integrated than in other parts of the city and in which both immigrants and third- or fourth-generation Mexican Americans live (Bright 1995b:98). I argue that these factors, combined with the pervasiveness of gang culture in the area, led to particular types of quebradita clubs and events not found elsewhere.

Watts has a tumultuous history as the site of the 1965 rebellion sparked by racial tensions and police brutality, and the similar 1992 rebellion that resulted from the Rodney King verdict was centered not far away in South Central. Although for most of the twentieth century Watts was predominantly African American, it also enclosed an older Mexican American area called "La Colonia" and bordered on mostly white South Gate and Lynwood (L. Rodríguez 1993:17). The cohabitation of several groups in the same area had advantages and disadvantages. Luis Rodríguez describes intensive cultural interchange between blacks and Latinos in the 1950s and 1960s, which among other

things contributed to the development of new styles of music such as Los Angeles Chicano rock; a generation earlier, similar exchanges had helped pachuco culture to grow. However, the same period also saw great animosity between poor Mexicans and better-off whites across the tracks, resulting in annual bouts of warfare between the two groups (1993:85–86).

Today, "white flight" has meant that the formerly white enclaves Rodríguez describes are increasingly settled by immigrants. Huntington Park became a particularly "Mexican area," though Watts was still predominantly African American when Siris and Jesús were growing up (Siris Barrios, interview, 2005). Demographics continue to change, though, and Watts is now 60 percent Latino and only 38 percent African American (Various 2001). Like East Los Angeles, the heavily Latino areas of South Gate and Huntington Park remain unincorporated and thus do not receive resources from the city, which, together with ongoing de facto neighborhood segregation, helps to ensure their continued marginalized status. In 1990, when the quebradita started emerging, the census showed that more than 50 percent of South Central's black and Latino males were unemployed or not in the job market. Poverty rates had actually risen since the 1965 Watts rebellion, and more than half the children in South Central were living below the poverty line (Phillips 1999:66). University of California–Los Angeles studies have shown that "unemployment is the single most prevalent factor that perpetuates gang membership" because gang networks "provide the most stable economic opportunities available for minority youth in some areas of Los Angeles" (Phillips 1999:68). In the 1990s, at least half of the youth in this area must therefore have been "at risk" for gang involvement, yet many of them chose to join quebradita clubs instead.

The first quebradita club prototype appeared in Huntington Park in 1990 as a fan club called Te Ves Bien Buena (You Look Real Good, the title of a popular song) and devoted to the group Banda Vallarta Show (Seo 1994), but it took a few years for the dance to emerge as a full-blown craze. Siris remembered that "in '93, '94 when the quebradita became popular, everybody was wearing the boots—and I was definitely wearing the boots too!" Suddenly, everyone in Watts began claiming their Mexican states of origin, and quebradita clubs proliferated. Many clubs, probably hundreds, arose in South Central during this period. Most were mixed gender, though one of the first, Club

Provoca, was for women only (Jesús Molina, interview, 2005). Neither of the two Watts dancers I interviewed was aware of quebradita activity in other areas (Siris stated, "I never thought of quebradita as a national thing"), suggesting both the degree to which that neighborhood was cut off from others and the self-sufficiency of the dance scene there. Club members and others thus shaped a unique variety of quebradita culture in the area.

South Central dancers created a distinctive style of quebradita dress. Although many wore the vaquero outfits found elsewhere, others altered their cholo wear[20] to incorporate the new ranchero aesthetic. Club members wore T-shirts with airbrush art that echoed neighborhood graffiti, with lettering like that of cholo tattoos and other artwork ("Old English"–style calligraphy). According to Jesús, a designated member of each club produced the T-shirts, one leadership role among many that included president, vice president, and those who were in charge of the club flag or flyers. When cholos themselves began to dance quebradita, Siris stated, they "wore their big pants with their boots, so they adjusted. They just took their identity that they had formed here to [match] that that was then popular at that time." Cholas (girls associated with gangs) also wore a hybrid style, she claimed: their typical tight blouses, contrasting sharply with the style of "Mexican women in Mexico—[who're] more modest in their dress," were combined with shorts, vests, hats, and bandanas. Yet they did not alter their trademark hairstyle: "Nobody took off their *copete* [forelock, the highly teased and sprayed bangs favored by cholas] to go dance banda. Nobody did. They kept their copete, but they altered their clothing."

The South Central scene also differed from others because it was centered not on dance competitions, but on "flyer parties," events local quebradita clubs promoted by distributing handbills at dances, at school, or among friends. Flyers came in a wide variety of shapes, sizes, and colors. The more prestigious quebradita clubs added graphics and color to their flyers, which made them into status symbols because they were more expensive to print (compare figs. 4.5 and 4.6). Yet all had a common format, which included information on the location and organizers of the party, usually called a *pachangón* or *desmadre;* the featured deejay; and lengthy lists of both "honored clubs" and "invited clubs." Club names were taken from popular song titles (Sangre de Indio, Si Tu Boquita Fuera); from members' states of

Figure 4.5 The front and back of a full-color flyer produced by South Central's Club Aguila to advertise a quebradita party it hosted in 1994. The back includes lists of invited and honored clubs that also participated in the event. (Courtesy Jesús Molina)

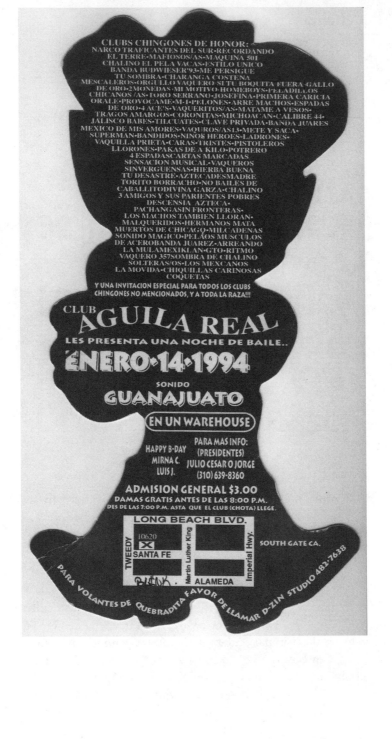

CLUB
Si Tu Boquita
Fuera!
A toda La Raza
Mexicana que quiera
Meterse al club,
yamar al area(213)
567-4974 pregunta
r por Adriana y á
pasar la de
peluche

Figure 4.6 A more typical and less pricey quebradita flyer, this time produced by the South Central club Si Tu Boquita Fuera. (Courtesy Jesús Molina)

origin (Sangre Zacatecano; Tapatíos, for Jalisco; Tropa Kora, after the Cora Indians of Nayarit); and from references to Mexican culture in general (e.g., Órale, a common saying, and Virgencita de Guadalupe) or to lo ranchero in particular (Potranquitas, Young Mares; Juventud Vaquera, Cowboy Youth; Chicas Country, Country Girls). Flyers also generally included some clever tag line indicating how late the party would go: "Desde las 7 hasta que se chinguen las botas" (from 7:00 until your boots get fucked up), or "hasta que llegue la migra" (until

the immigration service comes), or "hasta que llegue la policía" (until the police arrive). Many featured images or statements of pride, some of which could be quite political. One flyer for a party held on 4 July (1993?) shows a reworking of the Iwo Jima Memorial, where what appear to be revolutionary *bandoleros* in charro hats work to raise the Mexican flag. On the reverse of the flyer, Club Bandateca "invites you *not* to celebrate the gringos' independence day—instead come and dance zapateo" (fig. 4.7).

Also common on flyers were lists of dancers' states of origin: "To all La Raza of Zacatecas, Jalisco, Michoacán, Sinaloa, Nayarit, Durango, Coahuila, Guanajuato, Chihuahua, and all the Latin American race!" reads one flyer by Club Puño de Tierra (Fistful of Earth Club), recalling the lyrics to "¿De dónde es la quebradita?" (Banda Arkángel R-15 1993; see chapter 2). As there was a hierarchy of clubs, so was there a ranking of states, with some cooler to be from than others. "It was always Zacatecas, Michoacán, Jalisco, Nayarit. You know, it was never Veracruz, Campeche, or Yucatán," mused Jesús. Clearly, the northern and western states with ranching traditions commanded greater respect than the others because their ranchero authenticity and machismo could not be doubted. This hierarchy led to an odd situation in which those from the less-mentioned states would try to claim a more popular one by association: "I had cousins that were from Tamaulipas, that were born and raised over there . . . and just because they were related to us they started saying they were from Michoacán! We had Central Americans doing the same thing," Jesús exclaimed.

Flyers were distributed at parties and other get-togethers in order to drum up support for the next event. Smaller parties were held in members' backyards, and Jesús estimated that seven out of ten fit this description; the bigger and better ones might be held in warehouses. Each charged about a three-dollar entrance fee. Many such parties took place weekly, so that Jesús could recall "trying to hit five parties in one night, every day of the week. We always had a fat stack of flyers for the whole week." A *Los Angeles Times* report described one such event hosted by 150-member Huntington Park club Casimira at a tire shop, which attracted one thousand attendees and was kept violence free by two security guards (Seo 1994). Quantity was indeed important to clubs, both in terms of the size of their parties and the number of clubs listed on any group's flyer. The *clubes invitados* and *clubes de*

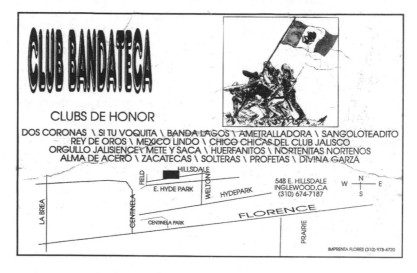

Figure 4.7 The front and back of a South Central quebradita flyer with a political message. Club Bandateca invites dancers "not to celebrate gringo independence day," but to dance zapateo on the Fourth of July instead. The artwork on the back depicts a reworking of the Iwo Jima Memorial in which revolutionary soldiers work to raise the Mexican flag. (Courtesy Jesús Molina)

honor lists indicated a club's size, strength, and the support it commanded. The more club names listed, the better, because a long list made a club "seem like they were associated with everybody," Jesús told me. This practice is analogous to placas (Chicano gang graffiti) in which "the size and strength of the youth gang is conveyed through clusters or lists of names as part of an insignia" (Sánchez-Tranquilino 1995:76). Jesús claimed it was so important to show this strength that some clubs simply name-dropped, inventing associations with other more powerful groups.

Not all quebradita dancers belonged to clubs. Some danced only socially or in competitions. Yet dance-club membership was important to many young people because these groups offered an alternative to gang activity. According to Siris, with quebradita clubs "you had young people organize themselves, not as part of a gang, but as something else. Before, what was the alternative? You organize around what? So they had now a reason to organize . . . to celebrate this identity." David Padilla experienced the dance's unifying power even on the other side of the border. "One time when I was in Mexico we got into a huge fight with another gang, and we were all angry." Then they heard about a banda playing in the town plaza and headed over to see the show. "Boom, we forgot about it. We would see our enemies on the dance floor, and we would not fight." For him, dancing opened up a neutral zone where normal rules of intergroup relations did not apply. Similarly, in Los Angeles a former gang member reported that after getting involved in quebradita, "instead of fighting we put our best dancers up against another club's best dancers" (quoted in Easley 1993). Jesús explained that for some people in Watts, quebradita clubs were the only alternative to *la vida loca* (the crazy life, or gang activity): "It was either that [dance quebradita] or go out and do something crazy."

Adults who saw this potential took steps to encourage gang members to join dance clubs all over Southern California. Thirty-four-year-old Rosa María Zepeda formed one in Orange County and established rules for her dancers: "My members are not allowed to dress like cholos. They are not allowed to miss weekly meetings and they are not allowed to join gangs or smoke or drink" (quoted in Ko and Avila 1993). Zepeda also established a sixteen-club alliance called Clubes Unidos in order to plan mutual events and act as "a close-knit family" for its young members, many of whom were in gangs or at risk (Ko

and Avila 1993). Manuel Velásquez, a worker with Community Youth and Gang Services in the San Fernando Valley, reported, "We encourage kids to join the [dance] clubs because it provides them with another alternative to gangs." Huntington Park High School principal Antonio García agreed: "The clubs . . . seem to promote having a good time, rather than getting into trouble." In order to buck any negative perceptions of their organizations, some clubs participated in charitable projects such as a KLAX food drive or parties whose proceeds purchased items for Mexican children (Seo 1994).

In spite of media hype, only a small percentage of inner-city youth belong to gangs (see Moore 1991), and some quebradita clubs actively enforced rules that prohibited gang members from joining, such as Huntington Park's Orgullo Maldito (Seo 1994). However, overlapping memberships did occur. For example, according to Jesús Molina, Club Disgusto belonged to the famed Thirty-eighth Street Gang. This central Los Angeles Chicano gang is one of the area's largest and dates back to the 1940s; its members were the defendants in the infamous Sleepy Lagoon trial depicted in the Luis Valdez play and movie *Zoot Suit* (Bright 1995b:100). And although in the early years dance-club members were mostly paisas, as time went on more and more cholos became involved either by joining others' clubs or forming their own. Jesús explained, "If it was in their neighborhood, then automatically they started joining, and it was only a matter of time, I guess. . . . I think that gave them an excuse not to gang bang, you know? They didn't have to go out and do crazy stuff. I think that was their only way of doing something besides gang banging." Dancing became an activity that could temporarily distract young people, even gang members, from more destructive behaviors. "[Clubs] did take up a lot of your time, and you felt like you were being part of a team, like you were doing something better than you could have been doing on the streets," Jesús added. Although he then qualified his statement with the idea that organized sports or Boys' and Girls' Clubs could have provided the same benefits, such services were not (and are still not) available in many inner-city neighborhoods. Quebradita clubs therefore can serve as an example of how youth organize themselves in the absence of social services.

The lack of recreational options is just one of several reasons for quebradita's success in interrupting typical gang activities and behaviors. Another explanation for its success is that it fulfilled many of

the same needs that gangs did, but avoided their violent nature. Gangs offer solidarity, protection, the respect of peers, and a familylike group of friends. Quebradita also offered opportunities for peer networking and helped individuals to become known in their neighborhoods, to be seen, and to feel proud. David explained: "La quebradita . . . it meant a lot. It meant that you were seen. If you were out in the darkness of your room and you had danced quebradita, you would come out into the light for a moment. It was something . . . [like] hip-hop. Hip-hop exposes you. Quebradita did that for a group of people. And I think that's why it was so big—because you would see yourself, you know? . . . And it was about pride, it was about 'I'm from this region, and this is the way we dance.'" Jesús added, "Around that time, at least in the hood, that's when Mexican pride came out. . . . It started being OK to say where your roots are from. Before that, I never did see it." Clubs also provided peer support networks with familylike relationships, as in a gang. "The bigger clubs would *apadrinar* [become godparents to] the smaller ones, to help them come up," remembered Jesús; mini-*apadronazgo* ceremonies would take place at flyer parties, the *padrinos* (godfathers) agreeing to help the younger groups along and sealing the pact with drink. One *Los Angeles Times* article explained, "To complete this ritual [baptism], which symbolizes solidarity between two groups, members of one club will go to a party and pour champagne on another club's members" (Seo 1994). Club members would even throw signs, hand signals like those used by gang members, to indicate their affiliation (Seo 1994). Also like gangs, for whom power is based on the number of members and how much territory they control, quebradita clubs existed in a hierarchy of status. In Watts, Amor Prohibido was top, followed by Órale, Pelonas, Incomparables, Charanda, Clavos Amargos, and others. According to Jesús, those clubs were considered "hot" because of numbers, association with the hottest deejays, or "how big an area you covered." They could gain status by getting bigger sound systems, throwing more parties, distributing more flyers than the others, and having longer lists of associates on those flyers.

Other parallels between gangs and quebradita clubs can be found in the use of dress and movement. Vigil has explained how clothing is a primary signal advertising gang identities, and it became the central feature of the banda/quebradita lifestyle. To him, kinesics, or movement style, is another defining characteristic of the "cholo front," a

combination of dress, talk, gestures, street rituals, and symbols that compose "the primary source of identity for many youth" (1988:xiii). For example, he suggests that the stoic posturing, slow and deliberate movements when walking, and accentuating gestures give the impression of being in control and are likely a means of managing the trauma and stress of street life (117). Obviously, movement also defined quebradita culture, although the quality of that movement was, if anything, the opposite of the cholo style. Many found it surprising to see cholos engaging in the fast, bouncy, even exuberant quebradita moves, though in doing so they seemed to be (consciously or unconsciously) evoking their predecessors, the pachucos, who were known for quick-stepping dance moves that necessitated the zoot suit's tightly pegged cuffs (Macías 2001:42). Just as pachucos' zoot suits and "in-your-face" pompadours "became politicized as they claimed space and drew attention to their wearers," so did quebradores' vaquero style and exaggerated movements indicate young Mexican Americans' refusal to be erased from California's social and political scene (Macías 2001:48).

These resemblances between quebradita clubs and gangs are no coincidence: both emerged from similar situations and locations. Vigil (1988) tells us that gangs began with massive European immigration to the United States in the late nineteenth century. These immigrants' experiences of adaptation to the urban environment and the search for employment were echoed in the experiences of later ethnic groups who also suffered poverty, discrimination, and exploitation as cheap labor. Cultural difference affected their lives, both in the changes they themselves had to make in order to adapt to U.S. society and in the treatment they received from the dominant culture. These conditions in turn affected urban geography by dictating where they would live and how they would be employed, by restricting them to low-level labor, and by setting up cultural patterns of acculturation or resistance. These patterns often led to increasing distance from Anglo culture and society by segregating new immigrants geographically, linguistically, and socioeconomically. The improbability of escape from such a situation impelled the formation of gangs or associations of lower-class youth in urban areas. Gangs are one type of adaptive strategy young people adopt in the face of changes commonly wrought by the urban experience, such as the breakdown of family and schools, generational conflict, and identity confusions (Vigil 1988:3–4). For these reasons,

they have been endemic in segregated areas such as South Central Los Angeles for generations and are a part of daily life even for those who are not members.

Vigil (1988) further explains that Chicano gangs differ from the gangs of other immigrant groups because of their longevity, a result of continuous poverty and a continuous immigration that reinforces traditions. Their origins can be traced to the pachucos of the 1930s and 1940s, who, with their distinctive clothing and speech styles, combined Spanish slang and African American dress into a street style that expressed barrio pride. Later, a new street style called "cholo" emerged in its stead. Like the pachucos, cholos also mix *caló* slang into their English and adopt a countercultural stance in reaction to racism; but unlike the pachucos, they "consider themselves traditionalists" (1988: 6) in retaining Mexican customs such as a strong sense of family and machismo.

Quebradita club culture in the 1990s in many ways resembled the pachuco subculture of the 1930s and 1940s. The material conditions in which quebradita emerged were similar to those that gave birth to the pachuco in that the city's economic restructuring in the 1980s created the same conditions of working-class poverty and unemployment as existed in the 1930s. Social conditions were also similar. In the 1930s and 1940s, friction between Anglos and Mexicanos led American-born youth of Mexican heritage "to establish their own group cultural style" (Vigil 1988:109) and to "reject the conventional social standards of the Anglo and Mexican communities" (Barker [1950] 1970:46). In the 1990s, similar ethnic and class conflicts led quebradores to adopt an aesthetic that went against both Mexican and Anglo middle-class tastes. In addition, all these groups felt the need to explore their heritage and to valorize it in the face of an often hostile society. For pachucos in zoot suits, cholos in baggies, and quebradores in vaquero clothing, dress style became one way in which to "identify with the past" and with one's roots (Vigil 1988:110). Finally, both pachuco and quebradita club culture initially arose in Los Angeles, specifically South Central, from there spreading throughout the Southwest and making connections between youth in widely separated locations. In 1950, for example, Barker found that one of his Tucson-based informants on pachuco speech had been a pachuco as a teenager in Watts. Los Angeles was then the pachuco capital, but the culture had traveled along the railway lines to other southwestern cities, and Barker's in-

formants' biographies reveal much traveling back and forth between Tucson, Los Angeles, El Paso, and other Southwest locations.

The pervasiveness and longevity of gang culture in many Los Angeles Mexican American communities means that other varieties of youth culture assume similar forms naturally, even when there is no direct connection between the two activities. Quebradita clubs are certainly not the first instance of a nonviolent youth cultural activity that has echoed gang formations. For example, car clubs, a type of youth culture that first arose in the 1960s, can also resemble gangs. They, too, are named associations of young men in which membership can be marked by club colors and matching jackets. Pachucos were the first to "cruise," and low-rider aesthetics were influenced by the cholos' slow, deliberate movement ideal (Vigil 1988:121–22). The first car clubs were in fact established by social workers in the 1950s as an alternative to gang involvement, foreshadowing later uses of quebradita clubs (Vigil 1988).

Bright suggests that in a segregated city where racial boundaries are continually enforced through policing, low riders can help to create "an alternate cultural space for performance, participation, and interpretation" and to rework "the limitations of mobility" (1995b: 91). In the 1990s, quebradita clubs performed a similar function, enabling youth from different neighborhoods to interact on their own terms and to perform and interpret their culture as they saw fit. Car clubs may in fact have had a direct impact on quebradita club formation in that they often took their names "from popular bands and lyrics" (Bright 1995b), and their car shows in the 1980s often included break dancing and other pop cultural forms (Bright 1998: 413). In addition, car clubbers were producing artistic reactions to the changed environment in Los Angeles at the same time and place in which the dance clubs were about to emerge. Bright observed car shows in South Central in 1989 where car muralists were using aesthetics as a site of struggle and a means of "grappling with issues of class and the realities of being postmodern subjects" (1998:424). At one South Gate show, the credits board advertising a low rider called "The Joker" invoked the Batman villain who described himself as "an artist promoting a new aesthetic"; in this way, the car customizer showed how he, too, could subvert the industrial system aesthetically (1998:419). Only a few years later quebradita dancers used aesthetics to challenge the racist political system in Los Angeles as well.

During the 1980s, other types of dance clubs appeared in Los Angeles as nonpoliticized predecessors to the quebradita phenomenon. Among the changes Vigil noticed in area high schools between 1974 and 1988 was the rise of the Cha-chas: "New subcultural innovations also surfaced. . . . [The Cha-cha group] has some superficial similarity to the gang subculture in that youths organize themselves into groups with monikers and such. However . . . the Cha-Cha lifestyle focuses on dancing and is generally nonviolent. Also, the Cha-Cha lifestyle is mostly a first or 1.5 generation phenomenon" (1997:42). Although Vigil does not provide information on the type of dance the Cha-chas performed in the 1980s or what music they listened to, he does imagine that this type of formation evolved into the banda subculture of the 1990s. Notably, at the same time in which the Cha-chas emerged, there was a shift toward "Mexicanization" and a new sense of pride among Mexican American teenagers (Vigil 1997: 14). Clearly, the time was ripe for the emergence of a dance that would resonate with preexisting social formations from gangs to car clubs while at the same time offering a new understanding of "Mexicanness" and a revalorization of Mexican roots.

Transformations: "We Were All Wearing the Boots"

Because of quebradita's emphasis on ethnic pride, individuals were transformed through their experiences with it. Sol, for example, explained how she went from "whitewashed" to a new appreciation of her Mexican heritage. Siris, meanwhile, was particularly impressed by the transformations of those who were associated with gangs:

> I thought what was more fascinating was seeing . . . hard-core cholos going into boots—because they used to make fun of people that used to wear boots, or wear the paisa clothes. That transformation to me is, to this day, still very amazing. Because we're talking about a neighborhood that, at the time, the neighborhood was very violent. It was because of the drugs, the gangs, and all these different things. But when this [quebradita] came out, it kind of pulled people out of the situation. It gave people kind of like two personalities, multiple personalities. Like, "OK, I'm the cholo," and then why not, "on the weekend I have my boots and now I'm this vaquero."

In addition, all those I interviewed went on to listen to and learn more about other types of regional Mexican music after being involved with the quebradita, even if they had been consumers of exclusively English-language styles previously.

Quebradita transformed groups as well as individuals, creating connections between factions that had previously seemed incompatible. For instance, both cholos and taggers danced it. Although both had listened to house, rap, and hip-hop music previously, in other ways the differences between the two groups were marked. As Siris explained, "Cholos are more hard core; they claimed a neighborhood. The taggers are just graffiti artists. They're just tagging, writing their name, claiming space. And they were more colorful in their clothes." Both groups wore baggy pants, but taggers wore bright oranges, reds, and greens and tight shirts, whereas cholos "were wearing their khakis . . . and their striped shirts and flannel." According to anthropologist Susan Phillips, "taggers are the least liked of all graffiti writers, both inside and outside the graffiti community" (1999:321). It was thus notable that both groups were united in their interest in the same dance and music style. Because cholos had previously been "hard core" into gang activities, peers particularly remarked on their new focus on dance and ranchero style. Again, Siris emphasized, "in Watts and Lynwood . . . you had generations and generations in gangs. And then when that [quebradita] happened with Latinos, it . . . kind of broke a little with that cycle. I think it might have allowed some people to [think], 'Hey, I don't necessarily have to dress this way,' or maybe, 'It's OK to look a different way.'" Sol saw the same thing happening in the San Fernando Valley: "A lot of people were in gangs, or wannabe gangsters. They would wear the outfits, you know. And I think when quebradita came in it was just diminishing that, wanting to be in that type of lifestyle or even dress like it. It was changing, and a lot of *pandilleros* [gang members], they became quebradores in quebradita clubs." In short, the quebradita allowed youth to imagine new possibilities and new directions for their lives.

Quebradita also united both immigrants and U.S.–born Mexican Americans in the dance. Jesús explained that before the quebradita movement, Mexican Americans in Watts had little unity or sense of a common identity, in contrast to their African American neighbors:

Black people were really united, you know? You could start a fight with somebody and black guys would come out, but Mexicans they never would come out. You were just on your own, you know? When quebradita and the clubs started coming around, you started cliquing up, and more Mexicans started getting together until they were all together. And then it got so tight that even when paisas were fighting . . . then the cholos started joining up, helping the paisas. They didn't used to. And then the taggers. Everybody that was Latino would band together, you know? Up to that point I had never seen it before.

Almost overnight, quebradita was able to produce a sense of common identity between Mexicanos and Chicanos. Sol had a similar experience in the San Fernando Valley. Before quebradita, there was less interaction between the two groups because they had different tastes: "In the past, it had been more like, if you listened to norteñas . . . it was like, 'Oh, that's paisa stuff, and we're Chicanos.'" But quebradita and tecnobanda music "made a lot of people transition to more of a cultural [identity]—proud of their heritage, you know: 'This is my music, I'm Mexican, and what?'" In addition, she contrasted immigrants of a generation ago with immigrants of today: whereas the former listened primarily to the romantic grupera ballads, the latter are likely to favor more traditional styles such as banda or norteña.

Still, not everyone was affected by the new sense of solidarity, and some wished to dissociate themselves from the new dance. In contrast to news reports that tended to treat quebradita as an exclusively immigrant phenomenon, Siris found that immigrants were in fact more likely to reject the style than were Chicanos: "Sometimes when you're an immigrant you have to reject certain things, or . . . you fool yourself to believe you have to reject some things to fit into a certain model. . . . To me, it was like the ones who were from here were acting more Mexican than the actual Mexicans that were living here." In the Bay Area, Lucina experienced conflict with her friends over her musical taste because they listened mostly to rock en español. "They I guess considered [quebradita] ghetto . . . they considered it was like circus [music] or something, and you guys are just doing *malabarismo* [circus acts]." However, later on even some of those friends who claimed not to like quebradita also became involved in it. Likewise,

the president of a West Los Angeles quebradita club told a *Los Angeles Times* reporter that he used to be a tagger and thought quebradores were "hicks." He changed his mind, however, after observing that "girls started going for guys who looked like [cowboys]" (Eric Ramírez, quoted in Easley 1993).

Just as the formerly déclassé ranchero aesthetic became popularized through the quebradita, forcing even steadfast rock listeners to take notice, an uncool rural Mexican identity also slowly became valorized. At first, Siris said, some rejected the dance and called those who participated in it "chunties." As David explained it to me, the slang terms *chunti*, *chunt*, or their source word *chúntaro*[21] were very offensive, derogatory terms for lower-class Mexicans—on a par with the N-word among North Americans. In a posting on a Web site dedicated to Tejano music (http://www.ondanet.com), "Alphonse" (a pseudonym I have assigned) explained, "It is simply a rudimentary inside 'subclassification' to identify people from a 'lower class,' or 'po folk,' more or less like a 'hillbilly.' Not much education, with a poor way of expression in the spoken word. Sort of like an ignorant person, cheap, and well, not very significant, in the social stratosphere" (30 June 2005). He added that the term has recently "resurfaced" in Houston, where Tejanos apply it to the "huge influx" of recent immigrants. Alphonse's posting generated some discussion on the site that is illustrative of the low opinion some Tejanos have of Mexicanos. One reply noted that "the taco head, gold silk shirts, white pants, red booted chúntaros" dislike the Tejano music that the "middle-class" Mexicans appreciate and support (30 June 2005). A third person added a caution that not all Mexicanos can be grouped together because class also makes a difference: it is only "the 'nacos' or 'tacuaros' that come from ranchos over there" that don't listen to Tejano groups (30 June 2005).

In spite of such derision, some Angelenos formerly slandered by the chúntaro label eventually seized on it and made it into a new symbol of pride and in-group solidarity, much as 1960s activists had done with the once-offensive term *Chicano*. David explained,

> The *chúntaro* word came out not long ago and it's very interesting because *chunt* was an insult. . . . Chúntaro is just like you're raggedy, you look poor. It's like in Mexico when they call you "naco." It means that you don't have class. . . . [But] now people

say things like, "What's up, chunt?" . . . [Now the word is] empowered somehow. . . . *Chunt* means that you dress quebradita, that you dress banda. If you're a chunt, you know how to dress. Because you're lower class, and the lower class knows the tradition, knows the fashion. And that was the thing, because banda is danced by the poor. It was music for the poor.

Personally, David still finds the word offensive, and he sees it as an insult that the word was applied to those who dress in the banda mode: "that's a style, it's a culture, and you're insulting [all of that]." The only reason he can see for people to use such a word to describe those who are actually very stylishly dressed and have invested a great deal of money to achieve their look is precisely that the style is so very Mexican.

[It's] because of the culture that we live in. Our own skin is something negative. As people of color, our own skin is negative. So if you're dressing up traditional, it's like "Ew! You uncivilized bastard." . . . It has to do with class, it has to do with race, it has to do with culture, with what society provides to you. And our models of beauty are Jennifer Lopez and Ricky Martin, sadly enough, and they're most likely very, very white. . . . I think that's how *chunt* came out. Like, "Oh, boots? You're not on a horse!" But it's not about a horse—it's a style, it's history.

Chúntaro thus remains an insult synonymous with *naco* or even *rascuacho* for some, but others have seized onto its newfound potency as a symbol of underdog cool. The Monterrey, Nuevo León, rock band El Gran Silencio recorded an entire album on this theme in 2001, entitled *Chúntaro radio poder* (Chúntaro Radio Power). One track entitled "Chúntaro Style" declares, "Este es el nuevo chúntaro style, / porque canto raggamuffin y bailo el gavilán" (This is the new chúntaro style / because I sing raggamuffin and dance the *gavilán* [a traditional son]). Such a lyric would not have been possible before the quebradita and tecnobanda made lo ranchero cool.

The question remains why such a dance was able to unite so many disparate groups, why it assumed such importance in individuals' lives at the time. I earlier suggested a political motivation, and Siris, examining the phenomenon retrospectively, reached the same conclusion: "There were a lot of things happening in '94, right? You have

[Proposition] 187 [saying] 'you're not really American.' You had all these different things, initiatives—209, 207—all these different initiatives that people were confronting. I think 187 was very key because it happened in '94. . . . It kind of affirmed, reaffirmed—it gave some people a sense of identity again." And even before Proposition 187, young Angelenos had experienced their share of political strife: the 1992 Los Angeles rebellion that broke out in response to the Rodney King verdict coincided with the emergence of quebradita. Racist politics therefore motivated those who had previously not had a markedly "Mexican" identity to reconsider their self-presentation and to assert their heritage through their music, dance, and clothing choices. Siris explained that those who "had tried to detach from [that identity], they had to reclaim it, because now they had to fight to make their space." In such an environment, even cholos had to take notice and make a more visible (or legitimately visible) presence for themselves in the city, becoming *chollos quebrados.*

Sol described quebradita as a "transition phase," and it is true that the dance was the first step on the road to politicization for many young people. "It started building a sense of pride to get back to your roots and really be involved . . . not politically, but first it was musically—to be culturally [involved], proud of your heritage." Jesús agreed: "That's when Latinos all came together. That's also when . . . it started being ok to say where your roots are from." Dancers often became more politically involved after having their cultural awareness raised through the dance. For example, Sol had been in a quebradita club in junior high and then became involved with the Movimiento Estudiantil Chicano de Aztlán (MEChA), a Chicano student activist association, in high school, where she participated in a walkout in protest of Proposition 187. Others were motivated to leave gangs, to involve themselves in charitable work, to listen to traditional Mexican music, and to learn more about Mexican culture (see Avila and Ko 1993; Ko and Avila 1993; Seo 1994). For these reasons, journalist Rubén Martínez called what happened with tecnobanda in Los Angeles in the 1990s a "cultural revolution." It enabled people to say, "We're Mexican, speak Spanish, dance *quebradita* and are damn proud of it" (1994).

Conclusions

To come full circle in our tour of the Los Angeles quebradita scene, we must return to the quebradita films with which we began. What did dancers think about the issues raised in these movies—the racial, gendered, and generational conflicts they portrayed? Race was certainly a salient issue for Los Angeles dancers because they experienced conflict between different ethnic groups in their neighborhoods every day. Jesús remembered that in Watts before quebradita came out, "it used to be Mexicans against blacks. People don't want to hear that, but that's what it was and still is." Siris added, "You had this territory struggle between African Americans and Latinos. So the way that Latinos were manifesting their identity . . . was through the music, and the type of clothes they wear." In this way, they increased their visibility and enhanced their claims on neighborhood space. At the same time, quebradita helped to bring the two opposing groups together; both Siris and Jesús remembered African Americans joining in the dance parties. Other dancers noted that African Americans were experiencing their own, similar cultural reawakening. Stated one high school quebrador, "I thought the black kids would make fun of me, but they didn't. They're wearing African clothes now themselves" (Eric Ramírez, quoted in Easley 1993).

The filmmakers and other outsiders to the dance felt that quebradita threatened traditional gender roles, but for dancers the issue was less clear. In some ways, they felt that the dance actually upheld tradition in that men would politely ask the women for a dance, escort them back to their table, and purchase them drinks; and, in general, women followed their male partners. As Simonett explains, "public dance events contribute to the continuity of the established social system, encouraging both men and women to act according to their gender roles" (2001:73). Yet some women, discontented with these roles, did actively challenge them. David Padilla explained that he has difficulty dancing with one friend who always tries to lead. In his opinion, "if the girl doesn't allow you to do it [lead and show off], it's an insult." Gender roles are therefore continually being negotiated and renegotiated on the dance floor, and many women (as seen in chapter 3) did lead both male and female partners.

As in the films, quebradores in real life also experienced a generational conflict, related both to differing musical tastes and to differing

opinions over gender roles. Sol's parents, for instance, listened primarily to grupera and Christian music, and their initial reaction to banda was, "Why are you listening to that? I don't understand that music!" Her stepfather Jaime López, a radio announcer, tolerated Sol's banda tastes, but was critical of quebradores' gendered behavior. He felt it was "not a very decent dance . . . not a dance that was very appropriate for girls of eighteen or fifteen." It was too sexual; the man held the woman's waist, putting his leg between hers, and they danced far too close together: "I don't know how many women have ended up pregnant because of that type of dance," he said (interview, 2005).

López's critique resonates with the fears presented in the quebradita films discussed, yet many women who danced quebradita had exactly the opposite experience. For example, Sol finds that men at banda clubs were and are much more "courteous," "nice, and pleasant" than at clubs that play other styles such as pop or hip-hop, and Oriel and Siris also find them more "respectful." Furthermore, Lucina, while recognizing that some saw the quebradita as "scandalous," pointed out that the close positioning of partners had a purpose: "the reason why his leg was between your legs was that he was kind of pushing you back and forth" or lifting the leg in order to lead his partner into a kick. Indeed, it is all but impossible to perform some of the dance's most difficult moves without this close position. Jaime López also worried (with some reason) that quebradita parties often included drinking, although this is a problem of any unsupervised teenage get-together and not particular to the social scenes centered on this dance. In addition, the critical view of quebradita's sensuality is the same one that has been leveled at nearly every instance of dance-oriented youth culture throughout the twentieth century, from jitterbug to rock to hip-hop. Although parental concern is understandable, such discourse points to a constant pattern of intergenerational misunderstandings as youth struggle to know and be comfortable in their own bodies.

In sum, whereas many observers focused on quebradita's potential to produce conflict, dancers saw it more as a means of coming together and freeing themselves from many of the difficulties they faced in other areas of life. For them, it was an activity that had emancipatory potential because it offered new ways of conceptualizing their personal and ethnic identities, new ways of networking with others like them, and new ways of relating to Mexican and Mexican

American culture in general. Bright writes, "the rhetoric of criminalization in Los Angeles has been historically and cynically localized in the bodies of men of color in central and East Los Angeles," so that Chicano and black car-club members have used their vehicles as "a site of resistance" (1995b:95, 93). So it was with quebradores. By adopting a controversial aesthetic, proclaiming ethnic pride, and participating in a highly visible activity, they transformed their bodies into sites of resistance. As they moved through neighborhood space, they claimed it for their own. Along the way, they also transformed the city's youth culture.

5

Quebradita in Tucson

In Tucson, Arizona, quebradita, banda, and the perceptions of both
these art forms also played a significant role in individual lives. Tuc-
son dancers' own words give a better understanding of how they
related to and felt about this dance and of what role it played in their
peer groups as well as in the community at large. The political en-
vironment was less charged here than in California, but Arizona
dancers nonetheless experienced many of the same challenges. As in
Los Angeles, the quebradita in Tucson was a means of working out
personal understandings of ethnic identity and of responding to cul-
tural pressures. But quebradita activities in this city assumed a dif-
ferent shape. Here, dance clubs were mainly a school-related activity,
and dancers from high schools across the city came together in que-
bradita competitions and performances. In addition, Tucson activity
had a more external focus; many dancers believed it served as a means
of creating intercultural understanding. These different practices were
a result of different local cultures and histories, wherein Tucson, al-
though it is an urban area, had more in common with the "safer" and
less tense atmosphere of the Los Angeles suburbs described in the
previous chapter.

Dorothy Noyes has pointed out how communities are con-
structed through networking, interaction, and the "collective con-
struction of tradition" (1995:468). Individuals become identified with
such groups by means of the repetition, formalization, and consensus
(in its etymological sense of "feeling together") that take place in
performance (see Noyes 1995:467–68). A look at Tucson dancers' ex-
periences and their reasons for involvement with this particular style
of dance clearly shows that quebradita played an important role in

forming both individual and community identities. Quebradita clubs and events provided opportunities for community building as Noyes describes it: by moving together, quebradores could also "feel together" and gain a sense of belonging. Narratives about the dance, including dancers' explanations and understandings of the dance's history, also played into these issues of self- and group identification.

About Tucson

Southern Arizona has received little attention in the literature on the border in comparison to places such as San Diego, Tijuana, El Paso, and Ciudad Juárez. This neglect is likely owing not only to its smaller population, but also to the perception that it is culturally peripheral to those larger urban areas. Yet Tucson has a unique history and culture that deserves further study, and I briefly outline them here in order to provide context for my discussion of its quebradita community.

Tucson occupies a region that has long been a crossroads of Mexican, Native American, and Anglo cultures: a perfect spot for the practice of a cultural conglomerate such as the quebradita. Inhabited for thousands of years by the Tohono O'odham (formerly known as the Papago) and prior to that by the Hohokam, it was first settled by Europeans in the seventeenth century when Father Eusebio Francisco Kino, a Jesuit priest, established the mission of San Xavier del Bac near present-day Tucson (it was completed in 1797). Tucson itself was not established until 1766, when Hugo O'Connor, an Irishman working for the Spanish Crown, chose it as the site for Spain's northernmost military outpost in the New World.

The next hundred years saw Tucson under the flags of four different nations. Though present-day southern Arizona began the nineteenth century as part of Spain, it joined Mexico in its fight for independence in 1821 and remained under that country's jurisdiction until becoming part of the United States in 1854. That year the Gadsden Purchase established the current border, six years after Mexico had ceded the rest of what is now the southwestern United States. During the Civil War, the Confederate flag briefly flew over the town after it was taken by Texan troops. Less than three months later, Tucson again became part of the Union, and in 1863 President Lincoln named Arizona a territory.

Throughout those years, the town's population was largely of

Mexican origin, but the arrival of the Southern Pacific Railroad in 1880 and the subsequent discovery of copper brought many Anglo newcomers to Tucson. Its appearance slowly changed, as brick and wood houses began to outnumber the traditional adobe structures. The Yaqui became a part of the cultural mix in the early twentieth century when they left their Mexican homelands owing to extreme oppression that began during the reign of dictator Porfirio Díaz and culminated in a series of anti-Yaqui military campaigns that lasted until 1927. The Yaqui who settled in southern Arizona established Pascua Yaqui village, annexed by the City of Tucson in 1952, and also moved onto a 222-acre reservation southwest of Tucson (Inter Tribal Council of Arizona 1997).

Father Kino named the region that Tucson now occupies the Pimería Alta, or the Upper Pima lands (the Tohono O'odham speak a tongue from the Piman language family). He recognized that the land from the Gila River in the north (which formed the northern border of the Gadsden Purchase) down into the northern part of Sonora comprised one unique cultural region, different from both the Apache lands to the north and the territories to the south and southeast, where other Piman-language speakers and the Seri dwelled. Today, Pima County, in which Tucson is located, is about 62 percent Anglo, 30 percent Hispanic (the term most commonly used for Mexicans and Mexican Americans in Arizona), and only 2.6 percent Native American, the latter concentrated mainly in the urban Old Pascua Yaqui Reservation and the rural O'odham one west of town (City of Tucson Planning Department 2002). In spite of the demographic changes produced by migration and urbanization, some inhabitants of the area still maintain distinctive customs. According to Jim Griffith (1993), an expert in local folklore, among those traditions still common on both sides of the border are folk art such as reverse glass painting, piñatas, and *cascarones* (decorated eggshells filled with confetti); folk beliefs and religious practices surrounding San Francisco Xavier; Mexican ranching traditions; the O'odham language; and the diet introduced by Spanish settlers and retained by Mexicans and Native Americans alike (and even by some Anglo interlopers), which relies on beef, cheese, and the Sonoran-style giant flour tortillas. Professor Xicoténcatl Díaz de León added to this list the Arizona-Sonoran style of dancing to cumbias, corriditas, and other types of songs from the norteño repertoire (interview, 1999).

Since Arizona became the forty-eighth state in 1912, it has experienced rapid population growth as well as cultural change because of the influx of migrants from other parts of the country. In 2000, the population of Tucson proper was 475,450, up nearly 15 percent from 1990 (Arizona Department of Commerce 2001); the population of the metropolitan area was probably greater than 700,000. In addition, the population grows temporarily by tens of thousands each winter owing to the arrival of "snowbirds," or mostly white and midwestern elderly seasonal migrants.

Tucson is, then, a multicultural town and has been throughout most of its history; ethnic conflict is therefore to be expected because history has repeatedly shown how difficult it can be for different groups to coexist peacefully in one geographic space. Mexican Americans have faced many of the same hardships in Tucson as they have experienced elsewhere, such as an education system hostile to their culture and language, lack of economic opportunity, and "barrioization." Middle- and upper-class Tucsonenses (Tucsonans of Mexican origin) sometimes made problems worse by reproducing highly stratified Sonoran society (Sheridan 1986:250–55). Yet, at the same time, Tucson has long had a reputation for being a "relatively benign place for Mexicans to live in the Southwest," a reputation that was based in the nineteenth and early twentieth centuries on such facts as the large proportion of businessmen and white-collar workers among Tucsonenses (Sheridan 1986:249). Today, neighborhood segregation still exists—for example, South Tucson remains largely Mexican, whereas the Catalina Foothills are predominantly white—but is nowhere near as severe as it is in Los Angeles, with the city geography offering a greater degree of mobility. Many Tucsonans still pride themselves on their political attitudes, more liberal than in most of Arizona, and on the unique cultural practices of the region, which are largely Mexican in derivation although Native cultures are also represented. To cite only examples of public culture, Tucsonans of all persuasions support annual events such as August's Norteño Festival; May's Waila Festival (featuring Tohono O'odham dance and music); the Easter celebrations at Pascua Yaqui village, located near downtown Tucson; April's Mariachi Conference, one of the largest and oldest in the country; February's rodeo, officially known as La Fiesta de los Vaqueros in order to underscore the Mexican cowboy tradition; the African American Juneteenth celebration; Tucson Meet Yourself (now Tucson

Heritage Experience, but many Tucsonans still use the old name), a food and folk arts festival celebrating the diversity of the region; and the Cinco de Mayo festivities common to all border states.

Quebradita Communities

Quebradita during its heyday was another cultural activity that was able to bridge difference. The dancers I interviewed in Tucson came from different parts of town. They represented both working and middle classes as well as U.S.–born and immigrant Mexican Americans. Their clubs in some cases included Anglo American, African American, and Asian American dancers as well. The enthusiastic audiences for their performances were equally diverse, showing that most Tucsonans found the dance clubs a welcome contribution to the city's cultural life. Here, as in Los Angeles, participation in quebradita clubs had a significant impact on individual lives and peer group formation.

In Arizona as in other places, the quebradita "scene" was organized around a number of dance clubs, usually associated with a school, but sometimes organized by other community members. Most dancers found it advantageous to join these groups for the purposes of performance and competition. In 1994, one radio station program director in California estimated that about 135 quebradita clubs existed in Riverside and San Bernardino counties, each with fifty to one hundred members (Johnson 1994); more than 800 clubs were reported to have sprung up in the Los Angeles area between 1990 and 1994 (Seo 1994). In contrast, perhaps only a few dozen existed in Tucson, but the ones that did form were very active and vital parts of the local community.

The first quebradita group that formed in Tucson, Ritmo Alegre (Happy Rhythm), appeared around 1994, when the Los Angeles scene was at its height, and was initiated by deejay Andrés Mejía from Radio Qué Tal, a local Spanish-language radio station (now defunct). The group consisted of twenty to twenty-five couples in two divisions; one was just for children and was known as Ritmo Alegre Junior (Ernesto Martínez, interview, 1999). Because Ritmo Alegre was Tucson's first quebradita club, it became widely known and well respected. Sandra Franco, a dancer from centrally located Tucson High, remembered Ritmo Alegre's performances for their beautiful costumes, good dancing, and child members who were able to do steps no adult could

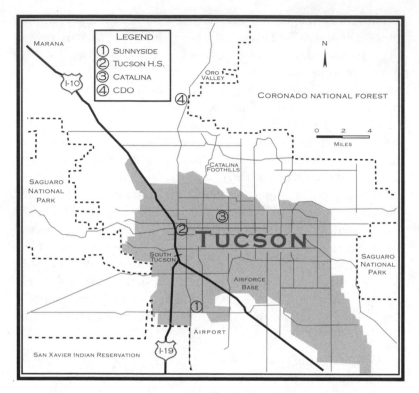

Figure 5.1 Locations of some Tucson-area high schools with quebradita dance clubs. (Map © 2006 by Sydney Hutchinson)

do (interview, 1999). Ernesto Martínez from Sunnyside High School on the Southside joined the scene earlier than any other dancer I met, so he naturally began dancing with Ritmo Alegre. When he began, competition was not an important part of the quebradita scene because there was only the one group. But soon thereafter, another group called Los Monarcas (The Monarchs) appeared, "And all of a sudden, it was competition. They wouldn't just dance having fun; all of a sudden after that it was competition. It was competition between everybody." Quebradita clubs soon began springing up at nearly every high school and junior high school in Tucson, including Los Diablitos (Little Devils) at Sunnyside; El Mexicano and later El Movilito (Little Movement) at Tucson High; and CDO's simply titled Quebradita Club (see fig. 5.1). Many were associated with preexisting folklórico groups,

such as Tucson High's Los Tucsonenses, or with cultural organizations, such as CDO's Hispanic Culture Club. Groups started by a single individual, such as Ernesto's Los Traviesos (The Trouble-makers), were less common.

Although all groups competed against each other, they respected each other as well, and feelings were usually friendly. As in Los Angeles, many groups were started in order to keep students in school and away from drugs and other dangers, providing an alternative to gangs and discouraging truancy. In most cases, the effort was successful: Tucson High dance teacher Marcela Cárdenas noted that even students who did not bother to attend their classes the rest of the week showed up on days with dance practice (interview, 1999a). Darma Quiroz felt that her grades improved during the time she was involved with the club at her school, although she noted that a number of her friends ended up as teenage parents in spite of their involvement with this constructive after-school activity (interview, 1999). Robby Espinoza, a dancer at CDO High School in the northwestern suburb of Oro Valley, also felt that the dance club was a positive influence in his life:

> If there wouldn't have been that dancing . . . I don't think I would have had fun in high school. Because I was not into drugs. I would drink, because all my friends are crazy, but the drug thing was totally out. All the friends that I actually grew up with, all the other friends, were into the partying, the drugs—they didn't know how to just have fun, so they went about it the wrong way. For me, as soon as I got into high school—I believe when you get into high school, your path can be either good or bad. You can turn either way. Luckily, I turned the good way. I got my choice, and that was dancing. It was like clean fun. So it was a good thing for me, I don't regret it at all. The best times of my life were in high school because of that. (Interview, 1999)

The dance itself was a much more central part of Tucson's que-bradita community than it was in South Central Los Angeles. Clubs held practices after school for several hours, usually in a member's house, but sometimes at school. The frequency ranged from once a week to every weekday. It was an intensive program, and many dancers were injured at one point or another; angry words were occasionally exchanged, especially when tensions ran high before a perfor-

mance. However, dancers regarded the rehearsals as enjoyable and important experiences in their lives. José Hunt said, "I really liked the practices because the people were a lot of fun. . . They would always be talking, dancing. And they would bring the truck, one of the cars they had, and bring it in to the front of the school. They would play the music really loud and they would start dancing" (interview, 1999).

Dancers could join a quebradita club through friends or family members, by virtue of their prowess, or simply because of their interest. Ernesto was able to join Ritmo Alegre simply by proclaiming his interest to the deejay in charge, but when directing his own group he actively recruited dancers. He looked for the following qualities in new members: "I just went by how they danced and how they learned. Their ability to move, and not just the couple—I would look at the guy and the girl, and if he was able to pick her up and do the moves that I would try to teach them." The main requirement to get into Darma's dance group was simply to attend the rehearsals. Of course, one had to have some dancing ability and contribute money for the costumes as well. A Tucson student reporter wrote that new members were found "when they're at concerts [because] they try to show off their skills in front of dance clubs or members of dance clubs to get in" (D. Rodríguez [1998]). The CDO club sought to include members from diverse backgrounds, which was sometimes difficult. Shannon Ortiz explained:

> We would advertise to "join the club" around school, and if they wanted to do it, they were welcome to go up there and start learning the moves. No requirements, as long as they were willing to do it. Of course, some would be intimidated, I know, because I knew a lot of good dancers, and I would tell them to join. A lot of them were in dance, or theater, or performing arts, and a lot of them were intimidated because, like I said, it was in the Hispanic Culture Club, the Quebradita [Club]. Most of us were Hispanic, so people that weren't were sometimes intimidated. But once they knew, once they found how everyone was willing to help, they would get involved. (Interview, 1999)

The Tucson High club also recruited by posting flyers, and Marcela noted that this was the first time in which young men showed up to participate in a dance group in greater numbers than young women. Furthermore, Anglo American and African American students also became involved in the Tucson High club in this way.

As explained in the previous chapter, quebradita clubs took the place of gangs in Los Angeles by filling many of the same functions, but putting them into a positive context. In Tucson, too, gangs have had a longstanding presence, and quebradita clubs shared some cultural practices with them. For example, many researchers have noted the importance of nicknaming in Mexican American culture in general; this practice plays a significant role in defining individuals' identities (e.g., Castro 2000:70). In gangs, nicknames are particularly important. Vigil explains that adolescents trying to define new identities for themselves are assigned nicknames by fellow gang members "to signify acceptance." Later, the nicknames may be tattooed on the body to cement affiliation or painted in graffiti to claim territory and gain public recognition for an individual who may feel ignored by the larger society (1988:113). Quebradita dancers in Tucson were often known by nicknames they had received prior to joining their group, most likely through friends or family members. Many were given animal names, such as Pollo (Chicken), Pato (Duck), Teterete (a type of lizard), Perro (Dog), or Gato (Cat). Other names might be related to Mexican culture, such as Ranchero, M'ijo (a contraction of *mi hijo*, "my son," and a common term of endearment), or Diablo (Devil, an important figure in Chicano folklore [see Castro 2000; Limón 1994]). Ernesto's nickname was Neto, a derivative of his given name. In his dance clubs, female members also had nicknames, such as Chola, Negra, and Placa. Dancers did not tattoo themselves with these monikers, but instead incorporated them into dance costumes, embroidering or appliquéing them on a jacket, pant leg, or bandana. Not everyone was given a nickname, however, and Ernesto's group seems to be the only one in which the girl dancers had them. Just as club names sometimes came from popular bandas or their songs, some nicknames were similarly derived; for example, "Teterete" is the name of a song by Banda Maguey.

Although outsiders often compared quebradita groups to gangs, the dancers themselves preferred another metaphor. Club members became very close, and it was not unusual to hear them describe their organizations as "families." For Robby, one of the most important aspects of his participation in a quebradita club was that he "grew these really great relationships and friendships": "we were like a big party, we would always be together. We would go dancing at quinceañeras, and we were together twenty-four/seven, all the time." The

group experienced a profound loss when one member, Robby's partner, was killed in a drunk-driving accident. The difficult times the others experienced as a result seemed to have brought the members of this group even closer together than the members of other groups with whom I spoke. Shannon described her fellow club members in the following way: "They were your friends and people to fall back on, to hang around and have fun. It was like a support group. A lot of them were like family; they would do everything together." She went on to note, "The dancing definitely brought us together as friends. A second family, I guess you can call it."

At the same time, many teenage dancers were aware that choosing to dance quebradita had a much greater political and social significance than choosing another dance—say, the Macarena. Group membership could become an important part of one's identity, affecting both the ways in which dancers saw themselves and the ways in which they were seen by others. Martin Stokes writes, "Music is socially meaningful not entirely but largely because it provides means by which people recognize identities and places, and the boundaries which separate them" (1994b:5). Music and dance are especially important as ways in which groups are formed and defined. Manuel Peña, in his article on Chicano dances in California, says that dance, as a "highly selective, expressive behavior, must clearly be seen as symbolically motivated. How else can we interpret the choice of Chicano music and dance, which by their uniqueness lend identity to the group?" (1980:65). Quebradita was and is a unique form of dance performed to a unique type of music; at the height of its popularity in the 1990s, it was also highly visible owing to all the attention paid it by the media. As such, it became a powerful symbol that was used to denote identity, place, and boundaries on individual and group levels.

In most high schools, "cliques" or small social groups are formed based on common interests, ethnicities, or musical tastes. Quebradita clubs were formed according to all three and in turn helped to form the participants' social identities. Shannon remarked, "You were known by, you were known to be in the quebradita group"; so involvement with clubs was one way in which dancers were identified by their peers. In Mexico, such associations were apparently even more important. Darma spoke of the way in which quebradita was used to define social groups in Hermosillo, Sonora, where *cheros* (short for *rancheros*, a social group defined by their Western-style clothing and interest in

Figure 5.2 Grupo Laberinto performs tecnobanda music
at a club in Hermosillo, Sonora, in July 1999.
(© 1999 Emily Simon; used with permission)

ranchero-style musics) danced it to distinguish themselves from op-
posing groups such as fresas (rich kids), skaters, and cholos. The
groups seldom mixed, and she cited this separation as one reason why
quebradita was still danced in Mexico in 1999 (fig. 5.2), but seldom
seen then in Tucson. In Sonora, the cheros had their own clubs where
they danced quebradita. The fresas made fun of people who wore
hats, and if one of them ever dated a "cowboy," their other friends
would give them a hard time. Chilangas, girls from Mexico City, were
another group that would not dance quebradita. Darma noted that
her brother's girlfriend was a chilanga, and she taught him to dance
salsa instead. Also, the one chilanga member of Los Diablitos never
wanted to dance quebradita, but chose to participate only in their
occasional salsa or merengue numbers.

Similarly, José was at first hesitant to join the quebradita club.
Emphasizing the importance of personal style and identifications in
such decisions, he explained, "The quebradita is kind of like the cow-
boy music in Mexico, and I didn't really dance that kind of music. Or,

I didn't dress like people who danced that kind of music. I just started dancing because my friends did it." Later he elaborated:

> I'm not sorry I joined. A lot of my friends looked at me weird because I was doing quebradita. It's like if I joined, a lot of people here don't like country music, and it's like I'm with my friends that don't like country music and I joined a country dancing [club]. And they're like, "Okaaaaaay." Some of them [saw me perform]. They would laugh. Yes, they would. They didn't like the whole concept. They didn't like the music, the outfits, anything. They would just make fun. "You little cowboy," whatever.

In California, Griselda Mariscal reported a similar initial reaction from her friends when she began to dance the quebradita: "They'd see me in my *botines* [boots] and ask me where my horse was" (quoted in Martínez 1994). She pursued her interest in spite of her friends because she found it a way to get closer to her culture and feel proud of it. Women often seem to have been the trendsetters. Another male Californian dancer stated, "I used to make fun of people who liked *banda* music. But then I went to one party, saw all the pretty girls, and then went out and bought myself the boots and the hat" (Ricardo Contreras, quoted in Seo 1994).

Although not all quebradita dancers were of Mexican descent, most were, and participation in quebradita clubs served to call attention to that ethnicity. In many cases, their Mexicanness had not previously been an important component of their self-images, as Shannon revealed: "[People would say], 'Wow! I didn't know you were in the group!' because I don't look Hispanic. But I would get compliments, my teachers would say, 'Yeah, you should have seen Shannon do those moves.' Things like that." Such revelations were especially significant in the high school context. Paula Fass's (1998) research has shown how youth use socializing institutions such as the school for their own purposes by reshaping and appropriating those spaces to create shared experiences, codes, and cultures. Quebradores did just that: by dancing in lunch rooms, in classrooms, at school entrances, and at school assemblies, they claimed those spaces, declared their affiliations, and created new cultural experiences they could share among themselves and with other dancers across the border region.

School demographics and geography seemed to play the most important role in determining dancers' level of involvement with

quebradita. For example, the three CDO dancers I interviewed, Robby, Shannon, and José, expressed most strongly the importance of quebradita in their lives. The physical distance between CDO, located in a far northwest (and mostly white) suburb of Tucson, on the one hand, and the other quebradita clubs and the local Mexican American cultural happenings (which usually take place in central or south-side locations), on the other, was one factor that made participation in this activity especially important to its dancers. In addition, out of all schools with quebradita clubs, CDO was the one with the smallest Hispanic population: in 2002–2003, only 14 percent of its students reported this ethnicity, and 80 percent were white.[22] Therefore, the cultural component of the dance was especially important to these students who had grown up having little contact with Mexican American culture. It enabled them to find alternative role models and to learn more about their heritage. Robby explained, "Quebradita just made me realize so much about myself. I don't think, if I wouldn't have danced, I wouldn't have had that inspiration. For me, going out and seeing the good dancers, I was like, 'God! I want to be like them!' I don't know—to live on the north side, and to be away from all the culture and stuff like that, it's hard."

Students at other schools found quebradita a useful tool of resistance in ongoing conflicts, both between students of different ethnicities and between students and administration. Catalina High School had a more diverse student body than did CDO, with 38 percent Hispanic and 49 percent white. Darma described how her school's administrators made little concession to its Spanish-speaking students, playing few or no Spanish-language songs at school dances: "We used to dance . . . at school. But they would only put on one song in Spanish. And the Mexicans used to go there, we always used to say, 'Well, we could dance this, but we really don't like it.' So we just used to leave, you know? Then we used to make our own dances, and we used to rent a band. And then they would always dance and dance and dance."

At one school dance, the deejay whom Nirvana's folklórico group had rented attempted to put on an English-language song. The groups' members became angry and demanded he take it off. In reaction to the lack of cultural diversity at school dances, she and her friends created their own dances where no English music was played; perhaps such events were also a factor in their decision to form a

quebradita group. Similarly, a Los Angeles–area deejay stated that he would "get booed" if he tried to play rap at a Latino-majority middle school dance where he was spinning music—he had tried once just to make sure (Quintanilla 1993). Stokes believes that "music is one of the less innocent ways in which dominant categories are enforced and resisted" (1994b:8); these actions may be part of such a conflict.

The other dancers with whom I spoke attended schools where Mexican American students were in the majority. At Tucson High, 59 percent of the students report Hispanic ethnicity, as compared to only 28 percent reporting white. Sunnyside High School currently (2005) reports 91 percent Hispanic, up from 87 percent in 2000, and only 4 percent white. Dancers at both of these schools had a wide range of opportunities for participation in Mexican culture. For instance, both schools have folklórico dance and mariachi programs. Both are also located closer to South Tucson, the traditional center of Mexican culture in the city, and to other sites where a broad range of Mexican music and dance can be found. Although Ernesto had greater success as a quebradita dancer than did the others, performing on stage with well-known bandas and winning numerous competitions, both he and the Tucson High dancers expressed less nostalgia for the quebradita than did dancers from the other schools. They simply transferred their dancing interests to other forms: Ernesto to cumbia and norteña, Sandra Franco and Ximena Gómez to ballet folklórico.

In Arizona, schools thus provided a platform on which quebradita could be developed. By creating school-based peer groups centered around the dance, quebradores established connections with older Mexican identities while also creating new ways of relating to them. Such activities are not new. Fass has shown that New York City high school students in the 1930s and 1940s formed similar ethnic groupings, creating hybridized American identities. The activities of these earlier German, Irish, Italian, and Jewish immigrants continue to resonate today in the lives of their grandchildren; "youth society shaped ethnicity for the second and third generations" by "refashion-[ing] their immigrant traditions into American identities" (1998:114–15). It is possible, even likely, that quebradores' activities will have similarly lasting effects. The embrace of regional Mexican styles in the 1990s gave many teenagers a new sense of pride and paved the way for more recent trends in Mexican American music (to be explored in chapters 6 and 7). These occurrences may in turn be seen as a con-

tinuation of earlier southwestern dance activities, such as the teaching of folklórico dance at schools, a practice that dates back to the 1960s in the United States and to the 1930s in Mexico.

Overall, quebradita was a positive phenomenon that took an important step toward the recognition and acceptance of Mexican culture by both Mexican American youth and people of other ethnicities. In the United States, this dance was a marker of membership in a larger Mexican American cultural and linguistic community; it also strengthened the bonds within this community by encouraging youth to participate in it. It made the general public aware of that community and its contributions, and it created a sense of belonging for those who participated in it. The very fact that so many quebradita performances were given in so many different types of settings shows that it played a significant role in public relations, and the fact that it succeeded in improving those relations is shown by the overwhelmingly positive reactions it provoked among both audiences and performers. Within Mexican—specifically, Sonoran—society, in contrast, the dance seemed to divide more than it unified. It marked identity in a particular youth cultural group and differentiated that group from others.

Yet the dance also functioned on a more personal level. It became part of each individual's identity because of the feelings of pride and accomplishment that resulted from mastering the difficult steps, from gaining acceptance and approval by performing them, and from identifying with its symbolic elements (ethnic, linguistic, social, and cultural). Several dancers cited their performance of quebradita as an activity that helped to define them as individuals, and all of them spoke of the time they spent with their dance club as a positive experience.

Quebradita Performance in Tucson

Quebradita dancers in Tucson occasionally attended nightclubs and concerts such as those in Los Angeles described in the previous chapter, but because of their age and economic situations these venues were not their primary performance sites. Flyer parties like those described in chapter 4 were not to be found in Tucson. Instead, other events—including public festivals, competitions, family celebrations, concerts, and rodeo events—took advantage of Tucson's unique quebradita organizations and were safer for the participants.

CDO Quebradita Club sponsor Darron Butler spoke of arranging performances for the group at school lunch periods, in malls, and at Mexican Independence Day (September 16) and Cinco de Mayo celebrations. He made arrangements mainly through "word of mouth, you know, I'd brag about the kids, and [that way] it would filter out, you know, it was just like a snowball effect" (interview, 1999). The group also traveled to other schools as sort of an outreach effort. For example, they once performed at a junior high school in San Manuel, a nearby mining town, where students were trying to form their own Hispanic Culture Club. They hoped to help the San Manuel students by inspiring more interest in this culture. The most memorable occasion for Darron was the time the group danced during halftime at a basketball game between CDO and Amphi, its archrival (see fig. 3.1). They chose this opportunity, Darron said, "because Amphi is, coincidentally, made up of a lot of . . . Hispanic population. And so we thought they'd really enjoy that, so we took advantage of that." The students put an extra measure of effort into the preparation for that event, but the thing that really made it a special performance was the audience response.

> We scheduled during halftime of this CDO-Amphi game and we got, I mean, really rave reviews. I mean, we ran into almost delaying the second half of the basketball game because the response was so good, and the kids just enjoyed it. They really set off the fan support and so forth. . . . I think the motion, the attitude, the "psych" was there you know, and it showed in their performance. They were really good. . . . They just—they fed off the fans, you know. . . . It was never more evident than that night at the basketball game because they just fed off that, and it consequently translated to a better performance for them, I thought.

Shannon, too, remembered the halftime show as a noteworthy event: "I was so nervous; I'd never done any performances like that at all. I'd done cheerleading, that was the closest thing. And we went out there and nobody made any mistakes. Everything just went so smoothly, and we got a standing ovation. It was great. The feeling when everybody's watching you, and afterwards, people said, 'Hey, that was awesome, at the basketball game!' Quebradita was one of our prides at the school. We were the ones that would get [the crowd] pumped up."

Performances were very positive experiences in general for the

CDO club because audience reactions were so overwhelmingly enthusiastic. As Shannon explained, "Everybody that I can remember from all the performances loved it. Just loved it, because you know, everything is upbeat and fun, and you want to move too. All my friends [would ask], 'How do you do that move?' A lot of people would want to join." For many dancers, this occasion was the first time they had publicly declared their Mexican heritage, and the encouraging response affirmed their new sense of ethnic identity.

José recalled that before the Quebradita Club was formed, CDO students danced mainly at weddings or parties, but once the group was created they began practicing with formal performances in mind. The first time he participated as a performer was at a fund-raiser in the school lunchroom. He felt good about this event because the audience, who had paid to attend, gave positive feedback. Later on, he performed for larger audiences in the gym, which he found more stressful: "It was just weird, I think the most embarrassing one. Because I was very embarrassed to dance in front of everybody in school. It was a lot of people, and we were right in the middle. And then if I messed up, it was a lot of pressure, because if I messed up I would look so dumb."

Robby, also with the CDO group, recalled dancing at the school's pep assemblies and at the carne asada dinners they held as fund-raisers. On one occasion, they traveled to Phoenix to perform at a "big event": "They [the event organizers] had a choice between a folklórico group and the quebradita group. And we sent them a tape, and they got to choose which group they wanted. They chose us over the folklórico. And we saw the folklórico tape, and that was *good!* We were like, 'God! We got picked! We better practice!' "

Robby enjoyed all the performances because, he said, "when you practice and practice, it feels good when you perform. It's like, Yeah! We're doing this, and we did this right, and the people are actually watching—it's just a thrill I guess." However, no single show stood out in his mind as particularly noteworthy; the memories of his late partner were more important to him than the dancing itself. "To look back at our performances, with me and [my partner] dancing, I think those are the most memorable. . . . It's so sad, but at the same time it brings joy."

Los Diablitos, a group with which both Darma and Ernesto were at one time involved, performed not only at places such as the South-

side's Kennedy Park (where the big Cinco de Mayo celebrations are held), but also and principally at parties, competitions, and the swap meet. There, they would dance for two to three hours. The large audience usually in attendance was composed of both Mexican Americans and other people who just "wanted to see something different," Darma told me. After dancing, one of the group members would pass around a hat to collect money, which they would then use to buy more music or other supplies. The group sometimes went on the road to places such as Phoenix and Nogales. Unfortunately, generational conflicts were as present in Tucson as they were in Los Angeles. Darma's parents disapproved of her attending parties and would not allow her to travel to performances. She was, however, able to perform at a local girl's quinceañera, inspiring others to join:

> There were four girls and like seven guys. We did like three dances, but I don't really remember them. There were a bunch of people there, a lot of young people and family members. It was over there by the west side. We danced out in the basketball court, 'cause it was in a house that had a basketball court, and we danced there. They liked it a lot. People from the neighborhood saw, and they really liked it. They would scream a lot and stuff, like people's names that they know. There were some girls who wanted to get in the group.

Of course, parties were also important locations for social dancing. Darma fondly remembered the dance parties that her group organized at their school that all students could attend.

> We had it at school, at the cafeteria. They let us borrow it. But first, we had to make car washes so we could rent the deejay and stuff. We didn't get that much off of it. We were supposed to get more for the tickets, but there were lots of people that didn't go. So they didn't want to make another one. We were like, "Make another one for Cinco de Mayo," but they didn't. It's kind of going away now, because last year I remember the Cinco de Mayo dances were nice, but this year they were kind of boring. There were so many Mexican people there [before].

By 1999, though, quebradita dancing was tailing off—perhaps owing to oversaturation—and attendance at these parties declined.

Robby mentioned that he and other group members frequently

danced recreationally at clubs and bars in South Tucson (although they were teenagers, they still found ways to get in), and they attended banda concerts. In fact, he was once called upon to dance on stage with Banda Machos, a highlight of his quebradita years. But such events were not always safe. Robby had painted such a rosy picture of his years with the quebradita group that he felt obligated to admit that he had deceived his parents into letting him go out to nightclubs in South Tucson by saying he was attending friends' quinceañeras. Darma, too, described trouble at certain events. She noted that alcohol was associated with the parties her group danced at and was even served at quinceañeras, which explains in part her parents' reluctance to allow her to perform with the group more regularly. At performances and competitions, however, drinking and violence were present less frequently. Alcohol was not usually available, and the audience's attention was so intensely focused on the dancing and music that there was little opportunity or desire to engage in fights.

Shannon did not often attend nightclubs, but found social occasions such as students' parties to be perfect opportunities for trying out new steps: "That's kind of when we got practice, too. You didn't have the pressure that you're going to make a mistake. But you still got attention, people would still watch you. . . . We wouldn't do the flips as much because people would think you were showing off or something. But to this day, I still do the moves when I go to dances. Like yesterday, I was goofing off, and I was doing the moves. It stays with you."

Like CDO's Quebradita Club, the Tucson High group danced mainly at school and community cultural events, including Tucson Meet Yourself, the local folklife festival, and they once traveled to Mansfeld, a nearby junior high school, for their Cinco de Mayo celebration. The group's arrangements were made by members on some occasions, at other times by their folklórico teachers. Sandra described one performance at Kennedy Park as being particularly memorable for several reasons: it was at night, which set it apart from daytime school affairs; a large crowd attended; and everything went well during their presentation. However, in her opinion it was the audience that made it such an outstanding performance. At Tucson High, only students attended; at Kennedy Park, all types of people were present. For the park show, they were also interviewed for the five o'clock news. Reactions were very positive, and friends and other audience members made comments to the dancers about particular steps they liked.

Ernesto's group, Los Traviesos, had different goals in mind. They did dance at community events such as the big Cinco de Mayo festival in Kennedy Park, but they also performed in a more official capacity. They were featured at events sponsored by Spanish radio stations and on commercials for TV network Telemundo. They also eventually teamed up with Los Centenarios, a local norteño group, and went on tour. Pollo, one of the quebradita dancers from Guadalajara, was originally the manager for Los Centenarios, and his brother asked Los Traviesos to join them, as Ernesto recalled: " 'I want you to dance with us, not just for us, but for you guys also, 'cause you know, it would bring you guys up and you guys would bring us up. We'll help each other.' And that's true; that happened, we helped each other out. We did. Centenarios, Los Traviesos, together all the time. . . . We started helping each other out, and it kind of became big, both of us. It was a lot of fun."

A major part of the dancers' efforts was directed toward competition. Ernesto questioned his dancers about their goals: "I asked them, 'What did they want?' And they told me that they wanted to be a team and they wanted to go and get first place—they wanted to [kick] some ass!" He himself eventually tired of the competitiveness. "Afterwards, I started thinking about it and it wasn't no fun no more. It was competition, everything was competition. I thought it was, I had fun, that's what I wanted, just go out there and have fun. I mean, I'm not trying to be better than nobody, just go out there and dance."

Sandra, Robby, and Shannon all described occasions in which a simple performance unintentionally turned into a competition, although their groups usually did not dance competitively. Sandra told of a show at Tucson High in which several quebradita groups participated, including Ritmo Alegre, one called El Mexicano from a different school, and her own group, El Movilito. Someone put on music for all of them to dance to, and the students in the audience then began to scream for the steps they particularly liked (one favorite was el toro). This encouragement caused a competitive feeling, where each group wanted to prove itself better than the others. Shannon stated that there was a competitive atmosphere even in the social dancing at clubs. Everyone knew which school each dancer came from, so they all tried to outdo the others in a quasi-competition between the schools. Robby recalled how a similar thing happened at a quinceañera he attended: dancers went onto the floor to dance socially, but competitive feelings soon took over. Dancing in the Kennedy Park Cinco de Mayo celebrations would often have the same

result, he remembered: "We wouldn't intentionally try to compete, but you know, everybody wants to be better than other people, so it would always turn into competition. And pretty soon they would, the stage would call us up and pick out the couples and stuff: 'You come and dance up here!' And we would compete; it would just turn into competition."

The organized competitions took place at various locations and were often sponsored by stores or radio stations. The biggest one was held every November at Super Kmart and involved participants from all over Arizona, including the border town of Nogales, thereby creating a space where dancers from disparate locations and with different life experiences could interact and form a common bond (see D. Rodríguez [1998]). Darma attended this event as an observer and remembered that Ritmo Alegre "always used to win" because "they had one of the best dancers, and they were the first group that started out here." However, she found one group composed entirely of girls from Catalina High School even more interesting to watch because "they danced quebradita, and they danced salsa, merengue, they would combine everything. They were pretty good." Darma also saw competitive dancing at the swap meet and at low-rider car shows. According to Ernesto, another important competition was held at the annual Tucson Fiesta de los Vaqueros, where a quebradita "king" and "queen" would be chosen: "[My partner] became queen here at eleven years old. Every year there was a competition, there'd probably be seven or eight bands that come to Rodeo Park, the Rodeo grounds. Bandas like Banda Machos. . . . They would start a circle, and everybody would start dancing in the middle. And they would pick the best couple. And she was picked."

The presence of the quebradita at rodeo events reinforced the dance's ties to ranchero culture and aesthetics, but Ernesto's groups participated in other types of events as well, including the Kmart competition. Los Traviesos placed second in their first year of competition. That year, Los Diablitos took first, but because they were being sponsored by Kmart, their win really didn't seem fair. Ernesto told me that the criteria on which they were judged included "how they dressed, how they danced, and how everyone was going at the same time, you know—if I'm doing a move, that other couple has to do it together, all at the same time, like that." Similar types of events also took place in Mexico. I saw one in Pitillal, Jalisco, in 1998 (see chapter

1). In San Luis Potosí, quebradita was included in a competition that also featured tango, cumbia, rock and roll, country, mambo, and cha cha chá (Flores 1999).

As all these interview statements show, quebradita performance served to strengthen bonds within the quebradita community in Tucson while at the same time promoting *mexicanismo* both implicitly and explicitly. At public festivals like the one for Cinco de Mayo, quebradita took its place alongside mainstays of Mexican traditional arts such as mariachi music and folklórico dance during an event whose stated objective is to celebrate Mexican history and culture. Another, more subtle affirmation was given in participants' wholehearted embrace of the ranchero aesthetic through symbols such as specific clothes and dance steps. At the swap meet and at Kmart, quebradita dancers (even middle-class ones) affirmed working-class ties. At the rodeo, the dance was paired with riding and roping events of Mexican derivation, and at low-rider competitions it was companion to that very Chicano art form. Quebradita performances helped to establish the unique nature of the quebradita community in Arizona, one that centered on small clubs and usually good-natured competition held in public spaces, and one that was simultaneously directed both inward and outward, promoting intercultural understanding even as it provided an affirmation of Mexicano and Chicano roots.

Multiple Histories of la Quebradita

Perceptions of quebradita's history, though they vary widely, were another factor in dancers' understanding of their own ethnicities and identities. Quebradita's origins were a controversial topic, but also of interest to most dancers. I spoke with most of my Tucson interviewees about the dance's history and received very different responses from each.[23] As I discussed the problem with more and more people, I came to believe that the "truth" of the matter was less important than what people thought and said about it: their perceptions of quebradita history had a greater effect on their performance of the dance than did any particular historical facts. Although it would be interesting from a purely intellectual standpoint to know where the dance actually originated, the dancers' perceptions affected the art form much more than had any particular history. In this case, their thoughts and opinions created their reality.

Los Angeles dancers seemed to vary only slightly from one another in their understanding of quebradita history. A majority of them agreed that the dance most people think of as quebradita, the style that involves flips and tricks, originated in California, even though it was strongly influenced by various regional Mexican dances. However, in Tucson and Hermosillo, farther from the centers of quebradita and banda culture, perceptions varied more widely. Some dancers had very strong opinions on the subject of the quebradita's origins, and I noticed that their responses could be divided into two contrasting types. On one side of the issue were those who believed that the quebradita originated in Mexico. To those subscribing to this explanation, it seemed a safe assumption both because it is certain that banda music began on that side of the border and because quebradita makes such heavy use of Mexican cultural symbols. Ximena had never heard any explicit information on the history of the quebradita, but she surmised that because both Banda Machos and Banda Maguey were from the state of Jalisco, the dance might also have originated there. Sandra seemed to concur with her friend's opinion, but also noted quebradita's similarity to other dances found in the border region. Ernesto's argument in favor of a Mexican origin was stronger because it was based on his personal experience and travels to Jalisco: "When I went, when I used to go up there [to Guadalajara], that's when I started seeing that dance. And I came down here like a couple of months later, I started seeing that dance here. Everything came from up there, that whole thing, that whole dancing thing. You know, I don't know how, but I guess they got the rhythm, they know what to do."

Ernesto also noted that most of the major bandas, many of whom he was able to meet in person, were from Guadalajara. However, the most compelling part of his argument was that chronologically he had seen quebradita performed earlier in Jalisco and that it took the arrival of dancers from Jalisco to spark interest in the dance in Tucson. This account of the quebradita traveling from south to north commonly appeared in newspaper and journal articles as well. As I noted in chapter 1, Simonett assumes the truth of this account: "Music and dance have undergone several transformations on their way northward—from the Mexican countryside to California's biggest city, they have become modernized and highly commercialized" (1996:42). The *Los Angeles Times* statement that the quebradita came from a dance "once popular among farm workers in Mexico" (Davis

1993) is puzzling because it does not specify either a location or a source, but it also appears to support the argument in favor of a Mexican origin.

In opposition were those who expressed with equally firm conviction that the dance is a Mexican American creation or a product of the border zone. José stated with certainty that the quebradita came from California; he had heard this explanation given on Spanish-language television news shows such as *Ocurrió así* and *Primer impacto*. Robby agreed: "From what I learned, I heard it came from California. . . . [Jalisco and Sinaloa], that's where the *music* came from. Folklórico came from Jalisco, from, you know, from Mexico. [Spoken slowly and with emphasis] *Quebradita is a* pocho[24] *dance*. We turned it, the Americans turned it, into quebradita. It's like, we made it up. I believe it came from the United States. It really started in California, where they were just being creative with Mexican music." As further proof, José stated that he had been to Mexico and saw that they danced quite differently there; they were surprised by his distinctive style. (Ernesto also noticed a difference in style, but it did not change his opinion on the dance's origin.)

California sources naturally corroborated this theory, though the specific location varied. Elizabeth Sandoval, manager of a tecnobanda in southern California composed of members from Jalisco, stated, "The fad began in California, I think in San Diego" (quoted in Welsh 1994). In Tucson, Marcela did not specifically cite the state of California, but did assert that she believed the dance came from the general border region. She found it to be a recent and unique creation, different from any of the folklórico dances (the youngest folklórico dance usually performed is at least fifty years old). However, she did notice similarities with dances of the border states of Sonora, Nuevo León, and Chihuahua, and for this reason she believes that the dance originated in that area. Valeria Gardea Nacoch, too, considered the quebradita to be native to the border region because it was more popular there. She pointed out that music of a more international flavor was popular in cosmopolitan Mexico City, but that people were more conservative in the north and thus more likely to accept and enjoy the quebradita there. The style of the latter dance "was the culture from a long time ago, it comes from way back . . . from the ancestors" (interview, 1999). However, Valeria did not cite any specific point of origin. Reporters disagreed as often as dancers did. One *Los*

Angeles Times article appears to contradict another *Times* article written a year earlier. In 1993, the paper reported a Mexican-origin hypothesis (Davis 1993), but in 1994 another journalist wrote that "in Mexico, *quebradita* is just starting to catch on, about two years after the scene took off here" (Martínez 1994).

It is interesting and perhaps suggestive that whereas the Mexican immigrants and Sonora residents I interviewed gave the California- or border-origin hypothesis, most of the dancers and journalists residing on the U.S. side of the border gave the Mexican-origin hypothesis (only a few siding with the other camp). Both in-group members (Ximena, Ernesto) and outside observers (Simonett, Davis) are represented in the latter camp. The only accounts that do not fit this pattern are those where Mexican bandas claim to have created the dance; for example, a Mexican newspaper reported that the caballito was created by the popular Jaliscan group Mi Super Banda el Mexicano (Flores Vega 1997). However, such a claim could very likely have been made for commercial or promotional purposes only. In addition, although some dancers used the caballito and quebradita labels interchangeably, others explained that caballito was simply an earlier Mexican version of the quebradita that did not involve flips and tricks (see chapter 4).

In order to explain this dichotomy of opinions the dancers expressed regarding quebradita's origins, we might want to look at some of the possible reasons the dance originally became so very popular. Eric Hobsbawm (1983), in his work on invented traditions, finds that movements defending tradition or promoting its revival tend to appear in response to historical events that disrupt the fabric of a society. I have already shown how in California many dancers saw their participation in the banda movement as a reaction to contemporary social issues; ethnomusicologist Steven Loza indicates that anti-immigrant legislation in California was one "issue reinforcing the social and aesthetic needs of the Mexicano/Chicano aficionados of banda" (1994:56). Although the social and economic situation was somewhat less dire in Tucson than in Los Angeles, English-only laws were also being debated there as in other southwestern states in the early to mid-1990s. Under such conditions, it became increasingly important to validate Mexican and Chicano culture throughout the region. Loza explains that in reaction to this political situation, "[b]oth Mexican immigrants and U.S.–born Chicanos have opportunized the moment to 'jump on the banda wagon,' a vogue in which they are not vulnerably

pressured to assimilate to a North American musical style, but where they can reclaim and renovate their own traditions while defying the commercial standards of MTV and its related industry" (1994:56).

Loza also points out a parallel with mariachi music. Though mariachi was "a tradition once scoffed at by many an identity-complexed Chicano youth thirty years ago," it, too, has experienced a resurgence of popularity in the current climate of "rapid reversal, cultural reclamation, and aesthetic liberation" (1994:55). One might also add that almost all practitioners of the quebradita were teenagers and that adolescence is a time in which most people, no matter their cultural background, are "identity complexed" and struggling to "find themselves" or to establish their own unique identities. Besides the aesthetic, social, and sensual pleasures of dancing that were undoubtedly attractive to the quebradita's devotees, the complementary desires to reject the dominant culture that seemed to have rejected them and to construct more "Mexican" identities are the most likely causes of the banda craze not only in Arizona, but across the United States. It was thus more advantageous or appropriate for dancers on the northern side of the border to allege a Mexican origin for the dance. Conversely, the low opinion of banda music and of the ranchero and rasquache aesthetic in general held by many on the Mexican side of the border may explain Mexicans and Mexican immigrants' reluctance to claim the quebradita as their country's creation.

The question cannot be settled here. There is not enough information available to pinpoint definitively the quebradita's place of origin, and in fact it most likely originated in more than one place because of its very transnational nature. In the end, it may not make much difference which explanation is the "correct" one. It is "what people *say* of their origins, *think* about their connectedness and *embrace* as their traditions [that] remain the most telling information sources" (Carol Robertson, quoted in McDaniel 1999:97, emphasis mine). Dancers' belief in the "Americanness" or "Mexicanness" of the quebradita influenced their style, choreography, choice of steps, and even their self-perception much more than did the facts behind the stories they tell. In addition, both Mexican and Mexican American groups have expressed some truth about the art form. Certainly, both have contributed much to the music and dance; and it is interesting that "many banda musicians, *los banderos*, have experienced living and working on both sides of the Mexico–United States border," contributing influences from each side to their music (Haro and Loza 1994:69).[25] Similarly, in chap-

ter 3, I demonstrated how the quebradita combines elements of both Mexican and North American dances. It has been noted that when music and dance are used in nation-building projects, actual historical continuity is often less important than is the creation of links to the past by present-day actors (e.g., Scruggs 1999). Quebradita's social impact in the United States was determined not by historical facts, but by the perception of historical continuity with older dance traditions. Beliefs and stories about the dance's history were another way in which its counterideology was advanced and its bonds of community were strengthened.

Whether the quebradita was created by Mexicans bombarded by images of North American MTV culture or by Mexican Americans refusing to conform to such images makes little difference. The fact remains that the dance became useful and important to people on both sides of the border; the variety of opinions on the dance simply reflects its practitioners' variety of experiences. One twelve-year-old who had recently moved from Colima to Los Angeles remarked, "I like dancing *quebradita* mainly because it reminds me of Mexico and this is the dance and music of Mexico and Los Angeles. It's a combination of the two" (Karen Velásquez, quoted in Quintanilla 1993). For many people, that hybridity is part of the attractiveness of this art form. Los Angeles journalist Rubén Martínez wrote, "I've come to admit that rock 'n' roll is as important to my spiritual well-being as *la Virgen de Guadalupe*. I will always be the outsider in Latin America. I also oftentimes feel like an outcast in the United States. The only place I could be at home is in the new—the almost new—Los Angeles" (1994).

What Deborah Pacini Hernández writes about Dominican bachata—another transnational Latin American music—applies equally well to banda: "although one segment of society unquestionably had the power to dominate, control, restrict, and impose, the subordinate classes were not powerless: they had the power to refuse, to challenge, and to subvert" (1995:228). In Mexico, banda music and dancing may be seen as a tool of class resistance. In the United States, it provided resistance not only to the pressures of social class, but also and probably more importantly to cultural pressures as well. As Rubén Martínez rightly asks, "While [many California politicians] rant about the 'immigration problem,' the more pertinent issue might be this: When will they learn to dance the *quebradita*?" (1994).

6

Pasito Duranguense

From Durango to Chicago

The map of Mexican America can no longer be contained only within the border area. Mexican-origin populations in the Midwest and the East Coast are growing rapidly, some already in their third or fourth generations. Chicago, for instance, boasts a Mexican community second in size only to that of Los Angeles among U.S. cities and dating back to the 1910s, when railroad and steel companies actively recruited Mexican workers. This community has many features in common with the better-studied California population, including conflict between Chicanos and Mexican immigrants. Whereas many Chicago Chicanos blame immigrants for social problems within the community, Chicago Mexicanos are equally mistrustful of Chicanos for their "inability or unwillingness" to speak Spanish (Guerra 1998:8). Nevertheless, both groups tend to cluster together in particular areas of Chicago, most notably in Pilsen/Little Village and adjoining neighborhoods in South Chicago, but also in growing suburban communities such as Aurora.

It was in Chicago that a purportedly new type of Mexican regional music appeared and took the United States by storm in 2003. This trend echoed the quebradita/tecnobanda craze of ten years earlier in several ways: it, too, arose in a U.S. metropolis; it, too, had a dance and clothing style associated with it that was propagated in live performances and on videos and TV; and it, too, relied heavily on synthesized sounds. Outsiders' perceptions of those who listened and danced to this new style also brought to mind earlier reactions to the quebradita crowd: both groups were seen as uneducated, tacky in

their tastes, and composed mainly of Mexican rural immigrants. Some observers made explicit ties between the two dances, saying that the one had evolved out of the other.

This new musical style was called *música duranguense* (music from the state of Durango), and its dance *pasito duranguense* (the little step from Durango). It brought attention to the Chicago Mexican community, little known to outsiders who at first thought Chicago an unlikely source of the latest Mexican trend. Duranguense bands laid claim to Durango authenticity by calling on that state's official symbol, the scorpion, and placing it prominently on all their recordings; in reality, however, band members generally came from a mix of Mexican states, and many were born in Chicago. To some detractors, the scorpion was the only thing making the music Durangan in any way because the music itself sounded so similar to the tecnobandas of the 1990s.

Música duranguense shot to the top of the charts in Mexican states such as Zacatecas, and it was so big in Chicago that even the English-language press took notice. As *Chicago Sun-Times* reporter Laura Emerick later explained, "when you see TV ads for auto lots and groceries done in the *duranguense* style, you know you have a cultural phenomenon on your hands" (2004). By 2004, the music had spread west and south. Puppet "El Morro," voiced by Jaliscan Tomás Rubio, recorded a pasito duranguense for the kiddie crowd (Inclán 2004), and by the end of the year even Banda Machos, one of the original quebradita tecnobandas, got on the Durangan bandwagon with their new album.

Dozens of musical groups now play música duranguense, perhaps even a hundred in the Chicago area alone, estimates Daniel (Dany) Castro, the teenage Web master of a site listing duranguense events in and around the city (http://www.duranguense.5u.com/). Chicago-based groups are hired to play at Mexican nightclubs and parties throughout the Midwest and into the South, and groups playing the same style have been formed as far away as Los Angeles. Many Chicago groups who earlier had played tropical or norteña music found that by 2004 they had to change over to duranguense in order to stay in business. According to Simplicio Román of Chicago-based Acatlán Records and of Grupo Ansiedad, several Southside clubs, including Casino Tropical, OK Corral, Noa Noa, and Los Lobos now feature the style weekly, as does El Alamo in the suburb of Aurora,

where the new dance is said to have been created; many others, including the famed Aragon ballroom, have occasional duranguense shows featuring the most popular groups (interview, 2005). Underage dancers attend events held less regularly in church basements or banquet halls, and one such place in Cicero on the Southside holds these affairs two or three times a month. In addition, although even in Chicago banda sinaloense is the music most typically played at rodeo events, música duranguense can be heard at jaripeos in locations such as the Plaza Garibaldi in Little Village/La Villita.

Chicago's duranguense scene in many ways resembles the earlier quebradita communities of the Southwest, although it is far removed from them in place and time. Young Chicago dancers have formed duranguense clubs in their schools or neighborhoods to practice the new style. In the early 1990s, Simplicio told me, Chicago quebradores had formed clubs with names such as Quebradores, Club .357, and Los Guayabitos, and Dany Castro finds current pasito activity to be "the same" as that earlier dance scene (interview, 2005). Pasito clubs practice weekly and meet on the weekends at nightclubs or parties for informal competitions, where the audience chooses the winner by the volume of their cheers. Quebradita-style lifts are always big crowd pleasers, and club names resemble or are even identical to those of the 1990s: Los Tequileros, Diablitos, Club Parranda, and even Quebradores. Others take their monikers from popular music groups, who often return the favor by asking the club to perform their moves on stage (Las Hechiceras, interview, 2005). According to Dany, social dancers of the pasito typically wear expensive outfits combining tight jeans, elaborate belt buckles, and exotic skin boots with the new duranguense-style hats and shirts. However, club members "tend to dress ghetto," wearing jeans, sneakers, and T-shirts featuring the club's name when going out as a group. Gang activity is high in the duranguense stronghold of Little Village, and gang members do attend duranguense events, but they seem to have exerted relatively little influence on the scene as a whole as compared with their *cholo quebrado* predecessors (see chapter 4). Dany explained, "When I go out dancing, you can straight up tell who looks like a gangster, like a gangbanger. . . . They tend to cut their hair short, like almost shaved. Either they have it super short or they're bald. They have earrings and they wear certain colors, too." They are therefore easily distinguished from the rest of the dapper and usually clean-cut pasito duranguense devotees.

Also similar to the quebradita, duranguense is used to define peer social groups among Chicago teens. For example, Dany attends Prosser High School, a vocational school that serves the Belmont-Cragin section of Chicago, described by the Chicago Public School system as mostly working class, 46 percent black, and 36 percent Latino. However, because that Latino population is more Puerto Rican and South American than Mexican, duranguense has not caught on there. Dany told me that musical preference "all depends on the type of population or races that go to the school," so at his school the African American students listen to rap, but the Latinos prefer either rap or reggaetón. Listening to duranguense therefore makes him something of an "outsider" at school, but he avoids peer scrutiny by "dress[ing] like a person that listens to rap. I dress like that so I'm not looked at like a freak or an outsider. But there's times that, yeah, I feel left out, because I don't know a lot of people that like the same music as I do." Even rockers, a group similarly considered outcasts at Prosser, may disdain the duranguense style, and one of Dany's rocker friends makes fun of the associated outfit: "Oh, you're wearing a taco hat." At multiethnic schools like this, there can be stigma associated with listening to regional Mexican music, similar to that attached to a preference for American country music in other urban schools. Although in some parts of the city (such as Little Village) duranguense is all the rage, Dany must content himself with attending occasional weekend dances with older cousins while camouflaging his tastes during the week.

The current duranguense craze is not simply a repeat of the 1990s quebradita movement, however, despite these similarities. There exist several differences between the self-presentation and sounds of duranguense groups and those of the tecnobandas. Duranguense groups often draw on U.S. landscapes to create a transnational imagery in a way that their predecessors did not. They also further call into question the relationships between popular music, identity, and geography through their use of recontextualized regional symbols and a heightened artificiality, and their use of distinctive song forms reveals the emergence of new adaptations to U.S. capitalist society.

Duranguense Music

The most popular of the Chicago duranguense groups is Grupo Montez de Durango, also considered the originator of the pasito

craze. Most of the Montez musicians grew up and began playing in the suburb of Aurora. Over the past two decades, many Chicago Mexicans have been moving out of the city to escape urban violence and take advantage of more affordable housing.[26] Simplicio told me that some members who joined the band later came from inner-city locations, such as keyboard player Francisco, who attended Pilsen's Benito Juárez High School and there played in the mariachi band run by Victor Pichardo of Sones de México (Simplicio himself received the same training). This dance craze thus has the unusual distinction of having started in the suburbs and then spread into the cities.

Although Grupo Montez originally formed in the mid-1990s, their style was somewhat different from the then-popular tecnobandas, and it took a few years for sales to take off. After recording eight albums, Montez and their música duranguense finally "hit" in 2003. By August 2004, the band had sold more than one million copies of their CDs *El sube y baja* (2002), *De Durango a Chicago* (2003), and *En vivo desde Chicago* (2004). Founder José Luis Terrazas attributes the lag time to their former record label, who "didn't know how to manage them" because they were neither "norteño, nor banda, nor grupero, but 'their own style'" (quoted in Sauceda 2003). Lead singer Alfredo Ramírez instead gives credit for their extraordinary success to the fact that "we're from the *rancho, del pueblo* [of the people], and we have our feet very firmly *en la tierra* [on the ground]" (quoted in El Kaiman 2003). Montez's rhetoric of rootedness, transmitted through song, talk, and images, seems to have resonated with many immigrants in Chicago, as duranguense quickly replaced the more international grupera and tropical styles as the music of choice in the city's Mexican communities.

Música duranguense is the latest in the series of transnational styles generally categorized as "regional Mexican," including banda and tecnobanda. Some observers, such as Web columnist El Kaiman, give credit to Montez for again "awaking *lo mexicano* in our youth with your music . . . again you have made the young people who live here in the United States like Mexican music" (2003). Yet the duranguense style, in spite of its label, is a kind of "Mexican music" that cannot be traced to just one region of origin. Simplicio Román explained to me that traditional Durangan music is a local variation on norteño style that uses bajo sexto, bass, saxophone, and even flute, but Chicago groups have altered this sound by combining it with elec-

tronic sounds and influences from other parts of Mexico. Terrazas describes Montez's music as "harmonica with Sinaloan tuba flavor, but played on keyboards and tambora. . . . A bit was taken from Sinaloa, with traditional music of Monterrey, Nuevo León, and the tambora of Zacatecas, revolutionizing the grupero style" (quoted in Sauceda 2003). Likewise, the dance is a blend of banda, merengue, and other styles that was created by Montez fans in Chicago (Sauceda 2003; another reporter specifies "quebradita and merengue" ["El año 2004" (2005)]). *La Opinión* reporter Isis Sauceda traces the dance's trajectory as follows: born in Chicago around 1999, next popularized in Texas, then in Durango, and finally in Los Angeles with the release of Montez's *De Durango a Chicago*.

Although no one can deny Montez's popularity, their claim to be the "creators of the pasito duranguense" is debated. Patrulla 81, for example, is another Chicago group that lays claim to the title. Lead singer José Angel Medina maintains that he holds no ill will toward Montez because both he and they "are from the same *ranchería* [hamlet] in Durango" (quoted in Page 2004). However, he believes that the rhythm was actually born in Durango twenty years ago, then passed through Zacatecas and on to the border states, finally arriving in the United States with immigrants from Durango in Chicago, who formed their own groups in the duranguense style. Medina blames the quebradita for the delay in the popularization of the music, stating that the 1990s craze displaced the locally popular duranguense style in Mexico, causing many groups either to break up or to play that style instead (Page 2004). Simplicio agrees that Patrulla 81 originated the duranguense sound in the 1980s by being the first to play with a melodica, something like an accordion-harmonica hybrid, but claims that Montez innovated even further with the addition of the electronic tuba borrowed from Sinaloan/Jaliscan tecnobandas. Other Chicago duranguense acts choose to stay out of the argument on música duranguense's origins, but some do claim a unique style all their own. For example, K-Paz de la Sierra is made up of members from San Luis Potosí (in Michoacán), Guanajuato, Durango, and Chicago, and they describe their style as "duranguense combined with the *tierra caliente* style [of the Michoacán area]" ("Biografía" n.d.).

Some local fans believe that it was precisely the unique mix of influences provided by immigrants from different Mexican states that produced this unique Chicago style. In 2003, greater Chicago's Mexi-

can population was estimated at eight hundred thousand to one million. Two-thirds of this number are Mexican born, and, of those, 80 percent hail from Guerrero, Jalisco, Zacatecas, Guanajuato, and Michoacán (Bada 2003). Simplicio explained that although some immigrants are very regionalist—many Zacatecans, for example, listen only to norteña music or to their own regional tamborazo styles—the rest support the local duranguense scene regardless of origin. Dany Castro said that quebradita was very popular on Chicago radio in the mid-1990s just before the duranguense style emerged, and he thus surmises that quebradita "had a lot of influence on the music," while additional inspiration came from immigrants from Durango and the *tierra caliente* region that encompasses the hot southwestern states of Michoacán, Guerrero, and part of the state of Mexico. Although he believes that "the music is originally from Durango," it mixed with other styles in the Windy City because "there's different types of people from different parts of Mexico that play it." More specifically, Simplicio noted that when an event is advertised as "100 percent duranguense," the music may be all Durangan, but only a small percentage of the audience is.

The development of the duranguense sound also owes much to the influence of local media. José Luis Terrazas himself played an important role in this area through his founding of Terrazas Records in the 1990s. Under this label, he united all the local duranguense groups, including Patrulla 81, Banda la Interrogación de Durango, La Inicial de Durango, Alacranes Musical, of course Grupo Montez de Durango, and later other popular acts such as Los Horóscopos de Durango. He then convinced groups such as Patrulla to change over to the tuba-bass sound already in use by Montez, further consolidating the Chicago duranguense sound. Once local radio stations began playing his productions, the style caught on in the area, and CD sales picked up. Before long, Simplicio explained, the major labels noticed, and the most popular local groups were contracted by Disa, Universal, and Fonovisa.

Música duranguense sounds much like other norteño styles, with some songs in polka rhythm, others in waltz time, and still others in the faster two-four time suitable for dancing the pasito. Medina claimed that música duranguense owes its distinctive sound to the *tamborón* (large bass drum with cymbal affixed to the top) and the *melodeón* (melodion, but also a term used as a colloquialism for the

button accordion) (Page 2004), although most current groups do not include the latter instrument, instead imitating it on the synthesizer. Synthesized harmonica and flute sounds are also popular, a fact that Amaury Ruiz, director of the group Las Hechiceras de la Jungla, attributed to a possible revolutionary/nationalist connotation: "At the time of the Mexican Revolution the harmonica was used a lot, and so for that reason the bandas also put the harmonica sound on the duranguense keyboards [as well as] flute, which is a typical, very 'country,' and revolutionary sound" (Las Hechiceras, interview, 2005).

Duranguense groups therefore share with quebradita-era tecno-bandas their use of electronic instruments, but they can be distinguished from the latter by their use of the tamborón (sometimes informally termed *tambora*), their use of indexical Mexican Revolution symbols, and the rhythms they choose to play. Whereas tecno-bandas focused on the cumbia, Simplicio clarified, duranguenses prefer rancheras and corridos played in the new style. In addition, duranguense groups make even greater use of electronic sounds than did their 1990s tecnobanda predecessors. Instead of the trumpet sounds preferred by quebradita groups, synthesized harmonica, accordion, string, and tuba sounds are common among the duranguenses; and flute, organ, and electronic piano sounds make an occasional appearance (organ is particularly favored by Patrulla 81, and a reedy flute sound distinguishes Los Alacranes). Finally, the duranguense sound is more self-consciously artificial than the sound of the 1990s groups, who principally tried to re-create the original instruments' sounds on their keyboards. Duranguense musicians sometimes heighten artificiality through the use of the keyboard's pitch-bending feature, with which they create sounds that acoustic instruments would not be technically capable of producing. Through the combination of a fast tempo, synthesized flute and reed instruments, bass drum, and cymbals, a duranguense group can approximate the sound of a calliope, a fact that has led some banda fans to describe música duranguense disparagingly as "circus clown music."

Both fans and detractors have pointed out that many recent duranguense hits are actually new versions of much older songs. The practice of covering traditional songs and older norteña hits was also present during the quebradita days, but is more widespread among Chicago Durangan groups. Montez's hit "El sube y baja" (2002), for example, is a remake of a song composed by Paulino Vargas (though

possibly based on a still older song) and recorded by norteño group Los Broncos de Reynosa in the 1970s. A romantic first verse is followed by a cryptic chorus that makes a sly sexual reference. But perhaps it is telling that some fans, in posting the song's lyrics on the Web, have mistranscribed the second line in the chorus. For them, "Qué llega hasta el plan" (What gets to the bottom of it) has become "Qué llega hasta *Atlán*," where Atlán is a variant of the mythical Aztec homeland of Aztlán that Chicano movement poet Alurista located in the U.S. Southwest.

In this way, listeners transform a rather sensual pop song into a way of locating themselves, and by extension their midwestern city, in a continuum of Chicano history. Meanwhile, Conjunto Atardecer's "Ujole" closely resembled an old ranchera typically performed by mariachi groups, and K-Paz de la Sierra had a hit with their duranguense version of Hank Williams's "Jambalaya." Lyrics to original numbers are often on the common ranchera themes of lost loves (as in "Hermosas fuentes" by Los Alacranes [2004]) or longing for beloved places ("Colonia Hidalgo, Durango querido" by Montez). Immigration experiences also show up frequently, as in Montez's "Las mismas piedras," a song that tells of a man who leaves home at age twenty and returns later only to find his parents have died.

Although I do not wish to embark on a lengthy musical analysis, I do want to point out a few important structural features of música duranguense tunes. These songs often use the uneven phrase lengths common to many types of Mexican traditional musics (and to older North American country tunes as well). Yet they are very unlike older styles in their tendency to use closed forms with a remarkable degree of symmetry. A brief look at two pasito duranguense songs, both of which are in the fast two-four rhythm to which the new dance is performed, demonstrates these facts. Table 1 shows the pattern of thematic material used in the alternating instrumental and vocal sections of "El sube y baja" by Grupo Montez de Durango and of "Hermosas fuentes" by Los Alacranes de Durango.

In both songs, each instrumental section and its variations are characterized by a different synthesizer patch: harmonica, then flute in "El sube y baja" (A_1 and A_2); and harmonica, marimba, then a reed flute/saxophone combination in "Hermosas fuentes" (A, B, C). Both songs also combine odd and even phrases. The Montez tune features four 3-bar phrases in the verse (B), followed by a chorus (C) of four

Table 1 A Formal Comparison of Two Chicago Duranguense Songs

	Inst.	Vocal	Inst.	Vocal	Inst.	Vocal	Inst.	Vocal	Inst.	Vocal	Inst.
"Sube y baja"	A_1A_2+	B/C	A_1	B/C	A_1A_2+	B/C	A_1	B/C	A_1	B/C	A_1A_2+
"Hermosas fuentes"	ABC	D/E	C	D/E	**ABC**	D/E	C	D/E	ABC		

Note: The symbol "+" stands for a lengthening by vamping, and "–" stands for a lengthening through partial repetition. The boldface type indicates the true midpoint of the song.

2-bar phrases, whereas the Los Alacranes tune alternates a section of 3-beat phrases (D) with a contrasting section of 4-beat phrases (E). Finally, both are completely symmetrical in arrangement. In "Hermosas fuentes," all three instrumental sections return at the song's midpoint and end; otherwise, only section C separates the four verses. In "El sube y baja," each of the six verses is similarly separated by one instrumental section, and the entire instrumental opening returns at the exact midpoint of the song as well as the very end. These tight formats mean that nothing can be added or removed from the song without dramatically affecting its structure, so that both live and studio recordings of "El sube y baja" are the same length. In addition, a comparison with the Broncos de Reynosa version shows that the symmetrical form was a Montez innovation. The original 1970s recording is only half as long and takes a much simpler extended ternary form (AA+ BC AA+ BC AA+ BC AA+).

The closed forms that Chicago duranguense groups seem to prefer are significant because they are so different from the open-ended structures more common in older forms of norteña music. For example, the corrido is a narrative ballad that can be of any length. Any number of verses can be used, and they can be added or removed at the performer's whim without affecting the song's structural integrity. According to Peter Manuel, open-ended forms are typical of premodern societies, whereas closed "song form" is characteristic of bourgeois societies and thus of capitalism. He hypothesizes that song form emerged as a result of a "new conception of time" that allowed people to "think in terms of temporal blocks" (2002:49), as in the song sections outlined in the previous paragraph. The spread of literacy and the emphasis on individualism and rationality as markers of Western civilization contributed to the dominance of the rational, precomposed song form. (I would add that the rise of sharply articulated class structures might also be related to the spread of similarly defined structures in music.) Manuel uses "I Want to Hold Your Hand" as an example of this form. In this Beatles song, the AABABAA form has symmetry and an arch shape, as well as a sense of drama, climax, and closure achieved through recapitulation. Clearly, "Hermosas fuentes" and "El sube y baja" are two more examples of song form. The alternation between odd phrases of three bars and even phrases of four in both songs may simply be a trademark of this style, or it may mark the development of a uniquely Mexican or Mexican

Table 2 A Formal Comparison of Three Quebradita Songs of the Early 1990s

	Inst.	Vocal	Inst.	Vocal	Inst.	Vocal	Inst.	Vocal	Inst.
"Como la luna"	A–B	CDE–	A–B	CDE–					
"Al gato y al ratón"	AB	CDE	B	CDE	A	E	A		
"¿De dónde es la quebradita?"	ABAB	C	AB	CD	AB	C	AB	CD	EA

Note: The symbol "–" stands for a lengthening through partial repetition.

American variant of song form; further information is required before a definitive answer can be reached.

The forms of recent duranguense songs can be compared with the forms of the quebradita tunes of a decade earlier to show how this transition has occurred. Table 2 outlines three popular songs of the early 1990s: "Como la luna," composed by pop singer Juan Gabriel and recorded by Banda Maguey in 1995; "Al gato y al ratón," recorded by Banda Machos in 1992; and "¿De dónde es la quebradita?" recorded by Banda Arkángel R-15 in 1993.

These songs exhibit varying levels of structural complexity. In "Como la luna," two instrumental sections (A, B) separated by a percussion break (–) are followed by a verse (C), bridge (D), and chorus (E); after a longer percussion break (—), the whole thing is repeated. "Al gato y al ratón" is similar, merely adding repetitions at the end. "¿De dónde es la quebradita?" is similar to "Como la luna" in that its basic form is repeated twice. However, an additional repetition of instrumental material lengthens the introduction, and new melodic material is added to mark the ending.

Taken together, these three songs show a preference for binary forms. The addition of closing material in two of them creates something closer to a song form, but still an asymmetrical one. Thus, quebradita songs can be said to have a form intermediate between the open-ended corridos, where verses separated by short instrumental interludes can be repeated endlessly, and the closed song form of the current duranguense hits. The transition from earlier strophic forms such as the corrido to the closed, symmetrical song form of pasito duranguense seems to mark the change from a rural agricultural society to the transnational capitalist music marketplace, as Manuel predicted. This change was already well under way when the tecno-bandas arose in the early 1990s; by 2003, it was complete. But at the same time that the music has become structurally adapted to capitalism and its listeners to urban life, the lyrics often continue to reach back to rural hamlets and farming traditions. Duranguense musicians and dancers strive to reconcile the two impulses through the visual codes they employ.

Duranguense Style

Movement and visual codes are an essential part of música duranguense. The genre's popularity has been fueled in no small part by its

association with a dance style and a clothing style, just as occurred with the tecnobanda/quebradita boom of the 1990s. Tito Puente once credited the popularity of mambo music to its associated dance, stating, "Without a dance the music cannot be popular" (Feuerstein n.d.). Members of Grupo Montez de Durango seem to recognize this as well because they have promoted the pasito by giving out T-shirts to young women who compete to dance on stage at their concerts. Equally important is the group's clothing style, which is promoted together with the music and dance through the mass media, including fan magazines, radio and television programs, and music videos.[27]

One reporter described Montez's outfits as "peculiar," a combination of "norteño style, exotic boots, cowboy hats and silk guayaberas" ("El año de 2004" [2005]). As noted earlier, teenage dance-club members may simply dress in jeans and customized T-shirts to dance pasito duranguense. However, club-going social dancers tend to consider it important to invest significantly in their Montez-inspired wardrobes, and men dressed in the latest Western styles find it easier to attract dance partners. Duranguense style is a contemporary variant of the ranchero style popularized during the tecnobanda days, but it is toned down and, generally speaking, nonrasquache. Women wear dresses or jeans and tops like those found in any nightclub, only occasionally adding boots or hats to "westernize" their look. Neutral colors such as black and tan predominate. Men wear either tailored Western suits or jeans and button-down shirts, often short-sleeved affairs with an embroidered medallion on the back done in the same color as the fabric and depicting some ranchero-appropriate theme such as a scorpion or a horse's head. Expensive, low-heeled boots and matching belts are also essential. Yet it is the hat that is the most distinctive and recognizable aspect of duranguense style. The sides are tightly pinched upward, the characteristic that has caused detractors to describe them as "taco hats" (fig. 6.1). Fans may instead describe them as a *sombrero achalinado*, or Chalino-style hat, probably referring not to 1980s narcocorrido legend Chalino Sánchez (who generally wore a more traditional hat style), but to his son, Adán Chalino Sánchez, a singer who has become something of a cult figure since his 2004 death in a car accident at age nineteen. Because of this connection, Simplicio surmises that the hat style originated in California. Some dancers turn these hats into memorabilia by having their favorite musicians autograph the upturned brims.

Most journalistic descriptions of the pasito duranguense have emphasized its side-to-side hip movement. Alfredo Ramírez, lead singer of Montez, describes the dance as "a bit sensual" because of this motion (quoted in El Kaiman 2003). Many compare it to merengue for exactly that reason. Luis Berumen, tamborón player for Patrulla 81, also makes such a comparison, but then goes on to emphasize the pasito's speed and vertical motion: "If you know how to dance cumbia or merengue you'll pick up the pasito duranguense really fast. It has two steps, very fast and bouncy" (quoted in Page 2004). Simplicio added to these observations that the closeness of the pasito-dancing couple and the turns they perform also resemble merengue. Dany elaborated, "I heard that the idea of that type of dance is half merengue: from the legs down, it's merengue movement. And from the top . . . it's something else." The perceived connection between the two dances may be a result of contact with Puerto Ricans in Chicago because merengue is popular among that group. In this merengue connection, together with influences taken from rap and reggaetón, the pasito reflects the diversity of Chicago as the quebradita did for Los Angeles.

Although the pasito draws from various movement sources, Mexican, Caribbean, and North American, the overall effect it produces is quite different from that of its source material. If the pasito's aural aesthetic emphasizes artifice through its reliance on manipulated electronic sounds and overly determined musical forms, its kinesics do much the same thing by exaggerating the merenguelike hip motion to a high degree. In merengue, the piston action of the knees pushes the hips from side to side and emphasizes groundedness; the ribs sway to the opposite side, seeming always to lag behind the hips. Little vertical motion is used, and shoulders seldom tilt, maintaining basically a parallel relationship to the floor. This opposition of hip and rib motion makes the rib cage appear to float on top of the lower body, and the ribs' horizontal path breaks the line of the torso, producing a subtle S shape in the spine.

Pasito duranguense dancers perform a similar movement sequence but tend to use more force and less isolation. The hip motion is much like that of merengue, but is often larger. The ribs do not float on top, creating opposition with the hips. Instead, it is more common for the spine to maintain its straight line, meaning that when the hips are forced to one side the shoulders will be forced to lean to the other

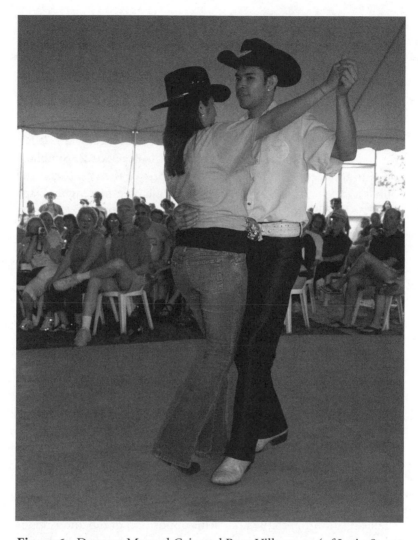

Figure 6.1 Dancers Manuel Ceja and Rosa Villanueva (of Latin Street Dancing, Inc.) show off their moves while Grupo Ansiedad performs for the Smithsonian Folklife Festival on the National Mall in Washington, D.C., on July 1, 2006. (Photograph by Ginevra Portlock, courtesy of the Center for Folklife and Cultural Heritage, Smithsonian Institution; used with permission)

along an angle. The overall effect in the upper body is one of rocking from side to side, while the dancer also pushes up off the balls of the feet to give the pasito a look that is both "bouncy" (much like quebradita) and somewhat inflexible, causing one musician to describe it as "robotic" (Norma of Las Hechiceras, interview, 2005). On top of this is layered the type of arm motion typical to most banda dance styles including quebradita: the clasped hands of the partners (leader's left and follower's right) punch out to the side or else move up and down in wide arcs, helping to produce a forceful lead while often accentuating the tilt in the upper body. For instance, when the leader wishes the follower to tilt to the left, he may arc her right hand up to a nearly overhead position. If he wishes her to tilt right, he may bring her right hand out to the right side until the arm is nearly straight (fig. 6.2). Down below, the feet shuffle close to the ground, sometimes performing heel-toe steps in a kind of modified zapateo. One Chicago dancer describes it as "*chicle pegado en el zapato*, having gum stuck [on] the bottom of your shoe and trying to get it off" (Jaime Barraza, quoted in Giraud 2005).

The pasito moves I have described here are common at Chicago Mexican nightclubs, and they also appear in music videos produced by Chicago groups such as Montez de Durango.[28] In such settings, the dance appears in conjunction with other images of high symbolic value for duranguense fans. For instance, the video for "El sube y baja" alternates between recognizable Chicago locations and a nightclub dance floor. Group members sing and play keyboards and tamborón on a rooftop with the Chicago downtown skyline behind them or by the Navy Pier, a well-known waterfront amusement park. They stroll through Chicago streets underneath its famous elevated train, wearing vaquero-style suits and duranguense hats, but emphasizing their words with hand movements and gestures that resemble those used in hip-hop. Or they join the crowd on the dance floor, where a group of mostly female fans dance individually in a way strongly reminiscent of country line dancing, sometimes partnering with each other or with men. The video melds two worlds together by combining strongly Mexican clothing symbols and auditory cues such as gritos with references to North American popular forms such as hip-hop and country, similar to the quebradita's combination of diverse movement vocabularies. Yet, at the same time, the video images serve to place música duranguense firmly within Chicago and the larger U.S. milieu.

Figure 6.2 Dancing to pasito duranguense in Little Village, Chicago. (Still shot from a video filmed by Juan Dies, May 2005; used by permission)

Another video (on Various 2003) by Grupo Montez makes their position even more explicit. "Las mismas piedras" (Grupo Montez 2002) opens with the group performing on a sidewalk in front of an archway with a Spanish-language inscription of welcome. This is the gateway on Twenty-sixth Street, the principal shopping avenue of Little Village, one of Chicago's most thoroughly Mexican neighborhoods. But then as the group sings of the difficulty of leaving one's home and family behind, the action shifts to an adobe house, presumably in Mexico. One of the group's members is leaving home, suitcase in hand; he receives a blessing from an old woman (his grandmother?) and embraces a woman in an apron with her long hair in braids (a girlfriend?). Later, this same man is pictured working in a warehouse, reminiscing about those he has left behind, until a friend distracts him and prods him into doing a few duranguense dance moves. With this video, Montez again shows that they are true Chicagoans as well as true Mexicans who understand and sympathize with the immigrant experience. The industrial setting where the main

character ends up gives context both to the feelings of longing expressed in the lyrics and to the dance style some see as "robotic."

Other groups are less visually explicit about their Chicago ties, perhaps trying to create bonds with fans in other areas, yet still they tend to choose recognizably U.S. locations. For example, the video for "Los chismes" by Brazeros Musical de Durango (Various 2003) follows the group from the entrance to San Antonio's La Villita ("Little Village," as in Chicago) to a sightseeing tour boat at the famous River-Walk to a city street by the name of "Durango." Here they recognize their fan base in Texas, where duranguense has become quite popular of late, while still acknowledging their presumed Durangan roots. In choosing to locate themselves and their genre in the United States, pasito duranguense groups break from the quebradita, whose popularity depended in large part on consumers' perceptions of its real or imagined Mexican origins.

Debating Duranguense

Música duranguense occupies an ambiguous and unstable position in several senses. It claims to be a new style of music with a new dance, but is unmistakably similar to earlier crazes. It wants to be seen as based in tradition, yet it relies heavily on artificial, electronic sounds. Chicago groups strive to appear "Mexican" in style and taste, while at the same time they make sure they and their music are placed firmly in the United States. These contradictory elements have served to situate their music in the middle of some hotly contested terrain. Debates over duranguense music and dance have surfaced on the Internet on sites devoted to Mexican culture, music, and sports. For example, on a site devoted to music of the Sierra one fan of the "traditional" music of Durango took issue with the new style. She lamented the fact that even the most vocal proponents of "música duranguense" never mention the older, more established groups of Durango, and thus the new tecnobanda pop style is made to stand for the state as a whole (Verduzca 2004). She cites the composition of original corridos as the true test for duranguense authenticity. To her, a real Durangan corrido must mention local people, establishing verifiable connections with the people of Durango: "The proof of their origin is in the fact that their corridos usually are sung to regional personages, giving immense credibility to what they say. . . . All the true duranguense groups write corridos for people worth their while, more importantly, for people

whom they have met." The new groups' recording of recycled songs, their "techno" sound, and their lack of explicit ties to local people and places make them inauthentic for this listener.

Other opponents of the style include Mexican rock groups such as El Tri. In a November 2004 performance at the Aragon ballroom of Chicago, they announced, "F— pasito duranguense, viva pasito chilango!" (F— the Durango step, long live the chilango step) (quoted in Emerick 2004), apparently promoting rock music as an alternative regional Mexican style—one that is particular not to rural Durango, but to urban Mexico City. Los Razos, a norteño group famous mostly for their obscene language, have also attacked this music on their CD *La raza anda acelerada*. In a less sensational but perhaps more illuminating way, in August 2004 several men discussed the topic of recent regional Mexican styles on a Web bulletin board devoted to soccer (http://www.bigsoccer.com). Here I quote their conversation at some length as an illustration of issues that the music has raised for many Mexican American observers (names changed for anonymity):

Metalman:	Tamborazo[29] sucks man!!!!
Serge:	It's an acquired taste like good tequila. Either you love it or hate it, no in between.
Metalman:	You are absolutely right, but I wouldn't say that I hate it, but I can only stand it when I am under the influence of tequila :D
Hector:	Tamborazo te da de comer. [Tamborazo feeds you.] Nothing beats cruising the streets of Los Angeles and blasting tamborazo during the World Cup.
Metalman:	¿Tú también eres de Tepezala? :D [Are you also from Tepezala (Aguascalientes)?]
Hector:	Naca tu abuela. [Your grandma's a hick.]
Metalman:	No, she does not cruise on the streets blasting tamborazo.
Hector:	Apoco te averguenzas del tamborazo, ¿cabrón? Qué, ¿muy metalero? Mendigo vende patrias. [Are you embarrassed by tamborazo, jerk? What, a real metalhead? Beggar, nation-seller.] I love you.

At this point, someone suggests a new thread, "What kind of music do you listen to?" In response, one person brings up a duranguense song.

Ameripunk: It's polka-waltz, duranguense is just an ignorant name, just 'cause they put lyrics to that type of music doesn't mean they created a new genre. Try to tell that to people who like "duranguense music" and you'll see how closed-minded they are.

Metalman: You are right. . . . I find it interesting that music like that is more popular here in the states than in Mexico. Same thing happened with "la quebradita." I wonder if it has to do with (and this is going to sound bad, so I apologize to whomever gets offended) demographics or the level of education of the majority of people that come to the states.

Hector: [. . .] It's to my understanding that the majority of us who come here do so because of economic reasons, uncertainty and instability. Lack of education is probably one of the primary reasons. How many city people (em/im)migrate to the states compared to rural folk?

Ameripunk: Quebradita, another ignorante name for swing dance. I'm not tryin' to diss the people, but they should at least know its origins, background. [Here, this conversation participant goes on to give a long summary of the "history of music in Mexico," beginning with mariachi and ranchera, and moving on to norteña; banda, which he or she says "evolved" out of norteña; grupera, of which Banda Machos is given as an example; and rock.]

Serge: ¿Y el tamborazo que? [And what about the tamborazo?]

Metalman: I told you before; tamborazo sucks.

This conversation reveals several ways of thinking about duranguense. First, many parallels are drawn between various recent styles of Mexican American music and dance: quebradita and duranguense, quebradita and swing dance, norteño and banda, and grupera and tecnobanda (in the form of Banda Machos). These linkages demon-

strate how fluid the boundaries are between the genres; they also show that even for those that do not see pasito duranguense as a direct outgrowth of the quebradita, the two dances do occupy a similar position. Second, the early part of the exchange takes the form of a debate over the meaning of true Mexicanness, where the symbolic role is taken up by the tamborazo. For someone who likes tamborazo, a heavy metal fan can be a *vendepatrias*, someone who is selling out his country and his culture. Serge equates tamborazo with tequila, another powerful symbol of Mexico and of machismo. Defending the tamborazo and by extension Mexico as a whole, Hector compares the music to food, a necessary substance without which one cannot live. He switches to Spanish to make this point, and Metalman must follow in order to make his claim convincing, to demonstrate that he is a true Mexican even though he doesn't listen to music considered Mexican. Finally, both tecnobanda/duranguense and the quebradita acquire class inflections at several points during this conversation. Hector calls Metalman's grandmother "naca," which roughly equates with the English term *hick* and has a lower-class inflection; Metalman responds by equating "naca" status with tamborazo listeners. Next, Metalman hypothesizes that the popularization of both the quebradita and música duranguense is a result of the immigration of uneducated (read "lower-class") Mexicans. Hector appears to agree, though he contributes the additional variable of rural origins.

Clearly, música duranguense, along with other Mexican regional musics, is a site for the contestation of Mexican identities. Does one have to listen to such styles to be truly Mexican? The metal listener does not think so, but he must call on other symbols such as the Spanish language in order to prove his point. Are duranguense and the quebradita only for rural people with little education? These computer-savvy cultural critics argue that this is so, even though some of them admit to listening to such styles. Are quebradita and duranguense really new dances deserving of their own label? Some say no, arguing that those who named these styles were simply ignorant of music history. The very act of naming confers some measure of status and legitimacy, and thus has the power to provoke strong reactions. Can electronic music be traditional, and can the traditional be new? Listeners do not agree on any of these issues.

As seen in this Internet conversation, those who attack música duranguense do so mainly on its aesthetic merits or demerits, though

their aesthetic evaluations are strongly class inflected. (In a number of other Internet discussion groups, the duranguense style is frequently described as "naco" or even "chúntaro.") Yet, notably, those who defend it do so based not on its artistic value, but on its importance as a cultural manifestation. On one Spanish-language discussion board (http://www.chalino.com), a Morelos-based participant by the name of "Alacrán" notes that duranguense groups are doing a service by re-recording traditional songs in the new style. He suggests, "If it weren't for música duranguense there would be a lot of songs that we wouldn't even know existed" (August 2004). Another participant by the name "Pocho" suggests that those who criticize the music do so only because they are jealous that their own state's tradition hasn't reached such heights. He concludes, "Let's hope pasito duranguense will last and establish itself as one more Mexican musical genre. Norteño and música duranguense 'Made in USA'" (November 2004). For both of these duranguense fans, the music's merit lies in their perception that it is continuing older norteña music traditions, and for the U.S.–based "pocho," it is equally important that this style comes from north of the border—that it is part of not just Mexican culture, but of Mexican American culture as well.

Duranguense is also a site for the contestation of gender roles. We have already seen how the quebradita was controversial in some circles because female dancers attended nightclubs, exhibiting their independence; performed sensual moves, taking their bodies away from the controlling mechanisms of a Catholic, patriarchal system; and otherwise usurped traditional males roles by performing athletic moves, sometimes even leading their partners. The pasito duranguense dance style is less complex and offers less opportunity for creative contestation. However, women are taking a more active role in producing the music than they did during the tecnobanda craze. Although some female musicians did play in Los Angeles–area tecnobandas, none went on to achieve fame. In duranguense, however, one of the top groups, Los Horóscopos de Durango, is led by two women who both sing and play a variety of instruments from saxophone to drums. Armando Terrazas, a cousin of Grupo Montez's José Luis Terrazas, formed the group in 1975. His Chicago-born daughters Virginia and Marisol began playing at a young age and now head the second generation of Horóscopos, which, changing with the times, scored a major hit in 2005 with their duranguense version of the Dominican bachata song "Dos locos."

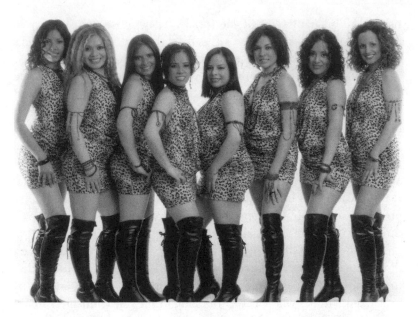

Figure 6.3 A press photo of Chicago duranguense group Las Hechiceras de la Jungla (2005). (Used by permission)

Duranguense has been the site for the emergence of some of the first all-female regional Mexican groups as well. For example, the eight-member Las Hechiceras de la Jungla formed in 2004 (fig. 6.3) as a reincarnation of an all-female tropical music group called Grupo Ecstasis. Together with their manager, Amaury Ruiz, the mostly Chicago-born members of the group (their parents hail from Durango, Zacatecas, Guanajuato, Guerrero, and Michoacán) decided to make the switch to duranguense because of the high demand for that style. Like the other Chicago duranguense groups, their repertoire comes mainly from "songs from the old times, but we now change the music and give it an [updated] touch—and now it's duranguense," according to keyboardist Rosa (Las Hechiceras, interview, 2005). The songs they record are based in part on audience requests and on what will sound well in their vocal range, but, aside from the higher register, their music is much like that of others working in the genre. However, they have chosen not to emulate the visual presentation of their male competitors. Instead of vaquero attire, they wear animal-print dresses and wooden or feathered accessories that echo their

name, the Enchantresses of the Jungle. They chose this strategy in order literally to distance themselves from their competitors. Amaury explained, "The duranguense groups . . . [their names] were always from a place. They were from the sierra, from Durango. So the jungle is a place . . . too far away to imagine that they come from there. From India! So we chose Hechiceras de la Jungla to make sort of a myth out of the name."

Although Las Hechiceras members realized that place was central to duranguense, and indeed to all of regional Mexican music, they also knew that there was little space available to women within that realm because "it's basically all run by men," as group-member Daisy put it. Paradoxically, by removing themselves from the regional Mexican geography completely and transplanting the group into a mythic jungle, they were able to find the space they needed. Audiences, though skeptical at first, are now quite willing to allow them that freedom. Daisy, a percussionist who formerly played salsa and cumbia, stated, "In my whole career of being in the music business, playing this type of music it's a different response from the public. It's actually a lot more comfortable—I mean, everyone loves it when you play this type of music. You can feel the response from the public, and it's a very satisfying experience."

New Regional Directions

At the moment, duranguense seems to be going strong, but some musicians in Chicago are already preparing themselves for the next big thing. They expect the style will have outlived its novelty within a few years, as did the tecnobanda sound of years past, and many are already predicting the next trend will arise from the grupera music of the tierra caliente. Simplicio Román is one who subscribes to this idea. A musician from Acatlán, Guerrero, who lives in Chicago, plays with Grupo Ansiedad, and records duranguense and tierra caliente groups for Acatlán Records, Simplicio Román feels that *música tierracalentana* is "what's next" not only because it is catchy and danceable, but because it both predates and was an influence on the current duranguense groups.[30] I have already noted that Patrulla 81 acknowledges its debt to this regional style; according to Simplicio, it has also been suggested that Michoacán-based group La Dinastía de Tuzantla influenced José Luis Terrazas in his creation of Montez's characteristic

sound. Guerreran groups Beto y Sus Canarios and Triny y la Leyenda also have large followings, Simplicio noted, and have been picked up by major labels, and groups playing the style have even been formed in California and Texas. Simplicio's Grupo Ansiedad plays tierra caliente along with duranguense, cumbia, and norteña and has been hired as far away as Alabama, Georgia, Florida, and the Carolinas, spreading the style to budding Mexican communities in the South.

Besides having purportedly influenced duranguense hitmakers, tierra caliente also has musical and social characteristics in common with previous hit styles. I leave a detailed study to future researchers, but point out a few characteristics here. For instance, it comes from an area that has supplied many Mexican immigrants to the United States, uses a flashy ranchero clothing style, and is another regional adaptation of the popular grupera/tecnobanda format.[31] To the uninitiated, it may sound no different than música duranguense, but to dancers and fans certain characteristics stand out. For example, whereas the duranguenses prefer muted tones, *tierracalentanos* wear brilliant—almost fluorescent—reds, yellows, and oranges, sometimes worked in flame motifs on their custom-made Western suits. Tierra caliente groups also use different instruments, including an actual trombone, often combined with live accordion and saxophone, as well as guitar, bass, drum set, and keyboards that simulate trumpet, electric guitar, and tuba sounds. The rhythm section thus closely resembles those of the other tecnobanda styles we have examined, but the electronic tuba part is more elaborate than the stereotypic duranguense tuba lines that come straight from Zacatecan tambora, in Simplicio's opinion. The other keyboard parts sound slower than their duranguense counterparts, with less rhythmic density, "as if dancing a waltz, but . . . it's ranchero," he explained. And tierra caliente singers always sing high, often in falsetto. The greatest difference between tierra caliente and duranguense, however, may lie not in the music, but in the dance. Zapateo is not a feature of duranguense, but it is absolutely central to the tierra caliente style: "It's by law," emphasizes Simplicio.

Regional music has long played an important role in Mexico and Mexican nationalism. Thomas Turino (2003) has shown how many nation-states in Latin American have "mainstreamed" regional folkways in order to make them accessible to people of other regions, thereby creating a sense of national unity that is able to transcend

regional sentiment. Because regionalism is more pronounced in music than in any other field, regional musical genres have played particularly important roles in this process. In Mexico, postrevolutionary governments used school and festival performances that juxtaposed multiple regional styles as a means to "[shift] indexical associations with a given style from region to nation," thus creating "the image (icon) of the nation . . . as the combination of these attractive sights and sounds" (Turino 2003:196). Mariachis thus became the national ensemble of choice by combining rural origins with cosmopolitan aesthetics and a multiregion repertoire.

The recent resurgence of regional Mexican popular music echoes these earlier processes. If *sonecitos de la tierra* (regional son styles) and the mariachi were musical symbols used to turn diversity into a more unified representation of national identity in Mexico in the early twentieth century, tecnobandas are accomplishing similar ends within a U.S. context a century later. The similarities between tecnobandas sinaloenses, grupos duranguenses, and tierra caliente music help to create a shared Mexican American aesthetic that is consumed by immigrants from many Mexican states as well as by many U.S.–born youth. At the same time, the adoption of place-based names for the various regional Mexican genres and groups shows that the symbolic relevance of region has never been diminished. Small differences in dress, vocal timbre, keyboard sounds, rhythm, and tempo serve to represent musicians' and listeners' state and regional origins. Yet, at some level, these affiliations are voluntary, as the claims by Central Americans and by eastern and southern Mexicans of being from the more popular states demonstrate. The decision to claim a state may be based on personal ties, but it may just as easily derive from that state's social capital within the current regional Mexican scene.

We have already seen how for quebradores some states were more stylish than others, with Sinaloa, Jalisco, and Nayarit at the top. In the current duranguense scene, Durango and Zacatecas occupy this position. The tierra caliente style may soon put Michoacán and Guerrero in the spotlight. For the past fifteen years, then, the West Coast has been hot, but the East Coast has not, and, overall, the geography of hipness seems to be moving south to central Mexico. The reasons for the placing of one state over another in this hierarchy of social capital are complex. Anthropologist Pablo Vila has shown how many Mexicans use regional discourse as a euphemism to replace ethnic or racial

discourses (2000:26). For example, people from central and southern Mexico, darker-skinned and more "Indian," may be contrasted with people from the north, an area thought of as predominantly white, emphasized through negative stereotypes of southern laziness and backwardness. I have found that the repertoire of the Ballet Folklórico de Mexico, the Mexican national folk dance company, can be read in this way (Hutchinson in press) in that it displays a preference for the mestizo central states. Such preferences seem to be replicated in the popular music sphere, as northern and western Mexican styles have long been favored over styles from the indigenous South or the eastern coast, where Afro-Caribbean influences may be discerned. Also, every state that has so far been the source of a major regional Mexican music craze has had a strong ranching tradition—a historic source both of wealth, as the major economic activity of many western states, and of cultural capital within the border region (for those who subscribe to lo ranchero, that is).

Regional preferences can also result from the unique characteristics of local populations within the United States. In the case of Chicago, the so-called duranguense style incorporates multiple regional influences, making it accessible to a wide range of listeners. This variety may be related to Chicagoans' unique political organizations. Sociologist Xóchitl Bada (2003) reports that Chicago Mexicans have created not only the commonly found hometown associations, but also eight federated groups representing Michoacán, Jalisco, San Luis Potosí, Oaxaca, Zacatecas, Guerrero, Durango, and Guanajuato, and these groups in turn have joined together to form an umbrella organization addressing human rights, politics, and cultural issues. Such an experiment had not been tried elsewhere in the United States and indicates that although Chicago Mexicans still feel ties to specific Mexican regions and places of origin, they also are willing to cooperate across cultural and geographic boundaries.

Conclusions

If the quebradita/tecnobanda craze was sparked in part by anti-immigrant and English-only legislation, what was the reason for duranguense's sudden notoriety? It may yet be too early to tell, but the new backlash against immigrants generated by the events of 11 September 2001 has likely played a role. As occurred a decade earlier,

young people who feel they are under attack by their own government have responded to that strife by using dance and musical consumption as a means to create a feeling of pride and to reaffirm their connections to the Spanish language, to specific places in Mexico, and to lo ranchero. Chicago-born Jaime Barraza explained, "Definitely Duranguense has restored the pride you have in where you're from" (quoted in Giraud 2005).

For these immigrants, regional Mexican music can help them adjust to a new life. Simplicio clarified, "Songs sometimes make you reflect. [Sometimes when you hear a song], you say, 'Oh, that song gets to me, and it's talking about me—when I came here, or about my wife I left back there.'" Grupo Montez and other duranguense groups' lyrics discuss such themes more explicitly than did most tecnobanda groups of the 1990s; their music, too, speaks to immigrants' recontextualizing experiences by taking older Mexican songs and revamping them through the use of electronics. And for the children of immigrants, duranguense serves literally to map an identity. Many duranguense lyrics mention specific places in Durango and Zacatecas that help Chicago-born children to understand the geography of their parents' or grandparents' lives. Discussing the Montez song "Camino a Tepehuanes," Norma Pérez explained, "When I was there [in Durango] this summer, we passed through [Tepehuanes]. My dad stopped and said, 'Oh look, you know that song that you're always singing and dancing to? That school that they mention, this is the school.' And I'm like, oh my God, I'm mapping them out" (quoted in Giraud 2005). Jaime Barraza had a similar experience in connecting song to place, and he found that "the stuff that they [Montez] sing is true. Even though these guys are from Chicago and they have no idea about like life back in the day" (quoted in Giraud 2005).

For some, duranguense represents just one more option available to fans of regional Mexican music; the pasito is simply one more dance that can be done at clubs already dedicated to other banda styles in the space opened for them by the quebradita. For others, it is a lifestyle, requiring them to purchase new and expensive clothing, to devote time to perfecting their dancing, and possibly even to join clubs. At the same time, the pasito has taken an important step beyond the quebradita. By proclaiming itself not just a Mexican style but also a uniquely Chicago (American) style, and by utilizing symbols of Chicago and other U.S. locations in its visual imagery, duranguense

creates an art form that reflects the local culture, *and* it stakes its claim to territory within the United States as a whole and becomes what is perhaps the first *explicitly* transnational regional Mexican style. Through these means, it demonstrates that space must be created for Mexicans in this country, and if the government will not do it, then the musicians will.

7

Postscript

Quebradita is about the body. For quebradores, bodies become "a site of decoration and style" (Lipsitz 1990:16) in the same way that low-rider cars are "a site of resistance" on which new scenarios can be imagined and through which space can be claimed (Bright 1995b:93). Quebradita is also about movement: movement across the border, to and from Mexico; the movement of the body, freeing it of societal constraints; movement through space, claiming urban territory and a spot in the national imagination; and the movement of two bodies working together to test the limits of physical endurance, of gender, of class boundaries. For quebradores in the past and for duranguenses now, dancing has been a way to mobilize style and bodies to accomplish the cultural work of politicization, of redefining ethnicity, and of revalorizing what might be termed an "aesthetic from below."

Both quebradita and duranguense are therefore about politics. By attempting to create space for Mexicanized music and dance within U.S. popular culture, they give voice to communities that have typically held little political power, from Mexican immigrants to the Mexican American working class and urban minority youth. By involving Chicanos as well as Mexicanos and other ethnicities, and by including both suburban and urban teenagers, these dances have formed bonds between disparate groups, creating at least the potential for more unified future political action. And through their use of rancherismo and rasquachismo, they have challenged class divisions internal to those communities while making a case against both assimilation and conservatism.

Quebradita aesthetics made the dance appear radically different from earlier southwestern youth cultures. However, there is in fact

much continuity with what came before. The pachucos with their equally flamboyant zoot suits or "drapes" also formed a youth culture that, transmitted through popular music recordings as well as through urban migrations, eventually spread throughout the Southwest. Anthony Macías has described how members of this youth culture included Chicanos, African Americans, and Filipino Americans who participated in multiracial dance contests in Los Angeles, questioned the moral authority of their parents' generation, and transgressed racial and sexual boundaries (2001:78) in a way that, I would suggest, strongly prefigures the 1990s quebradita movement. Also, anticipating later antigang workers, dancing was encouraged in 1950s Los Angeles as a healthful activity for minority youth, although the city failed to provide facilities in which dances could be held (Macías 2001:81). Such continuities demonstrate that the quebradita was actually part of longstanding historical processes in the region, even though its practitioners' use of lo ranchero went against the pachuco disdain for non-drape-wearing "country hicks" (Macías 2001:65). (They also suggest that city governments might learn from fifty years of mistakes and try to provide more youth activity centers in marginalized areas.) The pachucos have had a long-lasting influence. They helped to forge the later cholo style, itself a source for the hypercool James Dean "rebel" look (Macías 2001:74). And because of their confrontational, anti-authority stance, they became a powerful symbol of resistance to members of the Chicano movement in the 1960s, some of whom saw them as the first Chicanos. The quebradita movement might one day serve as a similar model if prejudices against rasquache aesthetics can be overcome.

Parallels can even be drawn with 1960s and 1970s Chicano rock. George Lipsitz (1990) has described East Los Angeles Chicano rockers as displaying a kind of postmodernism in their music by virtue of the ambiguity and irony that resulted from their juxtaposition of diverse influences. The quebradita dancers who inhabited the same geographic and cultural space decades later continued in this pattern, mixing Anglo, Mexican, and African American source material to create a new way of moving. As in Chicano rock, this kind of creativity helped to "undermine univocal master narratives" (Lipsitz 1990:149) that conceive of each of these cultures as monolithic and largely separate. At the same time, quebradores diverged from their predecessors in important ways. Whereas the rocker "[sought] inclusion in the

[North] American mainstream by transforming it," quebradores instead attempted to create their own mainstream, separate from that defined by Anglos—a space in the market whose terms they themselves would define. Although the transnational music industry of course promoted and propagated dance, the dancers themselves carried out the real work of defining the dance's terms, its style, and its steps. In the process, they created a way of moving so distinct that it was hard for some to accept: a new dance that resisted assimilation and appropriation.

Quebradita clubs are now defunct, and the intensity with which quebradita dancers devoted themselves to their dance at its height has passed. One reason for its decline may be the brief but intense media frenzy that surrounded it. Positive attention from radio, television, and print media encouraged the young dancers to strive toward ever more impressive choreographic feats, but when the media became saturated and stopped coverage of quebradita events, lack of such reinforcement may have caused a decline in interest: quebradita lost its glamorous sheen, as most popular styles eventually do. Or, dancers may simply have tired of the incessant rehearsals required to maintain a competitive quebradita club and needed a rest.

For these reasons, today one seldom sees quebradas on the dance floors of Los Angeles. There is less variety in banda dance steps, and there are fewer competitions. The clothing style is less distinct, although many men still do wear vaquero styles. New ways of dancing to banda have appeared, and old ones have reappeared. Although Pepe Garza, a deejay with La Qué Buena radio station (KBUE), has again popularized norteña, quebradita, and other regional Mexican styles in the twenty-first century, "now it has taken a different form" (Siris Barrios, interview, 2005). Although music for quebradita is now seldom played in banda clubs, displaced by corridos and reggaetón, it can still be heard at family events such as birthday parties and quinceañeras. A quebradita nostalgia has also surfaced, as evidenced by KBUE deejay Angel Garay's recent successful reintroduction of 1990s tecnobanda tunes into his "top five at 5:00" show.

In Tucson, the quebradita is still occasionally performed, though it is now a much more informal affair than it was in the past. In 1999, Darma Pérez spoke of the swap meet, formerly a popular Tucson performance site, remarking, "There was a little stage, and then quebradita went out of style; nobody uses it anymore. So the little stage is

empty all the time" (interview, 1999). But Reynaldo Franco commented, "Quebradita has declined but not disappeared. It hasn't disappeared at all. Because in nightclubs, if you go to a nightclub, many times they'll say spontaneously, suddenly, 'We're going to have a quebradita contest.' But you know, it's because the quebradita is still popular here in Arizona. All the groups here play quebradita, all of them" (interview, 1999). In 2005, this still seems to hold true. So, although competitive quebradita dancing exhibited the short lifespan characteristic of a fad, in other ways it has withstood the test of time, simply becoming a part of everyday life rather than the special event it used to be.

The quebradita movement had lasting effects on individuals, their musical consumption, and their level of cultural involvement. We are now in what Siris calls the "second wave" of regional Mexican music in the United States. Although in Los Angeles this "second wave" is centered on corridos, this trend, too, dates back to the quebradita era because that was when narcocorridista Chalino Sánchez emerged as a "ghetto superstar" and when youth first took notice of such music, explained Jesús Molina (interview, 2005). In addition, many of those whose first involvement with Mexican music was through tecnobanda have moved on to become avid listeners of traditional banda and norteña (Sol Porras, interview, 2005). For instance, during college Sol attended only nightclubs that played English-language music, but now she goes exclusively to "paisa clubs" because "whenever I listen to [banda] I feel really happy . . . you just feel it inside your blood, and you're like, 'Yeah! This is my music.' You just feel so happy, when you're at the jaripeos especially."

Others improved their Spanish-language skills because of their involvement with quebradita. Jorge Godínez, program director for a Spanish-language radio station in southern California, said at the height of the banda craze, "Mexican kids born in this country who don't even speak Spanish are singing banda songs. It's bringing people back to the Mexican culture" (quoted in Johnson 1994). Tucsonans Robby Espinoza and Shannon Ortiz stated that their involvement with quebradita led them to try to learn more Spanish, an interest no other 1990s trend seemed to have excited. California dancer José Velázquez, originally from Guadalajara, stated, "You do this dance because you want to keep alive the culture and pass it on to the kids so they can keep it alive" (quoted in Avila and Ko 1993). Furthermore, it

succeeded in keeping some teenagers away from harmful behaviors where other options had failed. Tucson dance teacher Marcela Cárdenas told of increased attendance from chronic absentees on days that featured quebradita practice (interview, 1999a). Darma noticed an improvement in her grades during the time she spent in the quebradita club. Robby described how he became involved with the quebradita instead of with the drugs that many of his friends were doing (interview, 1999). And in chapter 4, we saw how quebradita served as a tool to keep Los Angeles teenagers out of gangs.

The quebradita also brought young Mexican Americans together and helped them to create a new identity for themselves. Christopher Waterman writes of Nigerian jùjù music that it "portrays a[n] imagined community . . . and embodies the ideal affective texture of social life and the melding of new and old, exotic and indigenous, within a unifying syncretic framework" (1990:221). Not only did quebradita dance and music embody the ideal of lo ranchero and portray an imagined community of youthful Mexican American vaqueros, but they actually created that community by causing the formation of clubs. The clubs, in turn, led both to competitions where dancers from different locations were able to meet each other and to quebradita-themed publications and movies that portrayed this community. Many saw the dance as the perfect expression of a new kind of identity just emerging from Los Angeles and other Southwest urban centers, what demographer David Hayes-Bautista calls "a truly American identity for the 21st Century" (quoted in Martínez 1994). Lucia Espinoza, a Los Angeles quebradita club sponsor, explained: "My kids love this dance and music because it is a part of their culture, a part of life in their homes, in their neighborhoods where it originated. It's from the street, from East L.A., from being proud of being Mexican and Mexican American" (quoted in Quintanilla 1993). One of Espinoza's students added, "That's why I love it. It's music and dancing that we can claim as our very own" (Alfonso Méndez, quoted in Quintanilla 1993). This "new identity" may be most evident in Los Angeles, but it can be found all over the country, and it is one of the more intangible effects of this art form.

Furthermore, the quebradita led to the development of other new music and dance styles in the twenty-first century. Among them are still more transnational, syncretic regional Mexican dance trends such as the pasito duranguense, as we have seen. But quebradita also served

as raw material for artists working in other, very different music and dance genres. To them, the quebradita has become a handy index of modern Mexican America that can be used to represent both the traditional ranchero lifestyle that the dance originally symbolized and the transnational youth culture that created it. For example, critically acclaimed Mexican rock group Café Tacuba referred to quebradita and emulated its musical sound in their second album, *Re* (1994). The group has stated in interviews that their sound resulted from a search for a new Mexican identity based on national folk cultures rather than external influences such as North American popular music, and that they take sounds and music heard in the streets of Mexico City as their starting point (Dillon 1997). Songs on their first album, *Café Tacuba* (1992), treat themes of identity politics, such as youthful urban punks reclaiming mariachi music ("Noche oscura") and the valorization of mestizo Mexican beauty ("Labios jaguar"). On *Re*, the song "El Fin de la infancia" (End of Infancy) sets lyrics about the five-hundred-year search for Mexican identity to the sounds of banda music. Backed by the rhythm of quebradita, Tacuba asks:

> Desde ahora quiero ser dueño
> De mis pasos de baile
> Y bailando caballito
> Con la banda cafecitos
> ¿Cómo no lo voy a lograr?
> Y bailando quebradita
> Con la banda tacubita
> ¿Cómo no me van a respetar?
>
> (From now on I want to be in charge
> Of my dance steps
> And dancing caballito
> With the band "Cafecitos"
> How can I not succeed?
> And dancing quebradita
> With the band "Tacubita"
> How can they not respect me?)[32]

In this song, Hope Dillon suggests, "the dance steps represent the nation, Mexico, that surrounds them. The dancers are the Mexicans that want to have power. . . . [Café Tacuba's] music will give power or

worth to those that are searching for their own identity" (1997:81). The fact that banda and the quebradita were chosen to represent this search for power and identity along with the "end of infancy" or powerlessness is significant because banda connotes a rural region situated far from Mexico City, the center of power from which Café Tacuba speaks, and quebradita brings to mind the Chicanos' power struggles within the United States. The sound of this song thus aids the listener in contemplating the lyrics that question U.S. hegemony and search for a more "authentic" Mexicanness.

Even now, quebradita continues to provide a means of exploration. In 2003, a merengue song that includes sections that have a marked quebradita rhythm enjoyed a brief period of popularity on New York City Latino radio. In addition, Mexico City dancers Victor and Gaby of Salsa con Clave have found ways of mixing quebradita steps and styling into their salsa performances. After gaining fame as quebradores through performances with top acts such as Banda el Recodo and for Furia Musical's 1997 award celebrations, they "got bored" and decided to learn salsa. When dancer Johnny Vásquez suggested they perform "quebradita con salsa" in Puerto Rico, a new hybrid was born (Burroughs 2002). The couple have since been invited to perform their unique style in the United States and teach it at various international salsa congresses.

More recently still, the banda sound has been used as a background for rap. This new style, marketed as *regional urbano* (urban regional), was born in the Latino barrios of Los Angeles. Akwid was one early and very successful proponent of the style. On their 2003 album *Proyecto Akwid*, songs such as "No hay manera" and "Es mi gusto" are set to the sounds of live musicians playing trumpet, tuba, clarinet, and percussion in a Sinaloan style, though in short, repetitive phrases that imitate the looped sound of more typical hip-hop sampling. The Spanish lyrics are mostly unremarkable, discussing themes common to much popular English-language hip-hop, such as love gained and lost, sexual attraction, and boasting, although with a liberal sprinkling of caló, urban Mexican American slang dating back to the pachuco era and earlier. Still, the fact that the album's cover art depicts the two rappers surrounded by symbols of the U.S. Southwest and Mexican culture—such as saguaros, agave, tequila, a Catholic mission, the Los Angeles skyline, and even a tuba—demonstrates that Akwid's choice of banda music was an attempt at creating

a border-crossing hip-hop that combined African American and Mexican sensibilities. The combination has been successful, garnering the group a Grammy nomination in the category of "rock latino" and a Mexican tour. It also resonates with many listeners' ideas about Mexican American culture and identity. In an on-line forum at http://www.chalino.com, a site for fans of regional Mexican music, one woman joined in a discussion of Akwid's music to enthuse: "I think it's something a lot of us was waiting for, mixing two sounds that we listen to! I really like how they started this movement, regional urbano, and I will support them all the way" (2004). Other urban regional rappers have experimented by combining rap with other regional styles such as norteño. For example, on their 2004 self-titled debut the group Mexiclan layers raps and sung choruses about pride in Mexican roots over a bajo sexto and accordion playing cumbia rhythms.

Ragland (2004) has suggested that one important feature common to banda, norteña, duranguense, and música sonidera is how each reintroduces regionality into the Mexican diaspora. By reinforcing ties to Durango, Sinaloa, Puebla, or elsewhere, these musics create ties to a homeland for those who are far from it and help build a new identity for a population still largely on the margins of North American society. In addition, she argues, such practices form a clear disconnect from earlier Mexican American musical movements, such as Texas Mexican conjunto, because those movements had been aimed toward creating a specifically Chicano cultural consciousness that in effect distanced itself from Mexico. I agree with Ragland's findings, but I want to emphasize that each of these trends is a product of modernity, migration, cultural contact, and the new ways of thinking about place and roots that these conditions necessitate (another example of "transnational regional" music is Dominican merengue típico [see Hutchinson 2006]). Urban regional takes this musical exploration to its next logical conclusion. Although regional Mexican dances look backward by evoking "traditional" music and premigratory rootedness, they also look forward by helping to put down new roots elsewhere, thereby creating new possibilities for identification and inclusion.

On the macrolevel, then, quebradita dancing was and is significant for its political and sociocultural functions as well as for its aesthetic content. Teenagers used quebradita as a means of negotiating ethnic,

peer group, and individual identities. It was danced both by immigrants and U.S.–born youths, but it played an especially important role in the lives of middle-class dancers who had previously not self-identified as Mexican American. Through its use of a working-class border aesthetic, it made a statement of ethnic pride that confronted ethnocentric legislation head-on. Meanwhile, its integration of many dance styles demonstrated that teenagers were not content either with assimilation or with maintenance of a conservative interpretation of Mexican American culture. Instead, they were intent on creating a new space for themselves in U.S. society and a new means of self-expression to show how they fit into that space. In their use of pastiche, these young dancers made a metaphorical case for interethnic unity. The aesthetics and politics of quebradita are still relevant today to those who draw upon it in elaborating new kinds of regional Mexican music and dance.

On the microlevel, quebradita affected individual lives, sometimes in profound ways. The importance of quebradita to teenagers such as those I've described serves to point out a problem with secondary education: it became obvious through my talks with dancers that their needs were not being met by the traditional school curriculum. If many students came to school only when they had dance practice; if some improved their academic performance because of the dance; and if others were inspired to exercise more, learn more, or avoid destructive behavior because they were dancing, should not such activities be more widely available? In the cases I have presented here, the dancers were lucky enough to find mentoring and support from at least one teacher in their schools, but such things should not depend on luck. Teenagers need more neighborhood centers that offer dance classes, clubs, and social dancing; they also need greater variety in school physical education programs that take into account differing interests and needs. It is doubtful that many teachers and administrators would have learned of the quebradita had the students not already been actively promoting it and forming their own associations. Perhaps ethnomusicologists and other culture workers can help by identifying and studying emerging music and dance phenomena, thus providing politicians who control the funding for arts programs with the information they need to make more informed decisions.

Conclusions

I began studying the quebradita and banda music as popular art forms, and I hope I have increased my readers' appreciation of them as such by this point. I have explained how the two are tied together by the concept of lo ranchero, which in turn ties them to a greater tradition of Mexican art, one concerned with rural life, machismo, and strongly felt emotion. My exploration of the aesthetics of these art forms helped me to answer my second research question (see chapter 1), which involved relating my topics to antecedent forms. Other artistic expressions that use a ranchero aesthetic include norteña music, mariachi, and some types of folklórico dance; if one expands the boundaries, even country music can be included because North American cowboy culture drew heavily from the Mexican vaquero tradition. My sources drew connections between each of these art forms and linked them to the quebradita.

My third question, which involved discovering the dance's origins, turned out to be the most difficult to answer. It is possible the disagreement I encountered was simply one of definition: defining when a dance so closely tied to its predecessors actually began is like debating whether life begins at conception or at birth. Musically speaking, it is like trying to find the point at which a cumbia song becomes a quebradita. There is no metronome marking that can determine the answer once and for all; one just has to *know*, or at least to be able to make an educated guess. Yet the appearance of a geographic and nationalistic basis for dancers' answers to this question is still significant. It shows how narratives of history can be used in a binational debate over identity. My research on quebradita's origins, its diffusion, and its transformation also helped to show me why and how it had become so enormously popular. Its combination of popular forms, such as hip-hop and line dancing, with traditional ones, such as folklórico dances, seemed to make it especially significant and attractive for both Mexican-born and American-born youths.

My final investigation involved the role of the dance (and of the music for it) in individual lives. I have already discussed the positive impact it had on some dancers, motivating them to do better in school and to stay away from negative influences. I also have noted how it became an important part of the identities of many participants, especially those who previously had had little contact with

Mexican culture. Shannon confided that the dance was "one of the prides in my life. When people ask me what I'm about, it's one of the things I say: 'I used to be in a quebradita club' " (interview, 1999). A mere fad—the Macarena, for example—could never evoke a statement of such poignancy.

I believe that the impact of this popular music and dance complex is still being felt and will continue to be felt for years to come as part of a larger awakening of interest in Mexican and Mexican American popular and traditional culture that crosses class boundaries. That this particular facet of the movement has been largely owing to the efforts of teenagers who hold little political or economic power makes it all the more remarkable. Yet it is also evidence that much work remains to be done in securing equal opportunities and recognition for disenfranchised segments of the U.S. population, such as urban minority youth. Mexican anthropologist Mariángela Rodríguez tells us,

> The fight for citizenship in its widest sense is nothing other than the fight against anonymity and standardization; it is a search for legitimacy and social recognition in the face of a society that works to erase that social existence. . . . These processes of identification [in which immigrant youth engage] involve not only the formation of migrants' own identity, they also represent a contribution to the constitution of the national identity of the receiving countries together with the resignification of other identity contributions coming from other ethnic groups with whom they interact. (1997)

Thus, as quebradores fought against aesthetics and values imposed from without and worked their way into the national spotlight, they were symbolically fighting for citizenship as well. For a time, they succeeded in diverting attention away from the "youth problem" and onto their creative potential, making the country aware of their existence and creating a popular culture on their own aesthetic terms. Whether these youths have succeeded in diminishing deep-seated prejudices or in altering concepts of U.S. national identity to include them still remains to be seen. If it is true that "dance may reflect what is and *also influence what might be*," as Judith Lynne Hanna has suggested (1989:231, emphasis in original), then let us hope that the quebradita is indeed a herald of more harmonious and inclusive times to come.

Notes

1. The expression "jumping on the banda wagon" became current in the 1990s. *Frontera Magazine* defined it as "non-Latinos trying to learn the quebradita" (from "Frontera Glossary," *Frontera Magazine* 1996).

2. I witnessed the bloody end of a fistfight at a banda/norteña concert in Indiana some years later.

3. Simonett experienced the same reaction to her research on banda music: a friend's family suggested she study "some nice Mexican music such as mariachi" (2001:130).

4. Dance ethnology has a long history in both fields, although this history has been deemphasized and remains largely unknown, possibly owing to gender bias. In anthropology, Franz Boas had a great interest in dance and encouraged his daughter Franziska Boas to study this topic. She did, opening a dance school where figures such as John Cage studied and producing important early works on dance ethnology (see Boas 1944). In addition, numerous members of the Society for Ethnomusicology published on dance in the first two decades of its existence, including Adrienne Kaeppler, Joann Kealiinohomoku, and founding member Gertrude Kurath. An extended discussion of the history of dance ethnology is beyond the scope of this work, but it deserves to be explored more fully elsewhere. Clara Henderson's forthcoming dissertation from Indiana University's Department of Folklore and Ethnomusicology promises to do just that.

5. Although this situation was formerly discussed only in academic publications (particularly in the field of sociology), a recent *New York Times* article series attempted to reintroduce the concept of class to the North American public. These insightful pieces (DePalma 2005; Leonhardt 2005; Lewin 2005a, 2005b; Scott 2005) demonstrate that class continues to be a determining factor in North American lives in areas as diverse as education, career paths, health, and marriage.

6. I should note that although I here capitalize terms of nationality (such

as *Mexicano*) in order to conform to standard English usage, nationalities are never capitalized in Spanish grammar. Throughout this text, I conform to standard Spanish practice in Spanish passages.

7. Bandas can be traced back even as far as the colonial era, when wind ensembles were formed in the missions (Brenda Romero, personal communication, 2005).

8. For Olvera, cumbia norteña is only one of four types of Mexican cumbia. First, among the others are the "tropical cumbia" groups who adapt the genre to an instrumentation that includes electric guitar and keyboards. Though most popular in central and coastal Mexico, *grupos tropicales* are found all over the American Southwest as well (see Peña 1985:107); nevertheless, in places such as Tucson it is more common for cumbias to be just one part of a repertoire that also includes rancheras, corridos, polkas, and more, and thus appeals to a wider audience. Second, some groups attempt to reproduce cumbia in its original style, a musical genre that is known simply as "Colombia" in Monterrey. Finally, the large orquestas of central Mexico play Colombian cumbias together with popular salsa styles (Olvera 2000).

9. Texans, however, seem never to have caught on to the quebradita or to banda music in general, except for the major hits of Banda Machos (see Burr 1999:60), perhaps because of the popularity of their own tejana music at the time. The huge interest in artists such as Selena, Mazz, and La Mafia was concurrent with the banda/quebradita craze, which may show that the political and social needs the latter filled for Californians and other southwesterners were being met by local musics for Texans.

10. "Un Indio Quiere Llorar" by Ricardo Montoya Rivera ©1991 Zomba Enterprises Inc. (ASCAP)/ Grever Music Publishing S.A. de C.V. (SACM); all rights for the U.S. on behalf of Zomba Enterprises Inc. (ASCAP) administered by Grever Music Publishing S.A. de C.V. (SACM). Used by permission.

11. The popular group Café Tacuba has included English-language translations of lyrics in recent albums.

12. On the other side of the border, historian Manuel Gonzales has also noted "the increased popularity of salsa . . . especially among the Mexican-American middle class" (1999:258).

13. Even though quebradita itself, like the polka, is played in a very fast tempo, it is in practice always performed together with old-fashioned slow rancheras and therefore forms a part of the ranchera complex.

14. In fact, the first time I danced quebradita with a partner, we used this same step. The tight hold I kept on my partner's leg was necessitated by the vigorous motion of the step and the back-bending quebradas that give the dance its name, all performed almost instinctually.

15. I was once scolded for the misplacement of my hand by a partner who knew I was conducting research. Because I didn't know him very well, I had

tried to keep distance between us by placing my hand on his shoulder instead of wrapping it in a full embrace around his neck—a no-no.

16. A friend made a joke on the connection between quebradita and corriditas when I was interviewing the Ayalas. While watching an old, portly, and not particularly agile gentleman dancing corriditas on a video taken at Pablo and Daniela's wedding party, he remarked, "He's not dancing quebradita [the little break]; he's dancing *quebradote* [the big break]!"

17. One might argue that even the word *rasquache* reflects this biculturalism. Though in English orthography *qu* produces the requisite *kw* sound, in Spanish it does not. Thus, the "correct" Spanish spelling would be *rascuache*. Ybarra-Frausto's choice of the English *qu* spelling of the Spanish word itself shows a rasquache spirit.

18. "Naco" is also the name of a town on the Arizona-Sonora border, and Tacuaro is a town in Guanajuato. The reasons for which these two towns have been singled out for denigration are unclear to me, but perhaps future researchers will discover the answer.

19. Robby stated that the CDO principal had even recognized their efforts in this arena. She was therefore disappointed when the group finally broke up and told them that "dancing [is] a really positive way to show the culture."

20. Cholo dress originally derived from military and penal attire—baggy khakis, worn long and uncuffed; oversized plaid "Pendleton" shirts, usually long-sleeved; and polished Imperials, Hush Puppies, or deck shoes. After the Chicano movement attached greater status to indigenous customs, cholos began wearing bandanas tied around the head. Cholas favored long, flowing hair and heavy makeup. It is important to remember that cholo style is not necessarily indicative of gang membership; many young people adopt the look either as a fashion statement or as a deterrent to would-be attackers (Vigil 1988:110–12).

21. In the 1980s, Vigil heard the word *chúntaro* used by cholos as a derogatory term for Mexican nationals (1988:119).

22. All the statistics on school demographics in this section come from the Arizona Department of Education and are posted on the Web site http://www.greatschools.net (accessed 10 August 2005). *Hispanic* is the term used in reporting ethnicity on such school-related documents.

23. Such a lack of consensus was a puzzle also encountered by Deborah Pacini Hernández during her research on Dominican bachata, a music that has much in common with banda (1995:xv; see also chapter 2 in this book).

24. *Pocho* is a slang term for Mexican American or Chicano.

25. Jesús Arévalo, a musician originally from Guanajuato, noted, "I have friends I grew up with who play in bandas all over California and Chicago" (quoted in Ragland 1996).

26. Nonetheless, living situations are not always much better in the sub-

urbs. John Betancur reports that Latinos moving to Chicago suburbs tend to cluster in "the most deteriorated rental areas"; they also often face resistance from neighbors and "white flight," leading to further segregation (1996:1315).

27. So far there do not seem to be any feature films using the pasito as a theme, as with the quebradita films examined in chapter 4, but music videos are popular among duranguense fans. They are sold on DVD and often packaged together with CD releases.

28. The look I have described is that of couple dancing, but it may be toned down for solo dancing. Women, in particular, use more isolation in solo steps, bringing the dance closer to merengue style. In addition, as with any popular dance, style can very significantly from individual to individual.

29. *Tamborazo* is the name given to the regional banda style of the state of Zacatecas (Simonett 2001:9). *Tambor* means "drum," and *-azo* is an emphatic suffix, so the term can reasonably refer to any banda using a big drum sound. Therefore, one may also hear the term applied informally to Sinaloan bandas and even tecnobandas.

30. In an article recounting the trajectory of the "tierra caliente" style from popular singer Joan Sebastian to the "more agile, more aggressive" sound of groups from Michoacán and Guerrero, Web columnist Fabián Serrano likewise asked, "Will it be in the U.S. where tierra caliente music is recognized? . . . Will it come to be considered a new genre?" (2002).

31. It is important to note that this style of música tierracalentana is a popular music that draws from the same repertoire of romantic songs as do other grupera styles rather than on the traditional regional repertoire. The folkloric music most typical of the region is the son and the *gusto* (a local son variant in waltz time) played on violin. The influence of such traditions on the grupera–tierra caliente style is minimal, though some tenuous ties might be found between vocal styles or between the "waltz feel" Simplicio described and the waltzlike gusto.

32. "El fin de la infancia" words and music by Cosme, Meme, Quique and Joselo; © 1994 Warner Chappell Music Mexico, S.A. de C.V. (SACM) and Editora de Musica WEA, S.A. de C.V. (SACM); all rights administered in the U.S. and Canada by Warner-Tamerlane Publishing Corp. (BMI); lyrics reprinted by permission of Alfred Publishing Co., Inc.; all rights reserved.

Glossary

alacrán. (n.) Scorpion, the symbol of the state of Durango.

alegre. (adj.) Happy, joyful; (n.) *alegría.*

bajo sexto. (n.) A type of acoustic guitar with double-coursed strings used in norteña music.

banda. (n.) Literally "band," a term most commonly applied at present to popular Mexican brass-band styles, particularly banda sinaloense and tecnobanda.

brinquito. (n.) "Little jump," an early style of quebradita dancing.

caballito. (n.) Little horse; a name for another early version of the quebradita dance.

cachongo. (n.) A competitive, improvisatory solo dance from Nayarit.

caló. (n.) A term that originally referred to Spanish gypsy slang, but now generally refers to the argot of the pachuco and cholo youth cultures. A combination of Mexican Spanish, U.S. English, Mexican American dialects, and invented vocabulary.

chero. (n.) Cowboy (or one who dresses like a cowboy); short for *ranchero.*

Chicana/o. (n.) A person of Mexican descent born in the United States. Since the 1960s, the term has been politicized to refer to a person involved in the Chicano movement, which advanced the causes of equal rights and pride in culture and language.

chilanga/o. (n.) Person from Mexico City.

chola/o. (n.) Mexican American gang member or one who adopts such a style.

chunt, chunti, chúntaro. (n. and adj.) Derogatory term for a low-class, unrefined, or tacky person. Los Angeles banda dancers who wear Western-style clothing have reclaimed these terms as in-group terms of empowerment, similar to the "N" word among the hip-hop community.

correa. (n.) Leather strap worn by quebradores and often engraved with the name of a Mexican state.

corriditas. (n.) A term for the style of norteño dancing popular in Sonora and Arizona.

corrido. (n.) A form of narrative song common in the border area.

cuarta. (n.) A small horsewhip worn by some quebradita dancers.

culebra. (n.) Snake; a dance step or song of the same name.

cumbia. (n.) Originally a dance and musical genre from Colombia, now a standard part of the repertoire of tropical, norteño, and banda groups in Mexico and the border region.

diablo. (n.) Devil; a dancer's nickname.

D.F., el. (n.) Short for "Distrito Federal," or Mexico City.

duranguense. (adj.) From the state of Durango.

folklórico. (n.) Literally "folkloric"; the generic name given to all traditional Mexican dances that have been enshrined through performances by national and regional folk dance companies.

fresa. (n.) Literally "strawberry," but referring to a rich kid.

fronteriza/o. (n.) Border dweller.

grito. (n.) A stylized shout or yell, done especially when one hears a particularly moving musical performance.

grupera. (n. and adj.) A style of popular Mexican music based around a rock-type lineup of guitar, bass, drums, and keyboards, and often playing romantic ballads. By extension, it can also be used to describe regional Mexican musics played with a pared-down lineup, such as tecnobanda.

jarabe. (n.) A type of instrumental medley dating to colonial times and today played principally by mariachi bands.

jaripeo. (n.) A rodeo competition at which banda, norteño, or duranguense groups often play between events.

indígena. (n. and adj.) Indigenous person.

machista. (adj.) Male chauvinist.

media luna. (n.) Half moon; descriptive name for a quebradita step.

mestiza/o. (adj.) Exhibiting mestizaje; (n.) a person of mixed race.

mestizaje. (n.) The mixing of races or cultures. In Mexico, it refers mainly to the combination of Spanish and indigenous features in the country's arts and culture.

naco. (n. and adj.) Hick, a rural person considered to have bad taste; also a town on the Arizona-Sonora border.

norteña/o. (n.) Musical style from the U.S.–Mexico border region; (adj.) from northern Mexico.

pachuca/o. (n.) A member of a youth subculture found in Los Angeles and throughout the Southwest in the 1930s and 1940s, distinguished by the wearing of zoot suits (baggy pants with pegged cuffs and a wide-shouldered coat with fingertip-length sleeves) and the speaking of caló.

paisana/o, paisa. (n. and adj.) Literally a person from one's own country, used to refer to Mexicans, especially those of rural areas.

pandilla; pandillero. (n.) Gang; gang member. *Banda* for a band of youths and *ganga* from the English "gang" are sometimes heard as synonyms for *pandilla.*

pasito duranguense. (n.) A style of Mexican American dance arising in Chicago around the turn of the twenty-first century that combines moves from quebradita, norteña, and merengue.

pato. (n.) Duck; a dancer's nickname.

pocha/o. (n. and adj.) Slang term for Mexican American or Chicano.

polca. (n.) (also *polka*) A musical form in quick two-four time; the dance done to such music.

pollo. (n.) Chicken; a dancer's nickname.

punta. (n.) Honduran popular music based on a combination of rock and the traditional funeral music of the Garífuna people.

quebrada. (n.) break; the characteristic move of quebradita.

quebradita. (n.) A ranchero style of dance usually performed to tecnobanda music and popular in the 1990s.

quebrador. (n) A quebradita dancer (literally "breaker").

quinceañera. (n.) Elaborate coming-of-age party for fifteen-year-old girls.

ranchero. (n.) A rancher; (adj.) in a rural or cowboylike style.

rasquache; rasquacho/a. (adj.; n.) Having a flashy, over-the-top style that some members of the middle and upper classes consider "tacky"; one who exhibits this style.

reggaetón. (n.) A Spanish-language rap music style based on Jamaican dance-hall reggae.

sinaloense. (adj.) From the state of Sinaloa; a large banda playing in Sinaloan style.

sonidero. (n. and adj.) A deejay with a large and expensive sound system who plays mainly cumbia music for dances; most popular in Mexico City, in surrounding areas such as Puebla, and among Pueblan immigrants in the United States.

tacuara/o. (n.) Same as *rasquacho;* also a town in Guanajuato.

tambora. (n.) Drum, especially the bass drum; also used to describe the Sinaloan and Zacatecan musical styles centered around this instrument.

tamborazo. (n.) Regional banda style of the state of Zacatecas; the term is also applied informally to Sinaloan bandas and even to tecnobandas.

tecnobanda. (n.) Techno band; a banda that uses synthesizer and other electric instruments in place of some brass instruments.

tololoche. (n.) Upright string bass.

toro. (n.) Bull; descriptive name for a quebradita step.

vals. (n.) (also *waltz*) A musical form in three-four time; the dance done to such music.

vaquero. (n.) Cowboy; someone who dresses in cowboy style.

zapateado, zapateo. (n.) Quick, rhythmic footwork that strikes the floor; a dance composed of such steps; the music that accompanies such a dance.

Works Cited

Interviews and Personal Communications

Ayala, Daniela. 1999. Hermosillo, Sonora, 24 July.

Barrios, Siris. 2005. Los Angeles, 17 March.

Butler, Darron. 1999. Tucson, 3 August.

Cárdenas, Marcela. 1999a. Tucson, 3 and 18 August.

——. 1999b. Electronic communications.

Castro, Daniel. 2005. Chicago, 21 May.

Díaz de León, Xicoténcatl. 1999. Hermosillo, Sonora, 24 July.

Espinoza, Robert. 1999. Tucson, 16 August.

Franco, Reynaldo. 1999. Tucson, 14 June.

Franco, Sandra. 1999. Tucson, 16 August.

García, Jaime. 2002. Electronic communication, 12 August.

Gardea Nacoch, Valeria. 1999. Tucson, 29 July.

Gómez, Ximena. 1999. Tucson, 10 August.

Hunt, José Miguel. 1999. Tucson, 3 August.

Las Hechiceras de la Jungla. 2005. Chicago, 20 May.

López, Jaime. 2005. Oxnard, Calif. 16 March.

Martínez, Ernesto. 1999. Tucson, 28 July.

Molina, Jesús. 2005. Santa Ana, Calif., 18 March.

Ortiz, Shannon. 1999. Tucson, 22 July and 3 August.

Padilla, David. 2005. Los Angeles, 18 March.

Pérez, Darma (pseudonym). 1999. Tucson, 2 and 8 June.

Porras, Sol. 2005. Oxnard, Calif., 16 March.

Rodríguez, Lucina. 2005. Gardena, Calif., 19 March.

Román, Simplicio. 2005. Chicago, 18 May.

Siu, Oriel. 2005. Los Angeles, 18 March.

Published Works

Anderson, Benedict. 1991. *Imagined Communities: Reflections on the Origin and Spread of Nationalism.* London: Verso.

"El año de 2004, ha sido sin duda alguna, el año del grupo Montez de Durango." [2005]. *El Día* (Chicago). Available at: http://www. eldianews .com/Ediciones/News_010705/espectáculos.htm. Accessed 23 April 2005.

Anzaldúa, Gloria. 1987. *Borderlands / La Frontera: The New Mestiza.* San Francisco: Spinsters/Aunt Lute.

Apodaca, Rose. 1993. "Wanna Dance? Latino Accent on Oom-Pah-Pah." *Los Angeles Times*, 10 June.

Appelbaum, Nancy P., Anne S. Macpherson, and Karin Alejandra Rosemblatt. 2003. "Introduction: Racial Nations." In *Race and Nation in Modern Latin America*, edited by Nancy P. Appelbaum, Anne S. Macpherson, and Karin Alejandra Rosemblatt, 1–31. Chapel Hill: University of North Carolina Press.

Aranda, Julio. 1998. "'Demostraremos que en Morelos no sólo hay bandas de secuestradores o narcotraficantes': La Banda de Tlayacapan, premio Tradiciones Populares." *El Proceso*, 15 November.

Arbeláez, María S. 2004. "Low-Budget Films for *Fronterizos* and Mexican Migrants in the United States." In *On the Border: Society and Culture Between the United States and Mexico*, edited by Andrew Grant Wood, 177–97. Boulder, Colo.: SR Books.

Arceo-Frutos, René H., Juana Guzmán, and Amalia Mesa-Bains, exhibition curators. 1993. *Art of the Other México: Sources and Meanings.* Chicago: Mexican Fine Arts Center Museum.

Arizona Department of Commerce. 2001. *Tucson Community Profile.* Phoenix: Arizona Department of Commerce.

Attali, Jacques. 1985. *Noise: The Political Economy of Music.* Translated by Brian Massumi. Minneapolis: University of Minnesota Press.

Austin, Joe, and Michael Nevin Willard. 1998. "Introduction: Angels of History, Demons of Culture." In *Generations of Youth: Youth Cultures and History in Twentieth-Century America*, edited by Joe Austin and Michael Nevin Willard, 1–20. New York: New York University Press.

Avila, David A., and Mimi Ko. 1993. "*Banda* Music's Sour Notes: Dance Fans Stepping on Some Toes, Cities Say." *Los Angeles Times*, 12 Sept.

Bada, Xóchitl. 2003. "Mexican Hometown Associations." On *P.O.V.: The Sixth Section.* Available at the Public Broadcasting System (PBS) Web site: http://www.pbs.org/pov/pov2003/thesixthsection/special_ mexican.html. Accessed 27 August 2005.

Barker, George Carpenter. [1950] 1970. *Pachuco: An American-Spanish Argot*

and Its Social Functions in Tucson, Arizona. Tucson: University of Arizona Press.

Barth, Fredrik, ed. 1969. *Ethnic Groups and Boundaries.* Boston: Little, Brown.

Betancur, John J. 1996. "The Settlement Experience of Latinos in Chicago: Segregation, Speculation, and the Ecology Model." *Social Forces* 74(4): 1299–324.

Bettie, Julie. 2003. *Women Without Class: Girls, Race, and Identity.* Berkeley: University of California Press.

"Biografías: K-Paz de la Sierra." n.d. *Planeta Grupero.com.* Available at: http:// planetagrupero.com/more1072. Accessed 23 April 2005.

Boas, Franziska, ed. 1944. *The Function of Dance in Human Society.* Seminar on Primitive Society, directed by Franziska Boas. New York: Boas School.

Bolton, Herbert E. 1921. *The Spanish Borderlands: A Chronicle of Old Florida and the Southwest.* New Haven, Conn.: Yale University Press.

Bright, Brenda Jo. 1995a. "Introduction: Art Hierarchies, Cultural Boundaries, and Reflexive Analysis." In *Looking High and Low: Art and Cultural Identity*, edited by Brenda Jo Bright and Liza Bakewell, 1–18. Tucson: University of Arizona Press.

——. 1995b. "Remappings: Los Angeles Low Riders." In *Looking High and Low: Art and Cultural Identity*, edited by Brenda Jo Bright and Liza Bakewell, 89–123. Tucson: University of Arizona Press.

——. 1998. "Nightmares in the New Metropolis: The Cinematic Poetics of Low Riders." In *Generations of Youth: Youth Cultures and History in Twentieth-Century America*, edited by Joe Austin and Michael Nevin Willard, 412–26. New York: New York University Press.

Brown, Michael K., Martin Carnoy, Elliott Currie, Troy Duster, David B. Oppenheimer, Marjorie M. Schultz, and David Wellman, eds. 2003. *Whitewashing Race: The Myth of a Color-Blind Society.* Berkeley: University of California Press.

Burr, Ramiro. 1999. *The Billboard Guide to Tejano and Regional Mexican Music.* New York: Billboard Books.

Burroughs, Dena. 2002. "Up Close and Personal with . . . Victor and Gaby of Salsa con Clave from Mexico, D.F." On ToSalsa.com, at: http://www.tosal sa.com/forum/interviews/interview020615dena_victor_gaby.html. Accessed 29 August 2005.

Campos, Rubén M. 1928. *El folklore y la música mexicana: Investigaciones acerca de la cultura musical en México (1525–1925).* Mexico City: Secretaría de Educación Pública.

Canchola, Sandra. 1994. "I Won't Dance" (letter to the editor). *Los Angeles Times Magazine*, 6 March.

Carrasco, Rodolpho. 1994. "A Generation's Faith: A 21st-Century Identity Crisis." *Sojourners Magazine* (November). Available at: http://www .sojourners.com/soj9411/941110c.html. Accessed 8 July 1999.

Carrizoso, Toño. 1997. *La onda grupera: Historia del movimiento grupero.* Mexico City: Edamex.

Castro, Rafaela G. 2000. *Dictionary of Chicano Folklore.* Santa Barbara, Calif.: ABC-CLIO.

City of Tucson Planning Department. 2002. *Tucson Update 2002* (September). Available at: http://www.ci.tucson.az.us/planning/update.htm.

Clarke, John, Stuart Hall, Tony Jefferson, and Brian Roberts. 1976. "Subcultures, Cultures, and Class: A Theoretical Overview." In *Resistance Through Rituals: Youth Subcultures in Post-war Britain*, edited by Stuart Hall and Tony Jefferson, 9–74. London: Hutchinson.

Colvin, Richard Lee. 1994. "Music Was the Thing for Victim of Gang Attack." *Los Angeles Times*, 18 May.

Cordova, Randy. 1998. "Viva la revolución! 'Rock en español' Poised to Make Pop Music History." *Arizona Republic*, 26 February.

Darling, Juanita. 1994. "Fads, Fashion, and Foolery for 1994." *Los Angeles Times*, 4 January.

Davis, Maia. 1993. "Mexican Music Draws Crowd for Final Day of Fair; Fiesta Day Events Are Geared toward Ventura County's Latino Community." *Los Angeles Times*, 30 August.

Del Moral, Christian. 1997. "Las rolas de hoy." *El Nacional* (México City), 5 May.

De Palma, Anthony. 2005. "15 Years on the Bottom Rung." *New York Times*, May 25.

Dillon, Hope. 1997. "Café Tacuba: Forging a New Mexican Identity." *Journal of American Culture* 20(2): 75–83.

Donnan, Hastings, and Dieter Haller. 2000. "Liminal No More: The Relevance of Borderland Studies." In *Borders and Borderlands—An Anthropological Perspective*, special issue of *Ethnologia Europaea* 30(2): 7–22.

Doremus, Anne. 2001. "Indigenism, Mestizaje, and National Identity in Mexico during the 1940s and the 1950s." *Mexican Studies/Estudios Mexicanos* 17(1): 375–402.

Easley, Joan. 1993. "Strike Up the Banda: The Popular Mexican Dance Music Is Gaining Momentum with Young and Old, Who Turn Out in Cowboy Gear at Local Clubs and Private Parties to Do *La Quebradita.*" *Los Angeles Times*, 29 October.

Emerick, Laura. 2004. "Chicago's Own Montez de Durango Remains Leader of the Pack." *Chicago Sun-Times*, 29 November. Available at: http://www.suntimes.com/output/music/cst-ftr-latin29.html. Accessed 23 April 2005.

Erlmann, Veit. 1993. "The Politics and Aesthetics of Transnational Musics." *World of Music* 35(2): 3–15.

Farquharson, Mary. 1994. "Over The Border: Mexico Is a Whole Lot More

Than Mariachi." In *World Music: The Rough Guide*, edited by Simon Broughton, Mark Ellingham, David Muddyman, and Richard Trillo, 541–48. London: Rough Guides.

Fass, Paula F. 1998. "Creating New Identities: Youth and Ethnicity in New York City High School in the 1930s and 1940s." In *Generations of Youth: Youth Cultures and History in Twentieth-Century America*, edited by Joe Austin and Michael Nevin Willard, 95–117. New York: New York University Press.

Feuerstein, Alan. n.d. "Tito Puente: Much More Than a Legend." *Planet Salsa*. Available at: http://www.planetsalsa.com/quepasa/tp.htm. Accessed 7 January 2004.

Flores, Mauricio. 1999. "Y la fiesta del movimiento explotó en todo el país." Available on the Web site of the Consejo Nacional para la Cultura y las Artes (México City) at: http://www.cnca.gob.mx/cnca/nuevo/diarias/010598/diadanza.html. Accessed 8 July 1999.

Flores Vega, Ernesto. 1997. "Ciudad con alma, apela Castillo Peraza: El 'Jefe' Diego y la sombra de Cuauhtémoc." *Semanario Etcétera*, 3 July.

Fonovisa. 2004. "Banda el Recodo." Available at the Fonovisa Records Web site: http://www.fonovisa.com/bandaelrecodo.html. Accessed 10 June 2005.

Fonseca, José Jesús. 1998. "Patrimonio destruído con ruido y basura." *El Nacional* (Mexico City), 15 May.

Frith, Simon. 1988. "Art Ideology and Pop Practice." In *Marxism and the Interpretation of Culture*, edited by Cary Nelson and Lawrence Grossberg, 461–75. Urbana: University of Illinois Press.

Frontera Magazine. 1996–2001. Los Angeles. Available at: http://fronteramag.com.

Galarza, Ernesto. 1970. *Spiders in the House and Workers in the Field*. Notre Dame, Ind.: University of Notre Dame Press.

———. 1971. *Barrio Boy*. Notre Dame, Ind.: University of Notre Dame Press.

García Canclini, Nestor. [1990] 2001. *Culturas híbridas: Estrategias para entrar y salir de la modernidad*. Rev. ed. Buenos Aires: Editorial Paidós.

Garofalo, Reebee. 1993. "Whose World, What Beat: The Transnational Music Industry, Identity, and Cultural Imperialism." *World of Music* 35(2): 16–32.

Gaspar de Alba, Alicia. 1998. *Chicano Art Inside/Outside the Master's House: Cultural Politics and the CARA Exhibition*. Austin: University of Texas Press.

Geertz, Clifford. 1973. *The Interpretation of Cultures: Selected Essays*. New York: Basic Books.

Giraud, Melissa. 2005. "The World: Global Hit," Public Radio International (PRI), report on música duranguense, 9 March. Available on-line at PRI's *The World:* http://www.theworld.org/globalhits/2005/03/09.shtml. Accessed 17 June 2006.

Gómez-Peña, Guillermo. 1986. "Border Culture: A Process of Negotiation toward Utopia." *The Broken Line / La linea quebrada: A Border Arts Publication* 1(1): 1–6.

Gonzales, Manuel G. 1999. *Mexicanos: A History of Mexicans in the United States.* Bloomington: Indiana University Press.

Griffith, James S. 1993. "The Arizona-Sonora Border: Line, Region, Magnet, and Filter." In *Borderlands Festival Program Booklet.* Washington, D.C.: Smithsonian Institution. Available at: http://educate.si.edu/migrations/bord/azsb.html.

Guerra, Juan C. 1998. *Close to Home: Oral and Literate Practices in a Transnational Mexicano Community.* New York: Teachers College Press.

Hall, Stuart, and Tony Jefferson, eds. 1976. *Resistance Through Rituals: Youth Subcultures in Post-war Britain.* London: Hutchinson.

Hanna, Judith Lynne. 1989. "The Anthropology of Dance." In *Dance: Current Selected Research*, vol. 1, edited by Lynnette Y. Overby and James H. Humphrey, 219–37. New York: AMS Press.

Haro, Carlos Manuel, and Steven Loza. 1994. "The Evolution of Banda Music and the Current Banda Movement in Los Angeles." In *Selected Reports in Ethnomusicology X: Musical Aesthetics and Multiculturalism in Los Angeles*, edited by Steven Loza, 59–71. Los Angeles: University of California.

Hebdige, Dick. 1979. *Subculture: The Meaning of Style.* London: Methuen.

Heyman, Josiah. 1994. "The Mexico–United States Border in Anthropology: A Critique and Reformulation." *Journal of Political Ecology* 1: 43–64.

Hinojosa, Francisco. 1995. *Un taxi en LA.* Mexico City: Consejo Nacional para la Cultura y las Artes.

Hobsbawm, Eric. 1983. "Introduction: Inventing Traditions." In *The Invention of Tradition*, edited by Eric Hobsbawm and Terence Ranger, 1–14. New York: Cambridge University Press.

Hutchinson, Sydney. 2004. "Mambo on 2: The Birth of a New Form of Dance in New York City." *CENTRO Journal* 16(2): 109–37.

———. 2006. "Merengue típico: Transnational Regionalism and Class Transformation in a Dominican Neotraditional Music." *Ethnomusicology* 50(1): 37–72.

———. In press. "The Ballet Folklórico de Mexico and the Construction of the Mexican Nation Through Dance." In *Dancing across Borders: Danzas y bailes mexicanos*, edited by Olga Nájera-Ramírez, Norma Cantú, and Brenda Romero. Urbana: University of Illinois Press.

Inclán, Ramón. 2004. "El Morro se pone de moda." *La Opinión*, 27 April. Available at: http://www.laopinion.com/archivo/index.html. Accessed 17 June 2006.

Inter Tribal Council of Arizona (ITCA). 1997. ITCA home page, at: http://www.itcaonline.com/Home.htm. Accessed 15 December 2002.

Jáuregui, Jesus. 1990. *El mariachi: Símbolo musical de México*. Mexico City: Banpaís.

Johnson, Gordon. 1994. "Strike Up the Banda: People Are Swarming to Inland-Area Clubs to Listen and Dance to This Lively Music." *Press-Enterprise* (Riverside, Calif.), 27 March.

El Kaiman. 2003. "Montez de Durango: De Durango a Chicago." Interview. *La Farándula* (México City), 18 December. Available at: http://www. lafar andula.com/Montez.htm. Accessed 23 April 2005.

Keil, Angela, and Charles Keil. 1987. "In Pursuit of Polka Happiness." In *Popular Culture in America*, edited by Paul Buhle, 75–83. Minneapolis: University of Minnesota Press.

Ko, Mimi, and David A. Avila. 1993. "Tecali Founder Uses Dance Club as Anti-gang Measure for Youths." *Los Angeles Times*, 12 September.

Laslett, John H. M. 1996. "Historical Perspectives: Immigration and the Rise of a Distinctive Urban Region, 1900–1970." In *Ethnic Los Angeles*, edited by Roger Waldinger and Mehdi Bozorgmehr, 39–75. New York: Russell Sage Foundation.

Leonhardt, David. 2005. "The College Dropout Boom." *New York Times*, May 24.

Levitt, Peggy. 2001. *The Transnational Villagers*. Berkeley: University of California Press.

Lewin, Tamar. 2005a. "A Marriage of Unequals." *New York Times*, 19 May.

——. 2005b. "Up from the Holler: Living in Two Worlds, at Home in Neither." *New York Times*, 19 May.

Limón, José. 1983. "Texas-Mexican Popular Music and Dancing: Some Notes on History and Symbolic Processes." *Latin American Music Review* 4(2): 229–46.

——. 1994. *Dancing with the Devil: Society and Cultural Poetics in Mexican-American South Texas*. Madison: University of Wisconsin Press.

Lipsitz, George. 1990. *Time Passages: Collective Memory and American Popular Culture*. Minneapolis: University of Minnesota Press.

——. 1994. "We Know What Time It Is: Race, Class, and Youth Culture in the Nineties." In *Microphone Fiends: Youth Music and Youth Culture*, edited by Andrew Ross and Tricia Rose, 17–28. New York: Routledge.

Loza, Steven. 1993. *Barrio Rhythm: Mexican American Music in Los Angeles*. Urbana: University of Illinois Press.

——. 1994. "Identity, Nationalism, and Aesthetics among Chicano/Mexicano Musicians in Los Angeles." In *Selected Reports in Ethnomusicology X: Musical Aesthetics and Multiculturalism in Los Angeles*, edited by Steven Loza, 51–58. Los Angeles: University of California.

Macías, Anthony F. 2001. "From Pachuco Boogie to Latin Jazz: Mexican Americans, Popular Music, and Urban Culture in Los Angeles, 1940–1965." Ph.D. diss., University of Michigan.

Manuel, Peter. 2002. "Modernity and Musical Structure: Neo-Marxist Perspectives on Song Form and Its Successors." In *Music and Marx: Ideas, Practice, Politics*, edited by Regula Burckhardt Qureshi, 45–62. New York: Routledge.

Marre, Jeremy, and Hannah Charlton. 1985. *Beats of the Heart: Popular Music of the World*. London: Pluto Press.

Martínez, Iveris Luz. 2002. "Danzas nacionalistas: The Representation of History Through Folkloric Dance in Venezuela." *Critique of Anthropology* 22: 257–82.

Martínez, Rubén. 1994. "The Shock of the New; Anti-Immigration Fever Is at a Fever Pitch, But the Real Issue Is This: When Will the Old (Anglo) Los Angeles Join the New (Latino) Los Angeles, and Learn to Dance Quebradita?" *Los Angeles Times*, 30 January.

McDaniel, Lorna. 1999. *The Big Drum Ritual of Carriacou: Praisesongs in Rememory of Flight*. Gainesville: University Press of Florida.

Mohan, Geoffrey, and Phil Willon. 2001. "Census 2000; Focus: Whites—Population Abandons the Suburbs for Isolated, Affluent Fringe." *Los Angeles Times*, 30 March.

Moore, Joan W. 1991. *Going Down the Barrio: Homeboys and Homegirls in Change*. Philadelphia: Temple University Press.

Noyes, Dorothy. 1995. "Group." *Journal of American Folklore* 108(430): 449–78.

Olvera, José Juan. 2000. "Al norte del corazón: Evoluciones e hibridaciones musicales de noroeste México y sureste de los Estados Unidos con sabor a cumbia." In *Actas del III Congreso Latinoamericano de la Asociación Internacional para el Estudio de la Música Popular (IASPM) AL BUENOS AIRES 2005*. Available at: http://www.his.puc.cl/historia/iaspmla.html.

Ortiz, Vilma. 1996. "The Mexican-Origin Population: Permanent Working Class or Emerging Middle Class?" In *Ethnic Los Angeles*, edited by Roger Waldinger and Mehdi Bozorgmehr, 247–77. New York: Russell Sage Foundation.

Pacini Hernández, Deborah. 1995. *Bachata: A Social History of a Dominican Popular Music*. Philadelphia: Temple University Press.

Page, Dawn. 2004. "Los pasitos de Patrulla 81." *La Opinión* (Los Angeles), 1 May, 2004. Available at: http://www.laopinion.com/espectaculos/?rkey =00040430154800488231. Accessed 23 April 2005.

Palmer-Lacy, Jenifer. 1994. Letter to the editor. *Los Angeles Times Magazine*, 6 March.

Paredes, Américo. 1958. *"With His Pistol in His Hand": A Border Ballad and Its Hero*. Austin: University of Texas Press.

Pearlman, Steven. 1988. "Mariachi Music in Los Angeles." Ph.D. diss., University of California, Los Angeles.

Peña, Manuel. 1980. "Ritual Structure in a Chicano Dance." *Latin American Music Review* 1: 47–73.

———. 1985. *The Texas-Mexican Conjunto: History of a Working-Class Music.* Austin: University of Texas Press.

———. 1999a. *The Mexican American Orquesta: Music, Culture, and the Dialectic of Conflict.* Austin: University of Texas Press.

———. 1999b. *Música tejana: The Cultural Economy of Artistic Transformation.* Austin: University of Texas Press.

Phillips, Susan A. 1999. *Wallbangin': Graffiti and Gangs in L.A.* Chicago: University of Chicago Press.

Plascencia, Luis F. B. 1983. "Lowriding in the Southwest: Cultural Symbols in the Mexican Community." In *History, Culture, and Society: Chicano Studies in the 1980s,* edited by the National Association for Chicano Studies Editorial Committee, led by Mario T. Garcia, 141–75. Ypsilanti, Mich.: Bilingual Review Press.

Puig, Claudia. 1994. "'Buenos Diiiiiiias, Los Annnnngeles!!' Is It the Loyal Audience? The Popular Music? The Hilarious DJs? KLAX-FM's Domination of the Ratings in the Country's Biggest Market Is Attributable to All That and One Other Crucial Factor: Se Habla Español." *Los Angeles Times,* 12 June.

Quintanilla, Michael. 1993. "*Qué* Cool! So Long, Techno. Banda Music Is Here, and with It, Hotter Than a Jalapeño, Is the Latest Dance: La Quebradita." *Los Angeles Times,* 16 June.

Ragland, Cathy. 1996. "A Banda for Good Times." *Austin American-Statesman,* 11 April.

———. 2003a. "Mexican Deejays and the Transnational Space of Youth Dances in New York and New Jersey." *Ethnomusicology* 47(3): 338–54.

———. 2003b. "Música norteña: History of a Border Crossing Tradition." Unpublished manuscript.

———. 2004. "Shifting Borders, New Identities: Toward a Mapping of Working-Class Popular Music in the Mexican Diaspora." Paper given at the Society for Ethnomusicology annual conference, Tucson, Ariz.

Riding, Alan. 1985. *Distant Neighbors: A Portrait of the Mexicans.* New York: Alfred A. Knopf.

Rodríguez, Darío. [1998]. "Quebradita." In *Diálogo.* Tucson: Tucson School District 1. Available at: http://phs.tusd.k12.az.us/meta/ dialogo/quebra .htm. Accessed 1 August 1999.

Rodríguez, Luis J. 1993. *Always Running—La vida loca: Gang Days in L.A.* Willimantic, Conn.: Curbstone Press.

Rodríguez, Mariángela. 1997. "Tres comunidades transnacionales: Chicanos y mexicanos en California." *Estudios Migratories Latinoamericanos* 12(35): 325–40. Available at: http://tigger.vic.edu/marczim/mlac/papers/mari angela.htm. Accessed 18 June 2006.

Rouse, Roger. 1991. "Mexican Migration and the Social Space of Postmodernism." *Diaspora* 1: 8–23.

Sánchez-Tranquilino, Marcos. 1995. "Space, Power, and Youth Culture: Mexican American Graffiti and Chicano Murals in East Los Angeles, 1972–1978." In *Looking High and Low: Art and Cultural Identity*, edited by Brenda Jo Bright and Liza Bakewell, 55–88. Tucson: University of Arizona Press.

Sauceda, Isis. 2003. "Montez de Durango: Un grupo con estilo propio." *La Opinión* (Los Angeles), 30 December. Available at: http://www. laopinion .com/archivo/index.html. Accessed 18 June 2006.

Scott, Janny. 2005. "Life at the Top in America Isn't Just Better, It's Longer." *New York Times*, 16 May.

Scruggs, T. M. 1999. "Let's Enjoy as Nicaraguans: The Use of Music in the Construction of a Nicaraguan National Consciousness." *Ethnomusicology* 43(2): 297–321.

Seo, Diane. 1994. "Dancing Away from Trouble: Some Youths Have Left Gangs in Favor of Clubs Devoted to *Banda* Music." *Los Angeles Times*, 3 February.

Seriff, Suzanne, and José Limón. 1986. "Bits and Pieces: The Mexican American Folk Aesthetic." In *Arte entre nosotros, Art among Us: Mexican American Folk Art of San Antonio*, edited by Pat Jasper and Kay Turner. San Antonio: San Antonio Museum Association.

Serrano, Fabian. 2002. "La música de tierra caliente, ¿hasta dónde llegará?" *RadioNotas.com*, at http://radionotas.com/noticias/06_2002/ 07_tier ra_caliente.htm. Accessed 25 January 2006.

Sheehy, Daniel Edward. 1979. "The Son Jarocho: The History, Style, and Repertory of a Changing Mexican Musical Tradition." Ph.D. diss., University of Los Angeles.

Sheridan, T. E. 1986. *Los Tucsonenses: The Mexican Community in Tucson, 1854–1941.* Tucson: University of Arizona Press.

Sheriff, Robin E. 2001. *Dreaming Equality: Color, Race, and Racism in Urban Brazil.* New Brunswick, N.J.: Rutgers University Press.

Simonett, Helena. 1996. "Waving Hats and Stomping Boots: A Transborder Music and Dance Phenomenon in Los Angeles' Mexican American Communities." *Pacific Review of Ethnomusicology* 8(1): 41–50.

———. 2001. *Banda: Mexican Musical Life across Borders.* Middletown, Conn.: Wesleyan University Press.

Smeeding, T., L. Rainwater, and G. Burtless. 2000. *United States Poverty in a Crossnational Context.* Luxembourg Income Study, Working Paper no. 244. Available at: http://www.lisproject.org/publications/liswps/244.pdf. Accessed 27 July 2005.

Stewart, Doug. 1999. "This Joint Is Jumping." *Smithsonian Magazine* 29(12): 60–74.

Stokes, Martin, ed. 1994a. *Ethnicity, Identity, and Music: The Musical Construction of Place*. Providence, R.I.: Berg.

———. 1994b. "Introduction: Ethnicity, Identity, and Music." In *Ethnicity, Identity, and Music: The Musical Construction of Place*, edited by Martin Stokes, 1–29. Providence, R.I.: Berg.

Sturman, Janet. 1997. "Movement Analysis as a Tool for Understanding Identity: Retentions, Borrowing, and Transformations in Native American *Waila*." *World of Music* 39(3): 51–69.

Turino, Thomas. 1999. "Signs of Imagination, Identity, and Experience: A Peircian Semiotic Theory for Music." *Ethnomusicology* 43(2): 221–55.

———. 2003. "Nationalism and Latin American Music: Selected Case Studies and Theoretical Considerations." *Latin American Music Review* 24(2): 169–209.

Valenzuela Arce, Jose Manuel. [1988] 1997. *¡A la brava ése! Identidades juveniles en México: Cholos, punks y chavos banda*. 2d ed. Tijuana, Mex.: Colegio de la Frontera Norte.

Vanderknyff, Rick. 1994. "'The Music of Mexico': Trends (Such as *Banda*) Come and Go, but Mariachi Is Forever." *Los Angeles Times*, 5 May.

Various. 2001. "Census 2000" (special report). *Los Angeles Times*, 30 March, special section U.

Verduzca, Tita. 2004. "La música duranguense: ¿De qué color se pinta el verde?" *La Mesera.com: El sitio oficial de la música sierreña*, 21 July. Available at: http://www.lamesera.com/loPasado/durango2.shtml. Accessed 24 April 2005.

Vigil, James Diego. 1988. *Barrio Gangs: Street Life and Identity in Southern California*. Austin: University of Texas Press.

———. 1997. *Personas mexicanas: Chicano High Schoolers in a Changing Los Angeles*. Fort Worth, Tex.: Harcourt Brace College.

Vila, Pablo. 2000. *Crossing Borders, Reinforcing Borders: Social Categories, Metaphors, and Narrative Identities on the U.S.–Mexico Frontier*. Austin: University of Texas Press.

Vizcaya Canales, Isidro. 1971. *Los orígenes de la industrialización de Monterrey*. Monterrey, Mexico: Librería Tecnológico.

Waterman, Christopher Alan. 1990. *Jùjú: A Social History and Ethnography of an African Popular Music*. Chicago: University of Chicago Press.

Welsh, Anne Marie. 1994. "La Quebradita Stomps into Old Town; Hot Mexican Dance Takes Stage for Cinco de Mayo Celebrations." *San Diego Union-Tribune*, 26 April.

Wilgoren, Jodi. 1993. "O.C. Groups Fight Gangs by Offering Alternatives." *Los Angeles Times*, 2 December.

Ybarra-Frausto, Tomás. 1991. "Rasquachismo: A Chicano Sensibility." In *CARA, Chicano Art: Resistance and Affirmation, 1965–1985*, edited by

Richard Griswold del Castillo, Teresa McKenna, and Yvonne Yarbro-Bejarano, exhibition catalog, 5–8. Los Angeles: Wight Art Gallery, University of California.

Discography

Readers who wish to listen to tecnobanda should consult the widely available recordings by Banda Machos, Banda Maguey, or Banda Arkángel R-15. For banda sinaloense, listen to Banda el Recodo, Banda la Costeña, or Banda el Limón. For música duranguense, try Montez de Durango, Alacranes de Durango, Patrulla 81, or Conjunto Atardecer.

Akwid. 2003. *Proyecto Akwid*. Woodland Hills, Calif.: Univision Music.

Los Alacranes de Durango. 2004. *Con pasito duranguense*. Woodland Hills, Calif.: Hollywood Visa. Licensed to Fonovisa, a division of Univision Music.

Banda Arkángel R-15. 1993. *¿De dónde es la quebradita?* Los Angeles: Fonovisa.

Banda la Costeña de Don Ramón López Alvarado. 1997. *Secreto de amor*. Van Nuys, Calif.: Fonovisa.

Banda Machos. 1992. *Con sangre de indio*. Los Angeles: Fonovisa.

Banda Maguey. 1995. *La estrella de los bailes*. Van Nuys, Calif.: Fonovisa.

———. 1996. *12 éxitos*. Van Nuys, Calif.: Fonovisa.

Banda Zeta. 1999. *Los éxitos de la A a la Z*. Miami: WEA Latina, Metro Casa Musical S.A. de C.V.

Café Tacuba. 1992. *Café Tacuba*. Studio City, Calif.: WEA Latina.

———. 1994. *Re*. Studio City, Calif.: WEA Latina.

El Gran Silencio. 2001. *Chúntaros radio poder*. Monterrey, Mex.: Virgin Records.

Grupo Montez de Durango. 2002. *El sube y baja*. Ciudad Juárez: Disa Latin Music.

———. 2003. *De Durango a Chicago*. Ciudad Juárez: Disa Records.

———. 2004. *En vivo desde Chicago*. Ciudad Juárez: Disa Latin Music.

Grupo Montez and Conjunto Atardecer. 2003. *El pasito de Durango*. Miami: Lideres Entertainment Group. Licensed to BMG Latino and Universal Music Latino.

Los Huracanes del Norte. 1999. *Cumbias para norteños chidos*. Van Nuys, Calif.: Fonovisa.

K-Paz de la Sierra. 2004. *Pensando en ti*. Woodland Hills, Calif.: Disa LLC. Licensed to Univision Music.

Mexiclan. 2004. *Mexiclan*. Woodland Hills, Calif.: Univision Music.

Patrulla 81. 2004. *Soy de Durango: Sus inicios*. Vol. 1. Woodland Hills, Calif.: Garmex Records. Licensed to Fonovisa, a division of Univision Music.

Videography

Compañía Oxxo. 1997. *La última quebradita*. VHS. Encino, Calif.: Compañía Oxxo.

Gómez, Jorge, producer. 1993. *Bandas a ritmo de quebradita*. VHS. N.p.: Ritmo Films, RF-1004.

——, producer. n.d. *La quebradita caliente*. VHS. Los Angeles: Gómez Producciones, VHS 109.

Grupo Montez de Durango. 2004. *En vivo desde Chicago*. DVD accompanying CD. Ciudad Juárez: Disa Latin Music.

K-Paz de la Sierra. 2004. *Pensando en ti*. DVD accompanying CD. Woodland Hills, Calif.: Disa LLC. Licensed to Univision Music.

Luna Music Corp. and Video Emoción. 1993. *¡A bailar la quebradita!* VHS. Los Angeles: Luna Music, VE7100.

New Form, Inc. 1993. *De la quebradita una probadita*. VHS. Northridge, Calif.: New Form; distributed by Laguna Films.

Romero, Juan Manuel, producer. n.d. *Pasos de la quebradita: A toda banda*. VHS. Anaheim, Calif.: JC Films, JC-0001.

——, producer. 1993. *Pasos de la quebradita II: Lo más nuevo*. VHS. Anaheim, Calif.: JC Films, JC-0012.

Various. 2003. *Los mejores videos del pasito duranguense*. DVD. Ciudad Juárez: Disa Latin Music.

Index

About the Author

Sydney Hutchinson was born in California and raised in Tucson and is currently a doctoral candidate in ethnomusicology at New York University. She worked for several years in public-sector ethnomusicology in New York City after obtaining a master's degree in the same field from Indiana University. A pianist, accordionist, and dancer, she has published on salsa dancing, quebradita, public-sector work, Dominican merengue típico, and Mexican ballet folklórico in journals such as *Ethnomusicology, CENTRO Journal (Center for Puerto Rican Studies), Revista Dominicana de Antropología*, and *Folklore Forum.* Her dissertation research conducted in Santiago, Dominican Republic, and New York City focuses on issues of gender, transnational migration, and class structure with relation to accordion-based merengue típico. Other research interests include border cultures, Dominican carnival, national folk dance troupes, and music and revolutionary politics.

From Quebradita to Duranguense